HIS HOLINESS

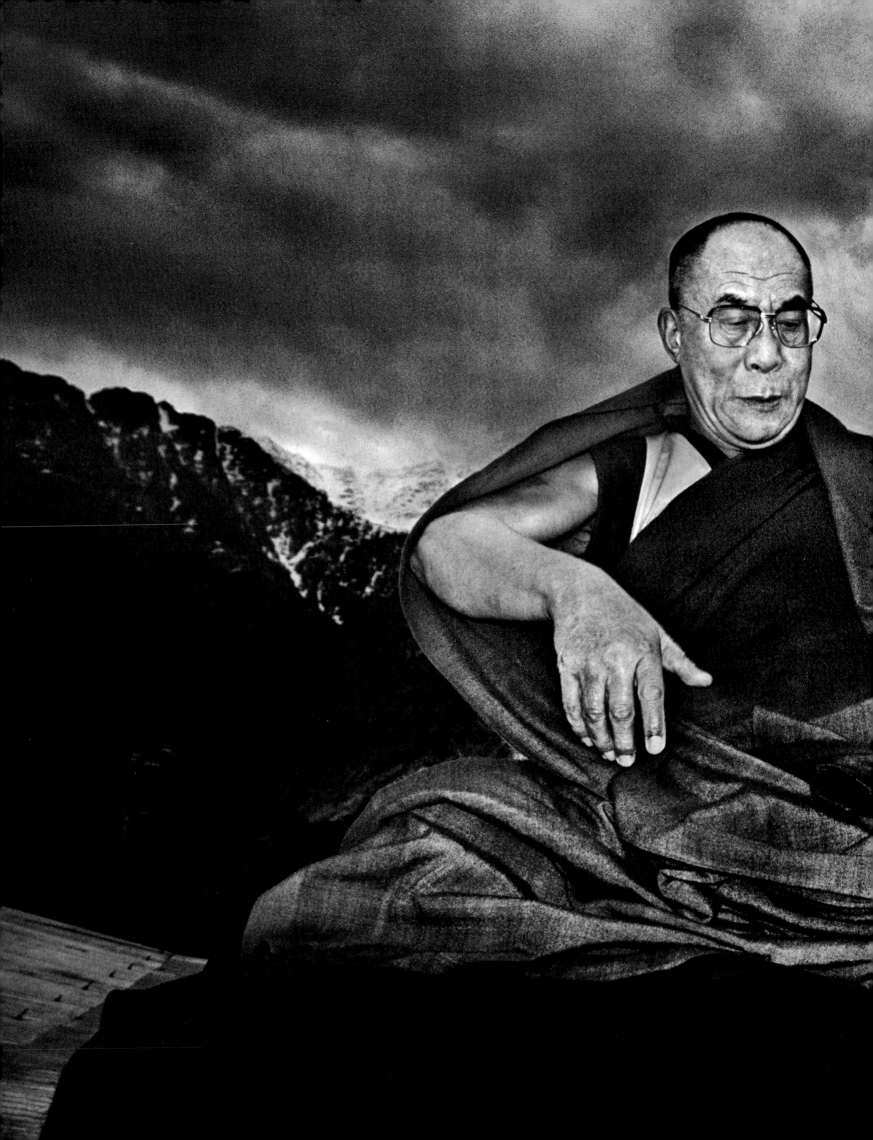

HIS HOLINESS
THE FOURTEENTH
DALAI LAMA

RAGHU RAI

Introduction by JANE PERKINS

MANDALA
PUBLISHING

San Rafael, California

MANDALA
PUBLISHING

An Imprint of Insight Editions
PO Box 3088
San Rafael, CA 94912
www.mandalaearth.com

 Find us on Facebook: www.facebook.com/InsightEditions

Follow us on Twitter: @insighteditions

Photographs © Raghu Rai
Introduction © Jane Perkins

Library of Congress Cataloging-in-Publication Data available.

ISBN: 978-1-68383-585-1

 REPLANTED PAPER

Insight Editions, in association with Roots of Peace, will plant two trees
for each tree used in the manufacturing of this book. Roots of Peace is an
internationally renowned humanitarian organization dedicated to eradicating
land mines worldwide and converting war-torn lands into productive farms and
wildlife habitats. Roots of Peace will plant two million fruit and nut trees in
Afghanistan and provide farmers there with the skills and support necessary
for sustainable land use.

Manufactured in India by Insight Editions

10 9 8 7 6 5 4 3 2 1

RAGHU RAI
FOUNDATION

A FOUNDATION FOR ART AND PHOTOGRAPHY

PREFACE

I have come to believe that His Holiness the Fourteenth Dalai Lama is one of those rare, pure souls, as I imagine Christ and the Buddha must have been.

Since 1975, I have fostered a unique relationship with him. I was working with *The Statesman* and photographed him on the first day of a ceremony, and on the second day asked if I could enter his tent and take more pictures of him, to which he agreed. He left an indelible impression on me—gentle, gracious, humble, and full of wonder. It is peculiar to say such a thing, but I got the strange yet pleasant feeling of being equals, despite his position. In hindsight, I realize it was because His Holiness behaved with such unfeigned kindness and lack of vanity. Since that time, I have cultivated a friendship with him that has strengthened and evolved over the years. Through my photography, I have learned more about His Holiness than I ever thought I would, and my respect for him has only increased.

I have photographed His Holiness at irregular intervals over several years, and the pictures in this book are, deliberately, not in chronological order. As such, the book gives an impression of a buildup of emotion in one "space"—rather, for instance, like the growth of a tree—instead of moving in a line, like walking from one place to another. The photographs offer an unprecedented glimpse into the Dalai Lama's life, and more importantly, into his character. Portraits, as the readers will see, are particularly efficient for this purpose.

This book entices the readers with an introduction by Jane Perkins, holds their attention with the following photo essay, and ends with shots of His Holiness's eightieth birthday—a sentimental and highly personal note. The introduction, both lucid and informative, provides context for and additional weight to the photographs. It takes the readers through a brief history of the Dalai Lamas, and then documents the Fourteenth Dalai Lama's early life as well as his harrowing exile. The photo essay, combined with Ms. Perkins's knowledgeable introduction, is emotional without hindering objectivity. The readers will vicariously feel close to His Holiness because the book is personal and open, rather than clinical and remote.

I have shared privileged situations with the Dalai Lama, including though not limited to shooting personal ceremonies. The photos, in combination with the text, show this great leader as a cheerful, childlike, and down-to-earth man, as worthy of friendship as he is of reverence. I hope, in particular, that I have captured his abundant childlike laughter and his readiness to heal the needy and pained. He is one of the saintly souls who are here on our planet to reduce suffering. These seem like natural and instinctive gestures that he cannot hold back. The readers will get a special look at this iconic figure, who is especially relevant in these tumultuous times.

When His Holiness first came to India, there was little international interest in Tibet. It was only after China began to grow aggressive that people started to want to know more about this now-famous dispute, particularly Tibet's side of the story. This book will provide concise information about this as well.

I hold great love and affection for His Holiness, and the readers, I think, will be able to sense that through these images. For instance, usually I travel when I have an assignment, but for this book, I traveled with no sense of compulsion: Mysore, Bodhgaya, Ladakh. This treasury of places offers varied and stunning backdrops and provides a sense of movement within the book.

The Dalai Lama strengthened my faith in humankind. I now firmly believe that, when all else fails, spiritual energy holds you together, and I hope others will feel the same after going through these pages, which are filled with his godly presence.

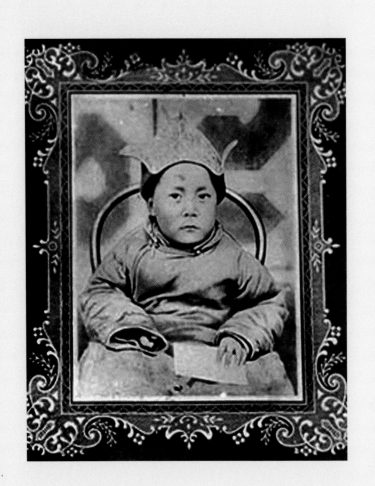

EARLY YEARS
INSIDE TIBET
AND THE ESCAPE

Jane Perkins

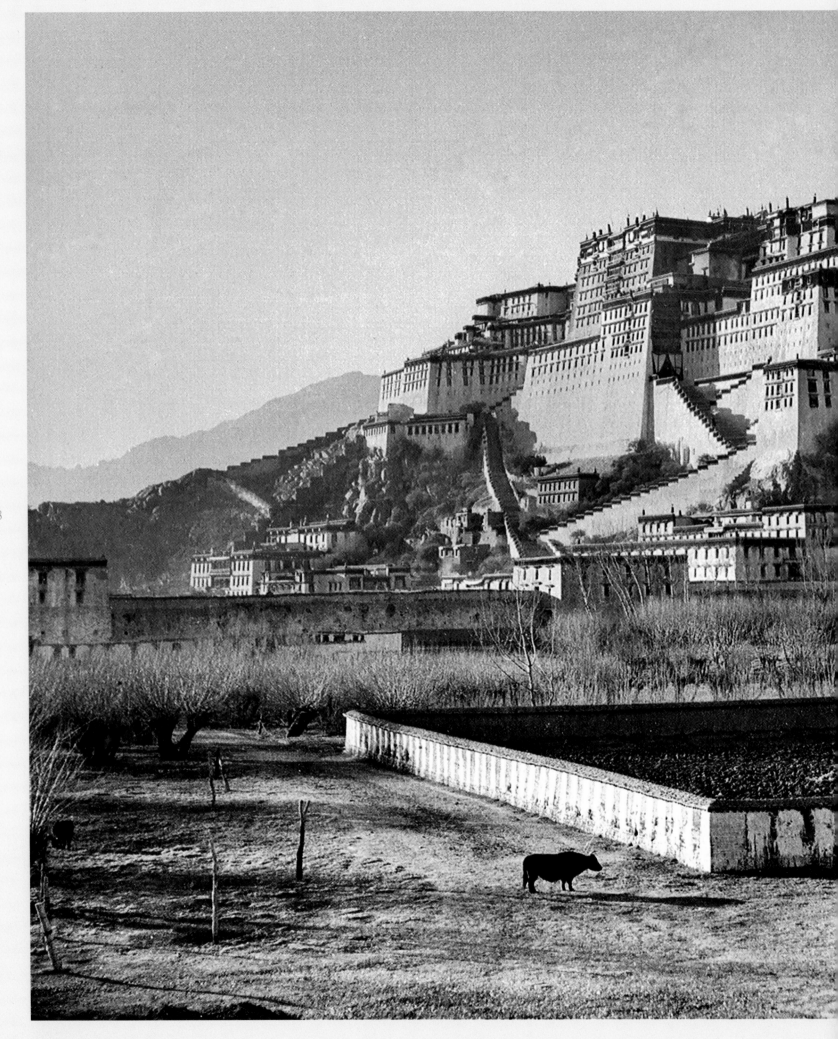

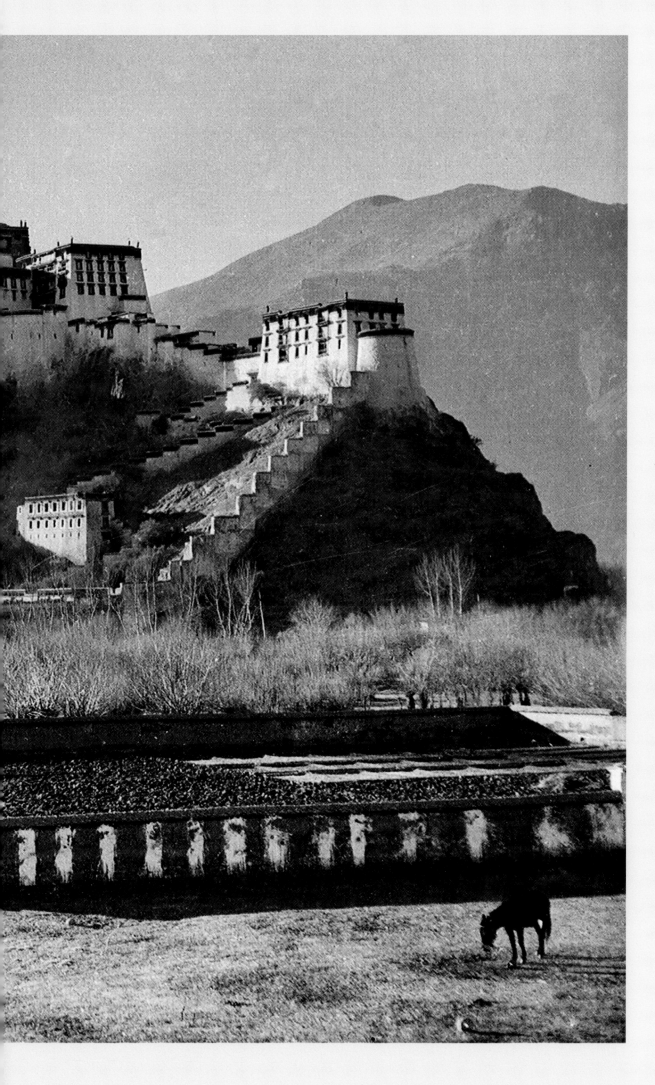

1930s. The seventeenth-century Potala Palace, winter residence of the Dalai Lama, gazes down at Tibet's capital city, Lhasa.

Page 6: 1936. The candidate to become the Fourteenth Dalai Lama at Kumbum Monastery in northeastern Tibet's Amdo province.

10

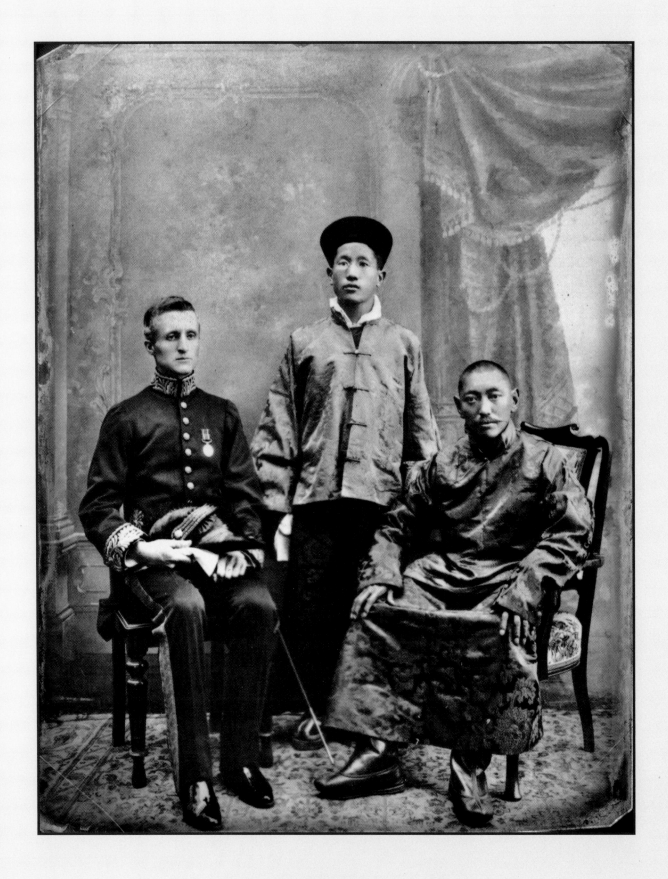

February 1910. The Great Thirteenth Dalai Lama
seated with Charles Bell, the Political Officer for Tibet,
while Sikkim's Maharaj Kumar, the Crown Prince,
stands at Hastings House, Calcutta.

In 1909 the Thirteenth Dalai Lama was picnicking beside a stupa overlooking a picturesque hamlet in Tibet's northeastern province of Amdo. Then he strode down the hill to inspect each farmhouse at Taktser and ask the name of its owner. Back at the stupa, he sat in meditation for some time and later told his host and companion, Taktser Rinpoche, that he would like to return to that same place one day.

Twenty-six years later, the Fourteenth Dalai Lama was born in one of the farmhouses at the village of Taktser, to a family whose eldest son was already enthroned at the nearby Kumbum Monastery as the reincarnation of Taktser Rinpoche.

The Great Thirteenth Dalai Lama, as he came to be known, had by then been wandering in exile in Mongolia and Qing-dynasty China for five years, after fleeing an armed invasion of his homeland by British India in 1904. The Younghusband Incursion was deployed ostensibly to open a trade route between Calcutta and the reclusive Himalayan nation. But in reality, what became known as the Great Game was being played out between tzarist Russia and imperialist Britain to establish and retain spheres of territory, power, and influence across Central Asia. The Great Thirteenth had been caught up in a late-nineteenth-century pursuit of political paranoia being acted out by elitist spies and orchestrated from London, Moscow, and Peking.

Only two months after his return to the Potala Palace in Lhasa, the Thirteenth Dalai Lama was forced to flee again in February 1910, this time on horseback to India, Tibet's closest border of refuge, with a cavalry regiment led by a Chinese warlord hard on his tail. China was in turmoil, the populace rising up against its Qing rulers, and within two further years of exile in Darjeeling, at the Himalayan hill station, it was feasible for the Dalai Lama to return to Lhasa while a Republican regime was ousting the foreign Manchu dynasty from its moribund throne.

It was in Darjeeling that the Thirteenth Dalai Lama formed a close and lifelong friendship with Charles Bell, British India's political officer for Tibet, Sikkim, and Bhutan; he was advised by Bell on institutions he should introduce when he returned to Tibet to establish, irrefutably, his country's independence. Until his early death in 1933 at the age of fifty-eight, the territory of Greater Tibet, including the three provinces of

U-Tsang, Kham, and Amdo, were peaceful, independent, and free from any Chinese presence.

However, from his understanding of the cataclysmic changes brought to Russia by Communism in 1917 and the rise of a popular young revolutionary Marxist leader in China, the Great Thirteenth saw the future dangers to his country more clearly than his subjects did. In a prophetic Last Testament issued in the early spring of 1932, after the Nechung Oracle had predicted obstacles in his life, the Dalai Lama warned his people about what was to come.

Reminding them of the events of 1909, when Chinese troops had invaded from the east, he said, "I took my ministers and officials and retreated into the holy land of India, where I appealed to the British government to mediate negotiations between China and ourselves. The British attempted to do this, but the Chinese were unresponsive." After he prayed for favorable changes in the situation facing him, civil war broke out in China, "so bit by bit we were able to rout them out and expel them from our land."

Seeing the looming dangers to Tibet so clearly, he went on to write:

> We must guard ourselves against the barbaric red Communists, who carry terror and destruction with them wherever they go. In Mongolia . . . they have robbed and destroyed the monasteries . . . destroyed religion . . . it will not be long before we find the red onslaught at our own front door . . . when that happens we must be ready to defend ourselves. Otherwise our spiritual and cultural traditions will be completely eradicated. Even the names of the Dalai Lama and Panchen Lama will be erased. . . . The monasteries will be looted and destroyed and the monks and nuns killed or chased away . . . we will become like slaves to our conquerors and made to wander helplessly like beggars.

It was into this world of earth-shaking political realignments that the Fourteenth Dalai Lama was born, in the sixth month of the Tibetan Wood Pig Year, to a family of farmers at the village of Takster in the summer of 1935.

His mother, Dekyi Tsering, had four children by then. The eldest, a daughter, was helping her with the household and farming chores. The first son, born in 1922, had been

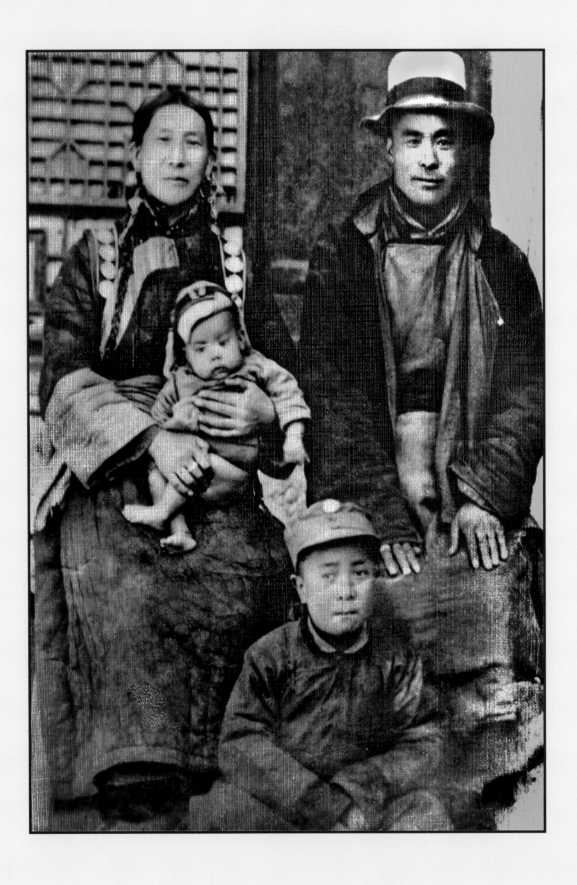

Late 1935. The baby Dalai Lama on his mother's lap
at Taktser Village. Her second-born son, Gyalo Thondup, is sitting on the
ground, while her husband, Choekyong Tsering, is seated beside her.

recognized as one of the thirty *tulkus*, or reincarnate high lamas, belonging to the historic Kumbum Monastery, a day's ride by horse from their village. Three male babies died before the birth of a fourth son in 1929 and a fifth in 1933. When Dekyi Tsering was pregnant once more, in the summer of 1934, she became anxious for the baby-to-be. And when her husband took to his sickbed in early 1935, and their horses and mules were dying without apparent reason, an apprehensive gloom descended upon their home. But friends and neighbors interpreted the obstacles as omens of joyful news to come.

Meanwhile, in the faraway capital, Lhasa, the regent, Reting Rinpoche, was preparing to embark on the search for the new Dalai Lama. The Great Thirteenth had already left clues. As his body was positioned on the throne, facing southwards, in preparation to be mummified, an attendant monk found that his head had turned left, indicating the east. A snapdragon and a star-shaped fungus grew on the eastern side of a pillar near the body. Unusual banks of clouds appeared in the northeastern sky.

But it was the clear visions Reting Rinpoche saw on the surface of Lake Lhamoi Lhatso that gave him the information to know precisely where to send his search teams. First came the Tibetan letters *a ka ma*, signifying the location as Amdo Province. Then the ripples subsided and a monastery roofed in jade green and gold arose. The Kumbum Monastery, near Amdo's capital, Siling, was easily identified. And finally came the farmhouse itself: turquoise roof tiles, a gnarled juniper drainpipe, and a small white Apso dog in the courtyard.

One search party came upon this house in 1936. Its leader was disguised as a retainer, to therefore be hosted in the servants' quarters, while a junior official wearing brocade and fur was entertained by the owners. In the kitchen, a small boy of almost two tried to sit in the leader's lap and asked for the rosary around his neck, which had belonged

to the Great Thirteenth. When asked to guess who the visitor was, the boy said, in the local dialect, "Sera lama." The leader was, indeed, Keutsang Rinpoche of Sera Monastic University near Lhasa, and the child went on to accurately name other members of the party.

Within a few days, a prestigious group of high lamas arrived to carry out more telling tests, equipped with other objects belonging to the late Dalai Lama. From two identical black rosaries, the child picked up the Thirteenth Dalai Lama's and placed it round his own neck; the same happened with two ritual drums, two walking sticks, and two yellow rosaries. When one of the lamas recalled the Great Thirteenth's close scrutiny of the hamlet in 1909, the decision was made. A message was telegraphed to Lhasa: The Dalai Lama has returned.

It was hard to convey precise information in a world with no modern means of communication. So a rumor reached the ears of Ma Bufang, a notorious Muslim warlord then holding sway over Amdo for Republican China, and he swiftly summoned the child and his parents to Siling. During the ensuing months of bargaining, with messages being relayed by horse to and from the regent, 40,000 silver dollars were extracted by Ma as a bribe to give permission for the child to be taken to Lhasa. Meanwhile, the little Dalai Lama designate stayed behind at Kumbum Monastery with his eldest brother, Taktser Rinpoche, and the third-born monk brother, Lobsang Samten.

In July of 1939, the three-month-long trek began. While the soon-to-be Dalai Lama and Lobsang Samten rode in a closed litter borne by mules, the fifty-strong entourage was mounting horses each morning well before dawn. It was only when the party crossed into U-Tsang—the safe haven of Central Tibet—that the child's identity was officially announced and the litter was replaced by a gilded palanquin. So on the

13

1938. The unhappy period spent at Kumbum Monastery,
waiting to be recognized, while members of the search party were
communicating with Lhasa by overland horse-relay.

14

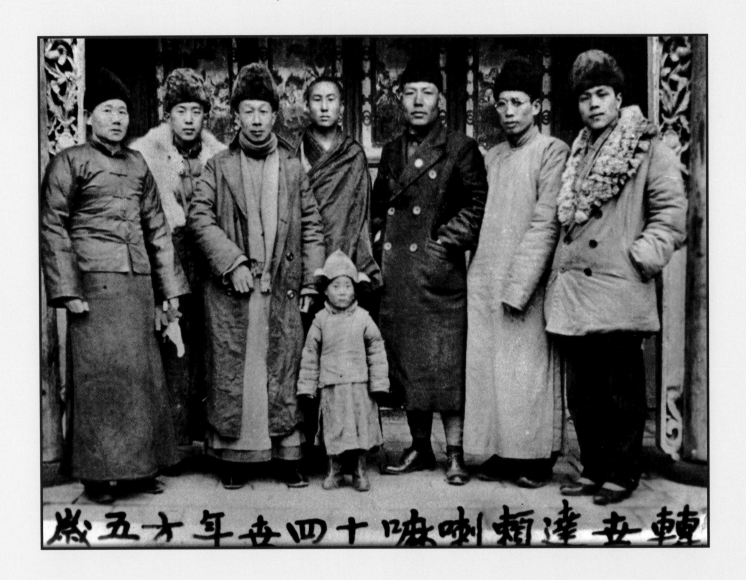

轉 世 達 賴 喇 呋 十 四 年 考 五 歲

1938. At Kumbum Monastery, near Amdo's capital, Siling. The Muslim warlord and
local administrator, Ma Bufang, third from left, is surrounded by his officials. The
Dalai Lama candidate's eldest brother, Taktser Rinpoche, stands at his rear.

morning of October 8, the citizens of Lhasa, dressed in their festive best, lined the capital's streets, and a round of celebrations, ceremonials, prayer rituals, and visits to the city's temples and monasteries began for the Fourteenth Dalai Lama. Witnesses observed that he was alert, composed, and amazingly dignified at the tender age of four.

The outpouring of emotions that day, as the crowds caught their first glimpse of the divine being who had ruled over Tibet for three centuries, were amplified by the lineage's more recent tragedies. The Twelfth, Eleventh, Tenth, and Ninth Dalai Lamas had all died in their youth; the eldest at twenty-one, the youngest at only nine. The future and fate of the precious new incarnation was uppermost in the prayers, hopes, and fears of the ecstatic and tearful populace.

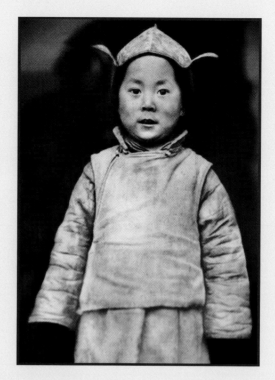

The lineage of the Dalai Lamas dates back to a great scholar, born in the fourteenth century at the site of today's Kumbum Monastery. Lama Tsongkhapa, whose focus on doctrinal purity and ethics brought about a reformation in monastic behavior and philosophical reasoning, went on to found a new school of Tibetan Buddhism, the Gelug—the "Virtuous Ones." His "heart student" and nephew was destined to become the First Dalai Lama.

The Second Dalai Lama was ecumenically broad-minded, taking teachings and initiations from the important lineage-holders of that era. By building a monastery high above Lhamoi Lhatso, it was this early Dalai Lama who unlocked the lake's spiritual powers so Tibet's powerful protectress, Palden Lhamo, could be invoked to manifest visions on the water's surface.

The title Dalai Lama dates from the late sixteenth century, when the Third Dalai Lama visited Altan Khan in Mongolia and was honored as the "Taleh Lama" in an exchange of honorific titles. The Mongolian ruler had earlier turned to Buddhism to validate his attempts to overthrow the Ming dynasty and reinstate Mongol rule over China. The great-grandson of Altan

Khan was enthroned as the Fourth Dalai Lama, escorted by a Mongolian military detachment—an event that later influenced the reign of the Fifth Dalai Lama, the first lineage-holder to earn the prefix "Great."

Ngawang Lobsang Gyatso was born in 1617 and became the secular and spiritual ruler over the three provinces of Tibet in 1642 through an unassailable combination of personal dynamism, prolific scholarly output, and such physical endurance that he was able to teach widely while traveling the length and breadth of the vast plateau. The catalyst for the Great Fifth's rise to power was an armed Mongolian assault by the Qoshot strongman, Gushri Khan, on the dynasty of the Tsang rulers holding southern Tibet. A decade later the Dalai Lama, leading a motley entourage of 3,000, made a slow and stately journey to Peking at the invitation of Emperor Shunxi. In later years, the Emperor Kangxi called upon the Great Fifth to bring peace between China and the Mongols, thanking him for his concern for the well-being of both nations. Although in his long lifetime the Fifth Dalai Lama was feted for setting up nationwide medical and education systems, his most visible and lasting legacy is the magnificent Potala Palace, still towering over Lhasa.

Since the Great Fifth left instructions to keep news of his death from his people until the Potala was completed, the arrival of the Sixth Dalai Lama from his birthplace at Tawang, in today's Indian state of Arunachal Pradesh, was delayed by fourteen years. By then the teenage incarnation was rebellious, beyond discipline, and fun-loving, indulging in sports, socializing, penning love songs to amuse his companions, and moving to an apartment below the Potala after renouncing his monk vows. At twenty-three he mysteriously died at Lake Kokonor in Amdo, ostensibly en route to Peking at the invitation of the emperor.

After this apparent hiatus in the lineage, the Seventh and Eighth Dalai Lamas cloistered themselves more from the political intrigues and neighborly machinations of the eighteenth century, living spiritual lives in prayer and writing extensively.

15

July 1939. With part of the bribe of 40,000 silver dollars demanded by Ma Bufang being handed over by the search party, the soon-to-be Fourteenth Dalai Lama was ready to journey to Lhasa in a mule-borne litter.

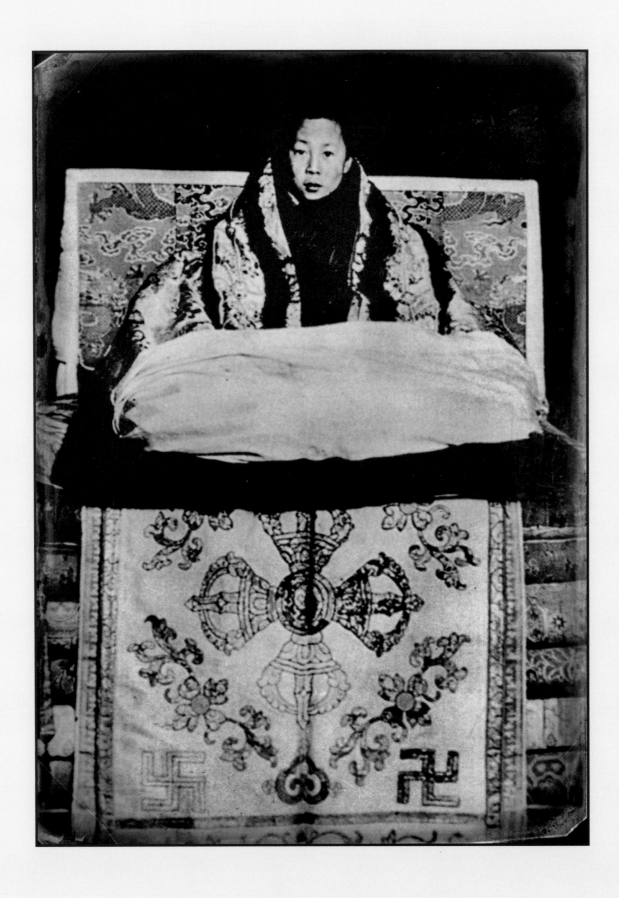

Later 1940s. This was a period of intensive education for the Dalai Lama, who was engaged in a demanding curriculum of study, memorizing and perfecting quick-witted rituals of debate. Ceremonials required him to assume the lineage's throne.

From a Tibetan spiritual viewpoint, the lives of the Twelfth, the Great Thirteenth, and today's Fourteenth Dalai Lama may be profoundly interlinked through karma. The Twelfth Dalai Lama could have chosen to die at twenty so that the Great Thirteenth would be in his prime to cope with the political turmoil facing Tibet, Mongolia, and China in the early decades of the twentieth century. And the Thirteenth Dalai Lama may have died prematurely at fifty-eight so the Fourteenth Dalai Lama could grow up to attain greatness by preserving Tibet's spirituality and identity while living in enforced exile, simultaneously serving, leading, and healing a broad swathe of humanity while traveling the globe in the twenty-first century.

For the first year of his new life in Lhasa, the Dalai Lama was given the freedom of staying at the summer palace, Norbulingka, with Lobsang Samten as his companion and his parents housed close by on the grounds. The extensive parkland contained small palaces built by previous Dalai Lamas and was surrounded by stables, an orchard, a lake, and the residue of the Great Thirteenth's zoo, which still included leopards, parrots, peacocks, and Mongolian camels. This transition period was idyllic for the Dalai Lama, then aged four to five.

Then, in the winter of 1940, he was moved to his golden-roofed apartment atop the Potala Palace, to be enthroned as the spiritual ruler of Tibet and take his novice monk vows. His parents were ennobled, with a mansion below the palace. His sister, Tsering Dolma, and Taktser Rinpoche joined them from Amdo, so the family became complete. A year later a second sister, Jetsun Pema, was born. At that stage, the Dalai Lama was free to be with his family whenever he wished, and his mother often joined her young sons for Sunday lunch, carrying their favorite breads and pastries.

Below his four-roomed apartment, on the terrace above the thirteenth story, the medieval, thousand-room Potala

was unheated, laden with centuries worth of dust, and dimly lit by rancid-smelling butter lamps. Mice outnumbered humans. But the Dalai Lama remembers it as a "spacious and fascinating prison" of strong rooms and storerooms stacked with priceless artifacts gifted by Chinese emperors and Mongol khans, ancient armor and armaments spanning over 1,000 years of Tibet's history, and 7,000 weighty volumes of scriptures and biographies. While his own Namgyal Monastery was in the west wing, with government offices to the east, the capitol building also housed the parliament, the National Assembly, and a school for future monk officials.

As the two small brothers slid down the banisters and chased each other up the stone staircases, they were surrounded by a cornucopia of wonders to explore on every floor. These early rambunctious years of basic study and play ended with Lobsang Samten being sent to a private school when the Dalai Lama was about eight and the spontaneous meetings with his other family members being reduced to monthly visits.

By then the future education of the Fourteenth Dalai Lama was paramount in the minds of his tutors and administrators, and each day's regimen became repetitive, punctilious, and strict. After penmanship came memorization of a Buddhist text to be recited later in the day. This was followed by a lengthy meeting for government officials, during which the Dalai Lama waited for the sounds of the midday bell and the conch announcing his longed-for hour of play until lunch.

Meccano and clockwork train sets were his favorite toys, but with characteristic ingenuity the Dalai Lama began to fashion tiny tanks, ships, and airplanes from barley flour dough and challenge adults to produce better models. The blueprints for his superior creations came from piles of books about World War I he found among the Great Thirteenth's eclectic belongings. Amidst this treasure trove he also retrieved an air rifle, targets, and ammunition, which found their way to the Norbulingka grounds. By shooting through the stems of the orchard's fruit, the Dalai Lama proved to be the best

Late 1942. At age seven, the Dalai Lama received a delegation, sent by President Theodore Roosevelt, requesting safe passage for military supplies to be sent along an ancient caravan route to China to shore up the defenses against Japan's brutal occupation in the Second World War.

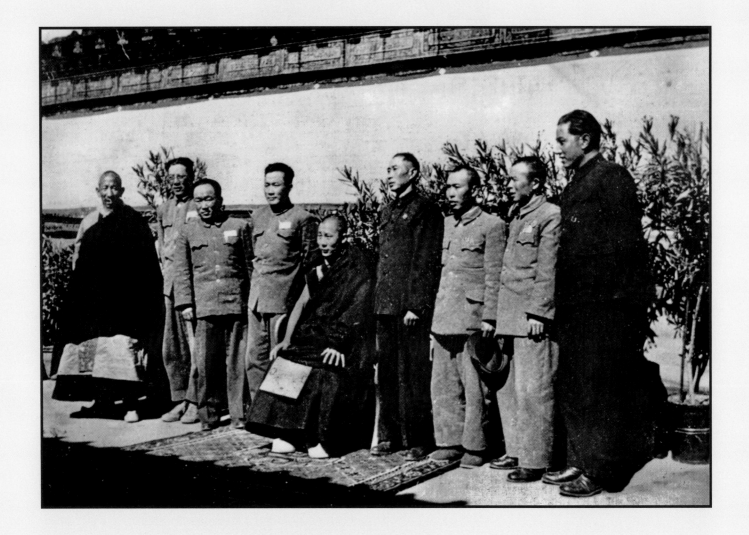

1951. In the Norbulingka summer palace gardens, with the lineup of
People's Liberation Army (PLA) generals who would soon enforce
their rule over Tibet. To the sixteen-year-old Dalai Lama's right, in dark
Maoist uniform, is General Zhang Jingwu, who became Mao's premier
administrator over occupied Tibet. To Zhang's right is the PLA political
commissar, General Tan Guansan, whose invitation for the Dalai Lama
to attend a theatrical show in early February 1959 precipitated the Lhasa
Uprising and the escape journey to India.

marksman among his brothers. But the most prized and useful find of all was a telescope, through which he looked down each evening on the ancient streets of the city, and could even recognize the faces of inmates exercising in the courtyard of the prison nearby. Sometimes an alert convict would prostrate himself if he caught a glint of glass and brass and, behind it, a watchful eye.

From the age of twelve, the afternoon's study curriculum began with ninety minutes of general education, followed by a debating session with a senior skilled debating partner to explore and clarify the subject of the day's study. Dialectics is a unique form of disputation, central to a Gelug monastic education, and is a key criterion in judging intellectual excellence. Students' memorization, philosophy studies, and grasp of logic are tested through debates in dramatic-looking confrontations between a questioner and respondent, who alternate roles. A quick wit and humor are vital qualities, and the Dalai Lama was exceptionally gifted with both traits.

In the late 1940s, after being admitted to Lhasa's monastic universities of Sera and Drepung, the Dalai Lama debated with the leading scholars of the time while studying hundreds of volumes of Buddhist literature from the thousands that exist. Although his intellectual inquisitiveness and precociousness at that age delighted his tutors and his religious beliefs had deepened, when Communist China's invasion in 1950 forced him to also assume his temporal role, he realized that his monastic education had left him ignorant of world affairs and history and, therefore, ill-equipped to lead and rule the country.

Perhaps forgetting the Great Thirteenth had warned them to be prepared to defend themselves against the "red onslaught" at their front door, in the 1940s the people of Lhasa remained relaxed and socially absorbed. The annual calendar was a nonstop round of celebrations and religious ceremonies, opening with the New Year rituals and at least a week of visiting, entertaining, and feasting. The first social high point of the summer was an incense- and prayer-offering for the

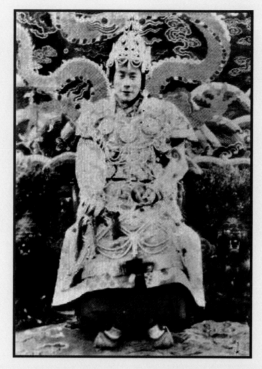

happiness of all beings, worldwide, accompanied by days of picnics and partying beside riverbanks and on mountain meadows across Tibet. Parties in the capital to celebrate festivals, hosted by the aristocrats and the other elite, extended over many days of camping in elaborately decorated tents, feasting, playing games, dancing, singing, and watching musical performances. Every summer the Dalai Lama looked forward to attending the opera season in the grounds of Norbulingka, hidden behind gauze curtains in his splendid tent so he could see but not be stared at.

As the end came of this timeless way of life, the nation was woefully ill-prepared. Although still in his early teens, the Dalai Lama was concerned by the social system's inequality and was introducing tax and land ownership reforms. His developing awareness was confirmed by Mahatma Gandhi's advice to a Tibetan delegation in New Delhi to congratulate India on its newly won independence: that their country should break out of its isolationism and spread the Buddha dharma throughout the world. A year later, in 1948, a trade delegation traveling on newly created Tibetan passports was touring India, America, and Britain to establish international outreach. For a country without newspapers, telephones, modern transport, and roads, these initiatives were too little, too late.

When 40,000 troops of the People's Liberation Army (PLA) crossed at six locations along Tibet's border with China in early October 1950, it took ten days for telegraphed messages to reach Lhasa. The government's offices had shut down for a festival. So not a word of the invasion reached the foreign media. As Kham-Chamdo, seat of the governor of eastern Tibet, fell to Mao's battle-hardened army on October 17, 2,500 of Tibet's 13,000-strong army were deployed in the strategic border region. Surrender was inevitable and swift.

Via its representative in Lhasa, India offered to airlift arms if a runway could be built immediately, but the elderly lama-regent who had replaced Reting Rinpoche seemed too emotionally

1954. The Dalai Lama presides over his first Kalachakra initiation at the rural Norbulingka summer palace on the outskirts of Lhasa, wearing the ceremony's traditional tantric bone-ornament headdress and vestments.

paralyzed to respond to this offer. A month later, aged fifteen and three years short of his majority, on the advice of a State Oracle, the Dalai Lama was enthroned as the absolute leader of Tibet.

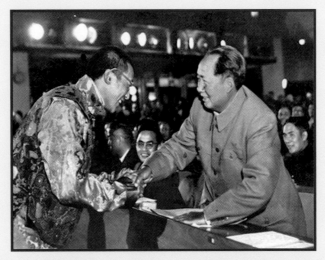

The gravity of the situation became clear when Britain, India, and Nepal refused appeals for support, and Taktser Rinpoche arrived from Amdo's borderland with China to warn his younger brother that the victorious Communists intended to usurp the entire Tibetan Plateau by claiming it as part of the Great Motherland. It was then that the National Assembly pressured the Dalai Lama to move for safety to the Indian border.

There, at the trade-mart town of Yatung, the Dalai Lama and his government heard more devastating news. A mission sent from Lhasa to China's renamed capital, Beijing, to negotiate a halt to the invasion, had been bullied and finessed into signing a document, which, in essence, ceded Tibet to the People's Republic of China (PRC). Clause II of the Seventeen-Point Agreement committed the Tibetan government to "actively assist the PLA to enter Tibet and consolidate the national defense," while Clause XIV denied Tibet all authority over foreign affairs. The document guaranteed that the existing political system would not be altered—nor would the status, functions, and powers of the Dalai Lama. Monasteries were to be protected and living standards improved, and reforms were not to be enforced. Since the delegates carried no authority to agree to the document without Lhasa's permission, government seals to validate their signatures were forged in Beijing.

A copy of this "agreement" was brought to Yatung by General Zhang Jingwu, Mao Zedong's appointee to oversee Tibet. He also carried a brief to persuade the Dalai Lama to return to the Potala. Beyond the general's blandishments and promises, the young ruler saw him in his shabby uniform as "drab and insignificant" beside his own officials, who were looking splendid in silk brocade.

Soon "drab" was to be the new hallmark of Tibet's capital. Within months, the city's population almost doubled with the arrival of 16,000 PLA officers and soldiers, who requisitioned houses, erected a mammoth military encampment that smothered the picnic meadow beside the city's river, and demanded provisions for themselves and fodder for their horses. Instead of the "living standards being improved," as guaranteed in the newly signed agreement, scarcities and inflation brought the simple subsistence economy to near famine.

By 1952, the generals were scheduling regular meetings with the cabinet, and before long the situation was confrontational. Tibet's patriotic and feisty prime minister insisted his government could no longer feed the military, and since there was no reason for such a massive force, it should withdraw back to China's frontier. The final confrontation was over the prime minister opposing an order to merge the Tibetan Army with the PLA. The Dalai Lama was then forced to request that his lay and monk prime ministers resign, and he decided to shoulder this onerous responsibility of communicating directly himself. Relying upon the mind training, ethics, and reasoning imbibed from his religious studies to guide and inform his interactions, he initiated a more conciliatory atmosphere at negotiations between his ministers and Mao Zedong's generals. As his surviving older brother, Gyalo Thondup, observes today, by this age the Dalai Lama's religious training had already "instilled him with remarkable discipline and control over his emotions." By now he was seventeen.

General Zhang proved far from "insignificant," and soon he and his ideologically driven wife were enforcing their own Maoist imprint on Lhasa. By late 1952, the Patriotic Women's Association (PWA) and the Patriotic Youth Association were established. With the Dalai Lama endorsing this move, his sister Tsering Dolma was elected chairman of the PWA. As vice-chairman and general secretary of this women's group, Taring Rinchen Dolma of the aristocratic Tsarong family had a ringside seat to experience the policies being imposed. When her group was requested by Mrs. Zhang to help build assembly halls for both patriotic associations, younger members from the nobility were terrorized into working there as laborers.

1954. In Beijing at the first National People's Congress of the victorious Communist PRC government. Chairman Mao Zedong stands to greet the nineteen-year-old Dalai Lama with a welcoming handshake.

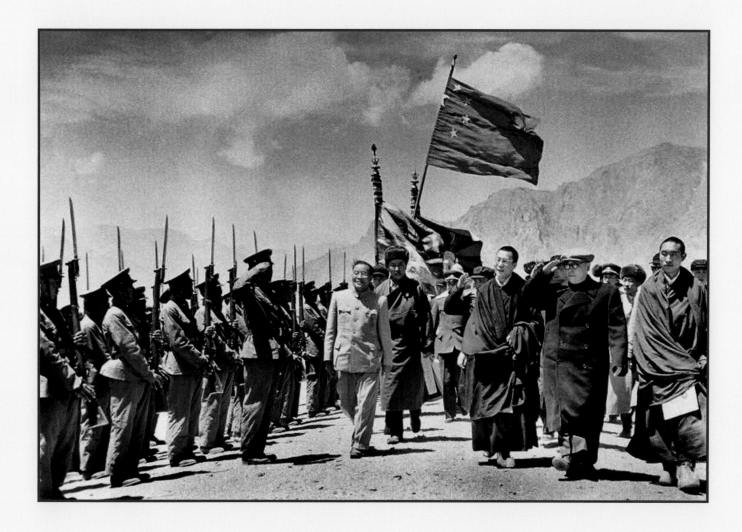

1956. Lhasa, at the inauguration of the PCART (the Preparatory
Committee for the Autonomous Region of Tibet), an administrative deceit
to effectively divide the central region of Tibet from the eastern provinces
of Kham and Amdo, so that Beijing could achieve absolute control. The vice
premier of Mao's China, Marshall Chen Yi, salutes a parade of
Tibetan Army soldiers with the Dalai Lama and the
Tenth Panchen Lama flanking him.

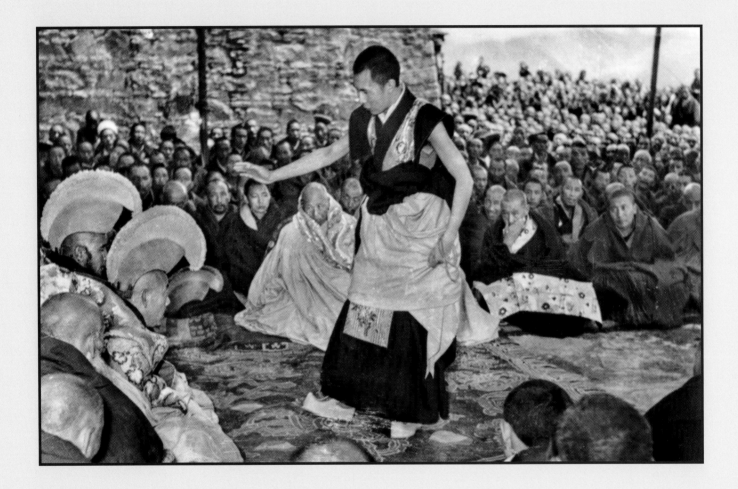

1958 or 1959. From summer 1958 until February 1959, the Dalai Lama was
engaged in rigorous examinations before the great scholars
of the day. His outstanding performance was rewarded with the highest
level doctorate degree, the Geshe Lharampa.

Instead of picnics and week-long parties, Lhasa's elite found themselves celebrating Communist International Women's Day and International Youth Day, and listening to endless lectures on Marxist political science. Meanwhile the populace had set up a people's council and was staging demonstrations against the Chinese armed presence. In the dead of night, posters were pasted up with the uncompromising slogans "Tibet Belongs to Tibetans" and "China, Get Out of Tibet."

If it had previously been possible for the Dalai Lama to be shielded from understanding the fate of his country, he held no illusions when, in 1954, he received an invitation to lead a delegation to the first National People's Congress in Beijing. To leave Lhasa with around 500 invited officials and their servants, the Dalai Lama and his party were paddled across the Kyichu River in yak-skin boats before motoring on perilous Chinese-built roads, changing to horseback at later stages and camping overnight. His first experience of flying was in China, but he found that his fascination with machinery was overwhelmed by his worries about what would happen in the days and weeks to come.

An apparently paternalistic Mao Zedong outlined plans for the Preparatory Committee for the Autonomous Region of Tibet (the PCART), an alternative to the Party's earlier decision to rule Tibet from Beijing. Since all but five of the PCART's fifty-one members were to be Tibetan, this seemed to the Dalai Lama a victory for his policy of nonconfrontation, and so his mood on returning to Tibet was more optimistic than when he arrived in the People's Republic of China. But he and his officials had concluded, during a three-month tour of cooperatives, workers' organizations, industrial centers, schools, and universities, that while some progress was impressive under the socialist regime, the Chinese people were neither happy nor free to express their real feelings. In Taring Rinchen Dolma's words, since criticism was the main activity, "people could not trust each other: That is Communism."

The long return journey to Lhasa across eastern Tibet was a further eye-opener. The government officials listened to horror stories of six years of China's occupation. There were consistent accounts of selective arrests, public criticism (or *thamzing*) meetings, and executions of "enemies of the people." Monasteries had been stripped of their gold, silver, and jewel-encrusted statues and ritual objects. In retaliation for resisting the military occupation, some ancient monasteries had been bombed. The Dalai Lama was able, however, to give teachings at every major town, and made a return visit to his birthplace and relatives.

The outcome of this journey was the inspiration of the proud easterners to launch a more resolute resistance against the invaders, so simmering opposition to unpopular Communist reforms escalated to outright violence. For the Dalai Lama, the situation had become so desperate by the first half of 1956 that he was contemplating giving up all political involvement. He was caught in a conundrum. As his people's religious leader, he was bound to oppose violence, but if they lost trust in him as their secular leader, it could only result in the Chinese destroying the faith and kinship existing between him and his people.

As he began to consider leaving Tibet to lead a freedom movement from exile, in August an invitation arrived from India. As president of the Mahabodhi Society of India, the crown prince of Sikkim was deputed to request Tibet's Fourteenth Dalai Lama to attend the 2,500th anniversary celebrations of the birth of the Sakyamuni Buddha.

While the people of Tibet were as delighted by this invitation as they had been apprehensive of Mao's invitation for him to visit China, the Dalai Lama was relieved to be able to withdraw from his "fruitless arguments with the Chinese" and "meet democratic leaders and followers of Mahatma Gandhi for advice." But permission to attend the Buddha Jayanti celebrations was withheld by the generals until a telegram arrived from the Government of India inviting both the Dalai Lama and the Panchen Lama to appear at the event together.

Mid-March 1959. The escape party paused for two nights at Lhuntze Dzong fortress at Lhoka, central Tibet, to officially repudiate the Seventeen-Point Agreement signed in Beijing in 1951, and establish a government-in-exile. With Cabinet Minister Surkhang leading his horse, and Lord Chamberlain Phala at his left side, the Dalai Lama rides onward south to request India to grant him political asylum.

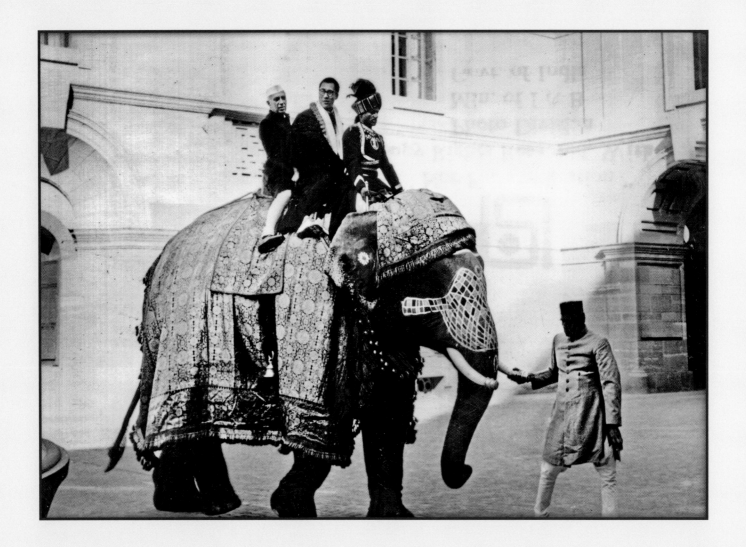

1956. At Government House, now Rashtrapati Bhavan. After lunch, hosted
by the first president of independent India, Dr. Rajendra Prasad, the Dalai Lama
(astride a caparisoned elephant with Prime Minister Pandit Nehru)
and the Panchen Lama were gifted identical orange ambassador
limousines by the Government of India.

After receiving a schoolboy lecture from General Zhang on what he may or may not say and being handed a draft of his official speech, the Dalai Lama took the route of Younghusband's 1904 invasion to reach Sikkim. At Palam Airport, he was welcomed by Prime Minister Jawaharlal Nehru and Vice President Dr. Radhakrishnan, and then received at the Rashtrapati Bhavan by President Dr. Rajendra Prasad, "with his gentle smile and voice."

On the morning of his first day in New Delhi, he stood before Gandhi's cremation memorial at Rajghat and pondered what advice the Mahatma would have given him. "I felt sure he would have thrown all his strength of will and character into a peaceful campaign for the freedom of the people of Tibet." In those peace-filled moments, the Dalai Lama vowed "more strongly than ever that I could never associate myself with acts of violence." And then the visit to Bodhgaya, the site of the Buddha's enlightenment, was to be the fulfillment of his dreams from his early youth. "As I stood there a feeling of religious fervor filled my heart, and left me bewildered with the knowledge and impact of the divine power which is in all of us."

A one-on-one meeting with Nehru, with only an interpreter present, was much more grounding. Opening his heart, the twenty-one-year-old ruler confided that he believed he should stay in India until there were positive signs of change in Mao's policies. He reasoned that at least from India he could mobilize moral support and tell the world what was happening in Tibet. After advising the Dalai Lama to return and work peacefully to try to implement the Seventeen-Point Agreement, Nehru promised to talk with Chinese Premier Zhou Enlai, who was arriving the next day. In a lengthy meeting with Zhou, the Dalai Lama described the troubles plaguing eastern Tibet and outlined instances of Chinese atrocities.

China's premier seemed sympathetic and promised to make a report to Chairman Mao, reasoning that the "local Chinese officials must have been making mistakes." Later, over dinner, hosted by Zhou at the Chinese embassy, the Dalai Lama's brothers, Taktser Rinpoche and Gyalo Thondup, were outspoken and critical of Beijing's treatment of Tibet. Though clearly resentful over their straight-talking, Mao's second-in-command promised the "gradual withdrawal of Chinese troops as soon as Tibet could manage her own affairs" and said he would convey their criticisms to the Chairman. Before the evening ended, he told them to persuade their brother to return to Tibet.

In a farewell meeting with the Dalai Lama, Nehru passed on Zhou Enlai's message guaranteeing absolute autonomy for Tibet, and his remark that it was "absurd for anyone to imagine China was going to force Communism on Tibet." At this juncture, the Dalai Lama wondered whether they were discussing the same reality.

The India sojourn ended prematurely when General Zhang sent a telegram summoning the Dalai Lama back because "spies and collaborators are planning a revolt," and news also came that Zhou was making an unscheduled return to New Delhi and was anxious to meet Tibet's young leader. So, writes the Dalai Lama, "I had to drag myself back to the world of politics, hostility and mistrust." Against the advice of Zhou, he spent a month in Kalimpong, waiting for the snow to melt on the Nathu-la Pass and giving teachings to the Tibetan community. In another act of defiance, he tore up the draft of his Buddha Jayanti speech and spoke extemporaneously. By April 1957 he was back home in Lhasa.

As the flow of refugees from Kham and Amdo swelled the capital's overburdened population by at least 10,000 newcomers, the brutal policies being inflicted on eastern Tibet were widely broadcast. With the PCART reneging on the more positive-sounding guarantees in the Seventeen-Point Agreement, a guerilla resistance was formed. The attitude of the generals became threatening, and the Dalai Lama could no longer calm his people down. When an attempt was made to take a census of the refugees camping around Lhasa, fearing reprisals, the Tibetans took to the mountains to join the growing armed resistance.

25

1956. During the Buddha Jayanti ceremonials at Rajgir, celebrating the twenty-five-hundredth anniversary of the Buddha's birth, Premier Zhou Enlai presented Pandit Nehru with a relic of China's seventh-century scholar and monk-pilgrim Xuanzang. This gift to India was a political ruse to give Zhou the chance to persuade the Dalai Lama to return to Tibet.

The culmination of the Dalai Lama's religious education came at the end of 1958, when he spent a month being examined for his doctorate degree by relays of scholar-monks at each of Lhasa's monastic universities. On March 1, 1959, he was taking his final examinations during Tibetan New Year ceremonies at the seventh-century Jokhang Temple, when political commissar General Tan Guansan sent him an invitation to a theatrical show at the PLA's military camp. An acceptance date was demanded and, knowing that he no longer had the status and freedom to refuse, a few days later he agreed to attend on March 10. On March 8, Communist International Women's Day, a function at the Patriotic Women's Association became surrounded by over a thousand irate Tibetan women shouting anti-Chinese slogans. Inside, on the stage, the guest of honor, General Tan, was bellowing invectives against the Khampa guerillas, threatening that monasteries would be shelled and destroyed if they refused to surrender.

By the morning of March 10, the streets of Lhasa were crammed with hysterical citizens, rushing to the Norbulingka to block the Dalai Lama from leaving for the army headquarters that evening. A brigadier had issued orders the previous day that no armed bodyguards were to escort the Dalai Lama, and the custom of armed Tibetan soldiers lining his route was forbidden. Knowing that high lamas and chieftains in eastern Tibet were never seen again after being similarly entertained by Chinese army commanders, his people assumed that the Dalai Lama was about to be kidnapped.

Barricaded in by an estimated crowd of 30,000, the Dalai Lama realized he was unable to leave. His citizens-turned-bodyguards, armed only with sticks, stones, and sharp knives meant for paring yak meat, camped around the Norbulingka walls for a further week. Letters were passed between the army camp and the Norbulingka, until one dated March 16 asked the Dalai Lama to identify his location in the complex to General Tan, since "they certainly intend that this building will not be damaged." This letter signaled the end had come.

The following afternoon, two heavy mortars were fired at the Norbulingka. One landed in the marshland outside the park's walls, the next in a pond within. So, at ten in the evening of March 17, a palace door opened and a soldier was handed a rifle to join a bodyguard patrol and march outside the Norbulingka walls. The soldier was the Dalai Lama. An hour earlier his mother, elder sister Tsering Dolma, youngest brother Tendzin Choegyal, an uncle, and a maid had left, all disguised as policemen. His own "patrol" comprised the lord chamberlain, the chief abbot, his brother-in-law, who was commander of the bodyguard, and two regular soldiers bringing up the rear.

When the Dalai Lama reached the river's southern bank, a posse of Khampa freedom fighters and extra horses was waiting alongside the escaping group of family, officials, and high lamas. And so began the fortnight's journey to seek exile in India. It wasn't until they reached the border that the fate of Lhasa in the wake of the escape was known in distressing detail. A three-day battle against Beijing's occupation forces had left an estimated 12,000 Tibetans dead and their ancient sacred sites in ruins.

The original plan had been to set up an interim government at a fortress monastery near the Bhutan border. But after the Dalai Lama heard that the Norbulingka had been reduced to a smoking ruin on the first day of the city's battle, and that in the evening Chinese soldiers were seen examining the faces of each body before realizing he had escaped, he accepted that he and his entourage would be hunted like animals if they chose to remain in Tibet. The response from Prime Minister Nehru to a message requesting political asylum for him was immediate: "But of course."

And so, on March 31, 1959, weak from fever, dysentery, and days of struggling through snowstorms and rain, the Dalai Lama of Tibet crossed into India near the location where, almost three centuries earlier, the Sixth Dalai Lama was born. Just as the Great Thirteenth predicted in 1932, the Fourteenth Dalai Lama had been forced by the "barbaric red Communists" to wander helplessly like a beggar.

Free at last, the Dalai Lama interacts with tribal Monpas in India's northern border state of Arunachal Pradesh.

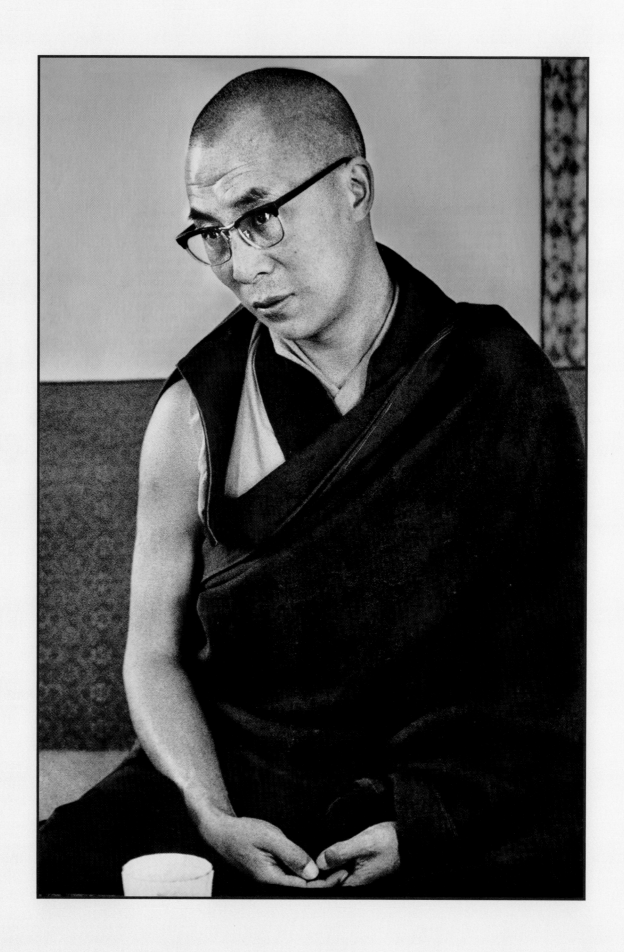

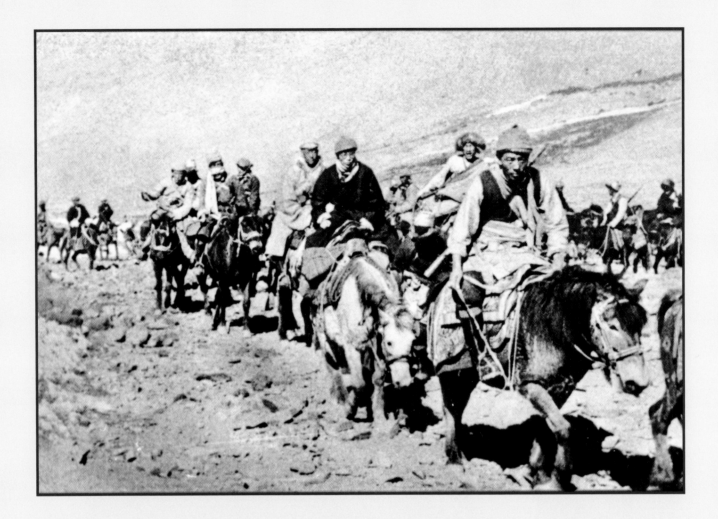

In the wake of His Holiness the Dalai Lama's arrival and acceptance as a refugee in India, a flood of distraught Tibetans crossed the Himalayan ranges carrying little but the clothes on their backs. In the face of Beijing's outrage and criticism from political colleagues and India's media, on April 27, 1959, Prime Minister Jawaharlal Nehru told the parliament, the Lok Sabha, that Zhou Enlai had assured him in 1956 that China ". . . did not consider Tibet as a province of China. The people are different from the people of China proper. . . . He told me further that it was absurd for anyone to imagine that China was going to force Communism on Tibet. Communism could not be enforced in this way on a very backward country . . . even though they would like reforms to come in progressively."

By May 15, as domestic opposition to his humanitarian decision mounted, Pandit Nehru told a press conference: "Even when we are abused, we maintain restraint. This is our attitude. It is not changed by threats." He admitted that the arrival of around 12,000 Tibetans seeking refuge would be "a burden on the country, but we are not going to throw them out. It has been the tradition of India that whosoever has come to our door for refuge has been welcomed and made a friend of the family. So, when we receive these Tibetan refugees and look after them, it is in the best traditions of our country."

He continued, "Well, I imagine that his stay in India is going to be prolonged. Everybody realizes, I am sure, how extraordinarily difficult and delicate this question of Tibet is and therefore we shall have to keep this in mind. Our sympathies, our feelings, go out in one direction; our capacity to do anything is obviously limited."

But by spring of 1964 a clearly despondent tone is voiced in Prime Minister Nehru's last letter mentioning Tibet.

March 21, 1959. Midway through the Dalai Lama's epic fifteen-day
escape journey to exile in India. Ahead of the Dalai Lama, his rifle slung across
his back, is General Ratuk Ngawang of the Khampa
resistance force, which escorted the young Tibetan leader
safely to the Indian border.

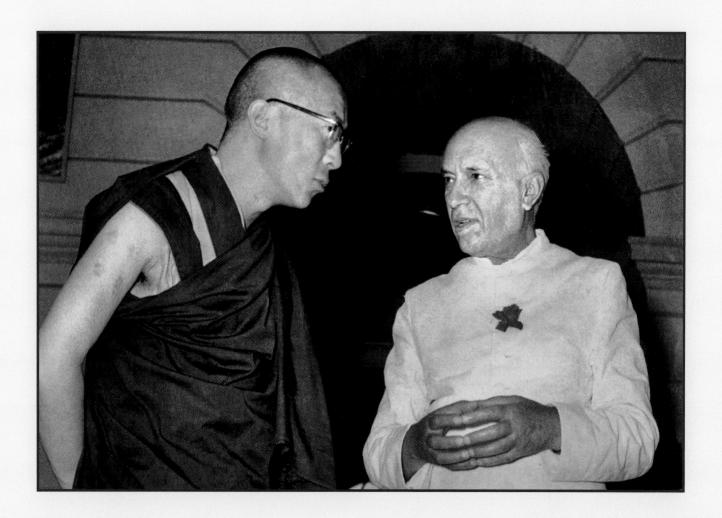

My dear Dr. Gopal Singh,

Your letter of the 20th May. It is not clear to me what we can do about Tibet in present circumstances. To have a resolution in the United Nations about Tibet will not mean much as China is not represented there. We are not indifferent to what has happened in Tibet. But we are unable to do anything effective about it.

Yours sincerely

Jawaharlal Nehru

24 May 1964 Dehra Dun

The last meeting at Teen Murti between the Dalai Lama and India's Prime Minister Jawaharlal Nehru.

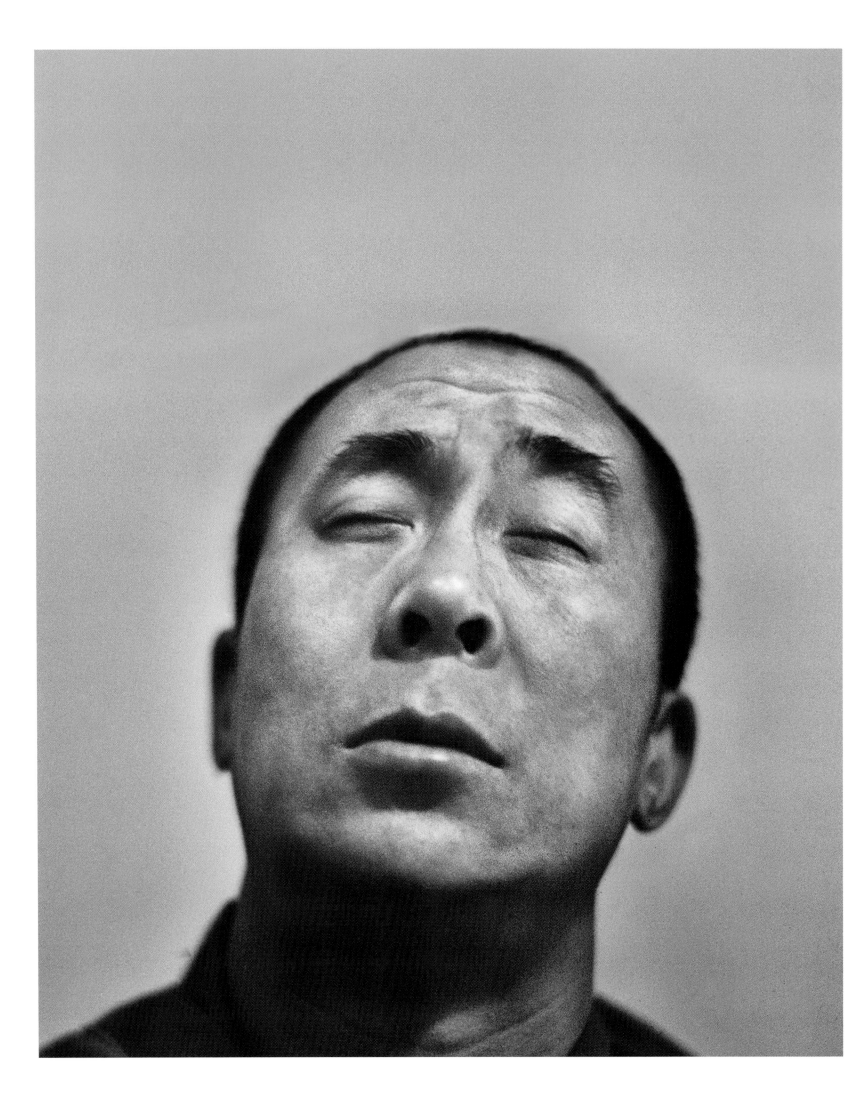

A GOD IN FOCUS

Raghu Rai

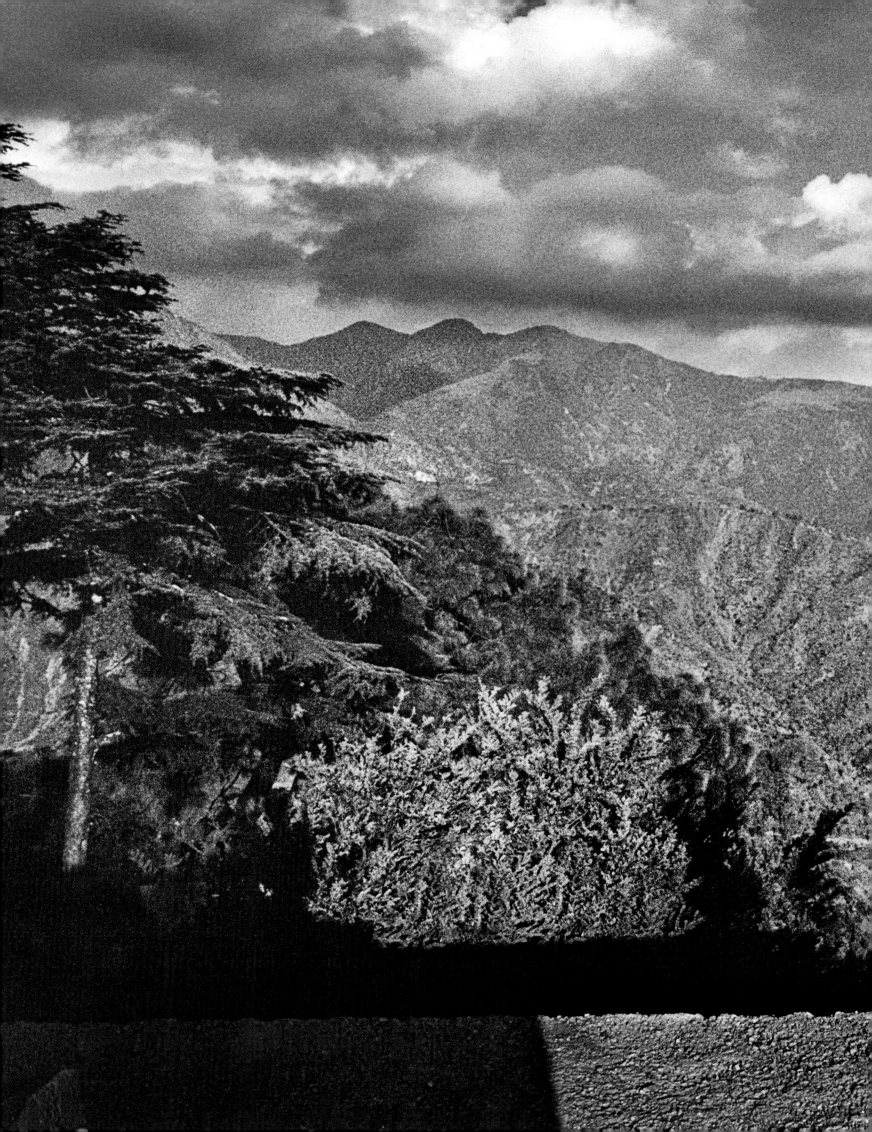

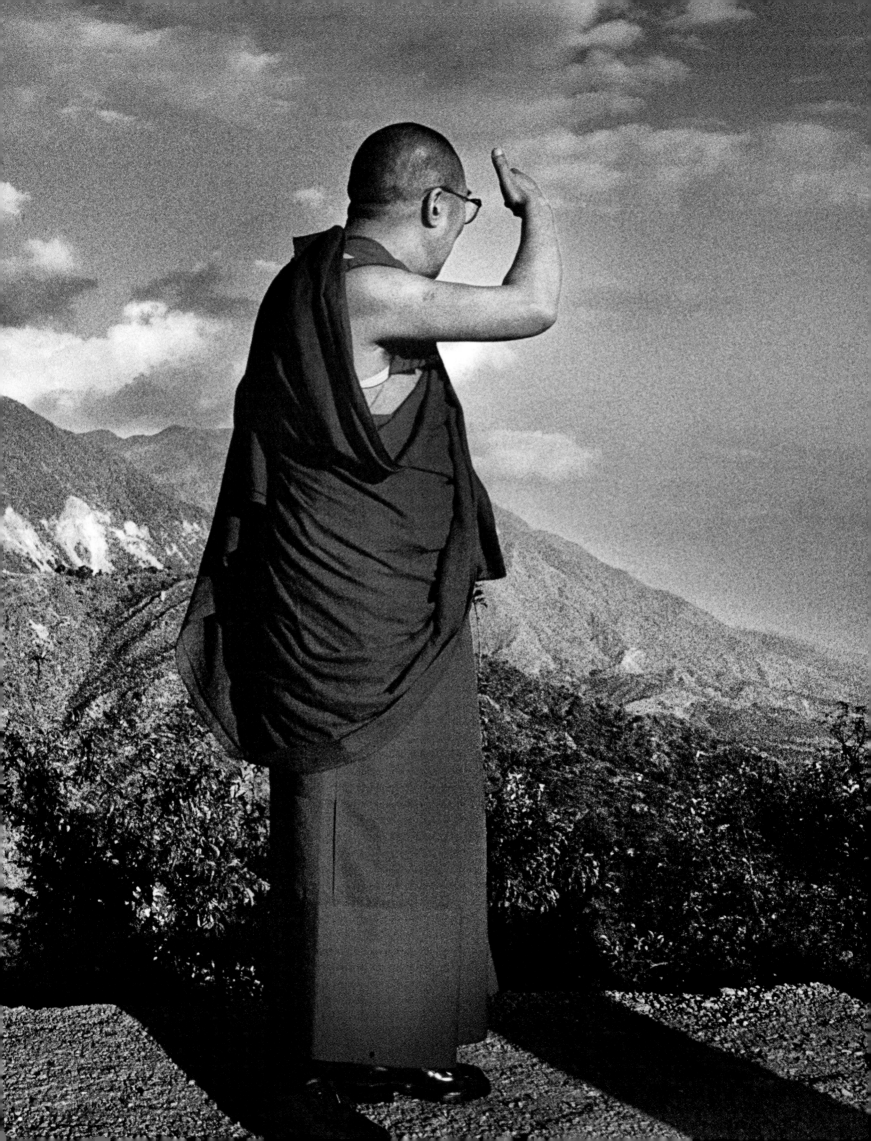

THE FIRST ENCOUNTER

I think it was 1975. I was working with *The Statesman* newspaper, and when hard news was scarce we would look for softer news stories. So when the news editor told us that His Holiness the Dalai Lama was giving teachings over three days in Ladakh, I set off with a reporter, Tavleen Singh. I'd never been to Ladakh. Normally the high-altitude plateau is dry, but we arrived in a downpour. Thousands of monks, nuns, and other Buddhists sat in the open air, soaked, shivering, still, and impassive as statues. A shaman weather-controller kept blowing his thighbone trumpet, but the drizzle just went on and on.

This was a Kalachakra ceremony. It was a barren landscape down by the Sindhu River. His Holiness was on a covered stage, while we were sheltered by raincoats. But the monks sat in rigid concentration, dripping.

I photographed the lamas, Tibetans, and Ladakhis that first day, and on the second day I asked to go into his tent to take more pictures. He said yes. Then, on the third day, Tavleen requested an interview and he gave us a whole hour. I took these pictures then—these portraits. He was gentle, wonderful, and at ease.

As we were driving back to Srinagar (there were no flights then), Tavleen said, "See what His Holiness has given me," flaunting a red thread that he had tied round her wrist. "What did you get?"

"Come on," I replied. "Between equals we don't exchange such things." The response was spontaneous. I don't know why I said it. Then I thought, "But he is a head of state, a spiritual leader, and you're saying you are equals?"

Much later I realized that my boast was a reflex, because His Holiness was so open, informal, and warmly welcoming that it seemed as though he were giving me the gift of equality.

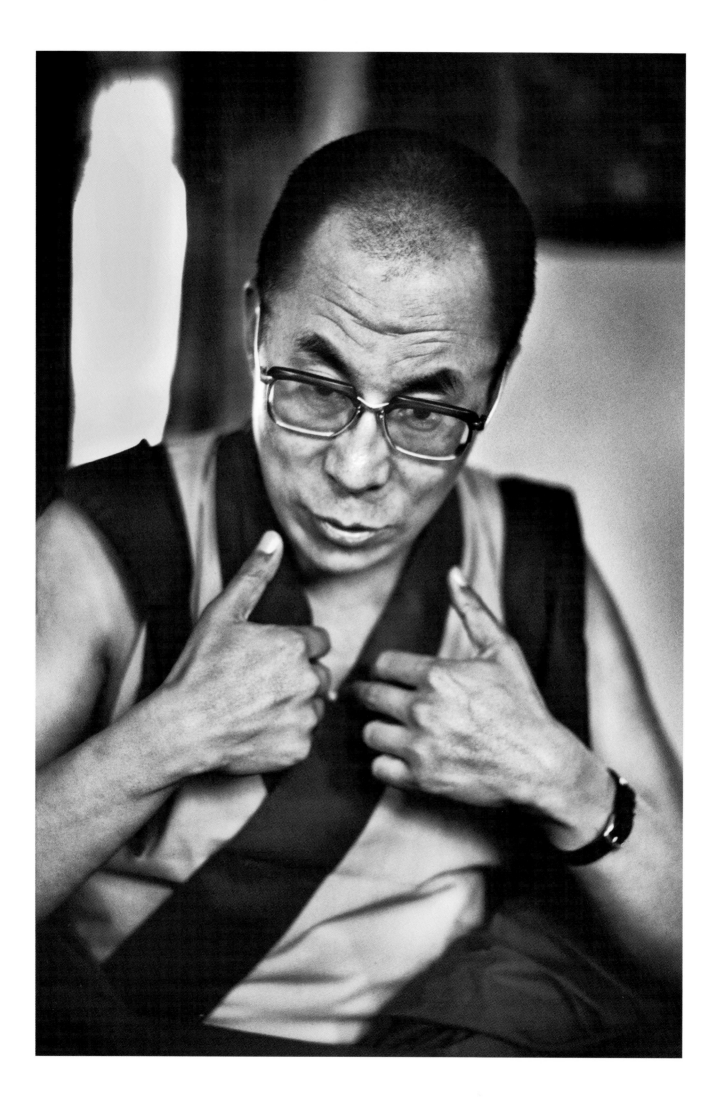

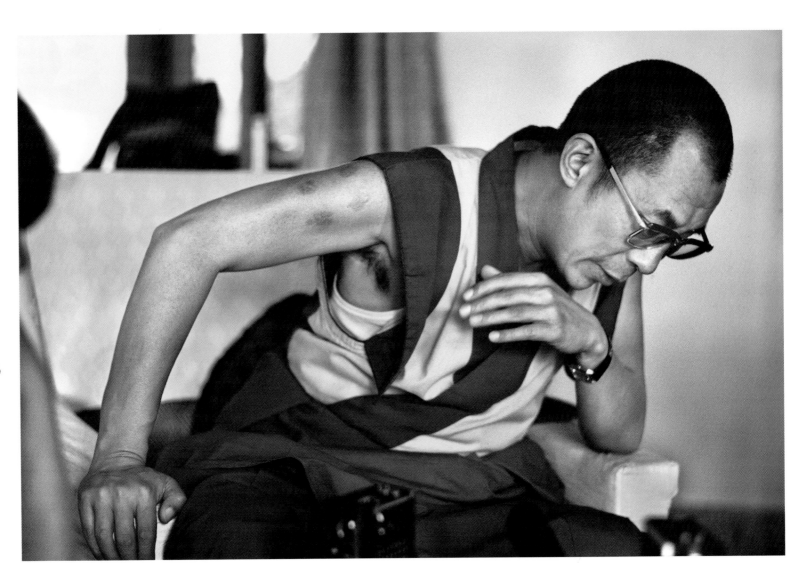

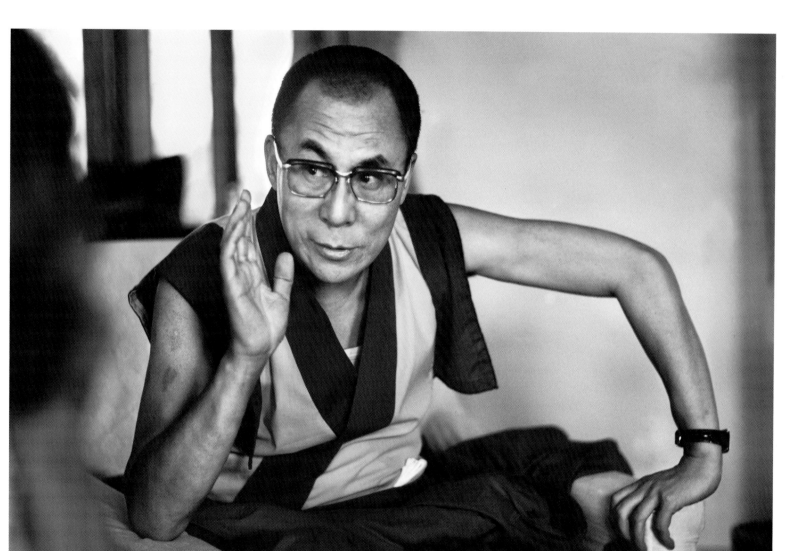

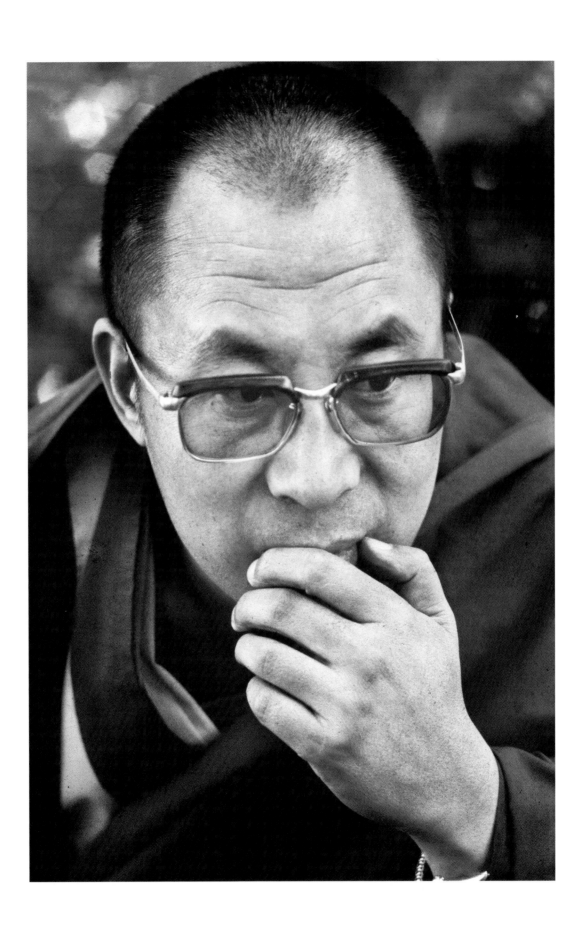

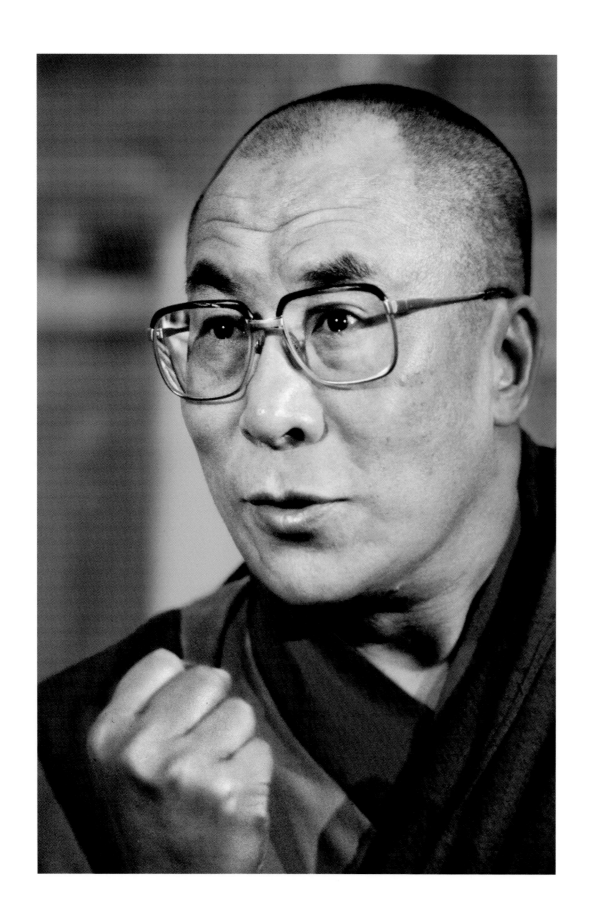

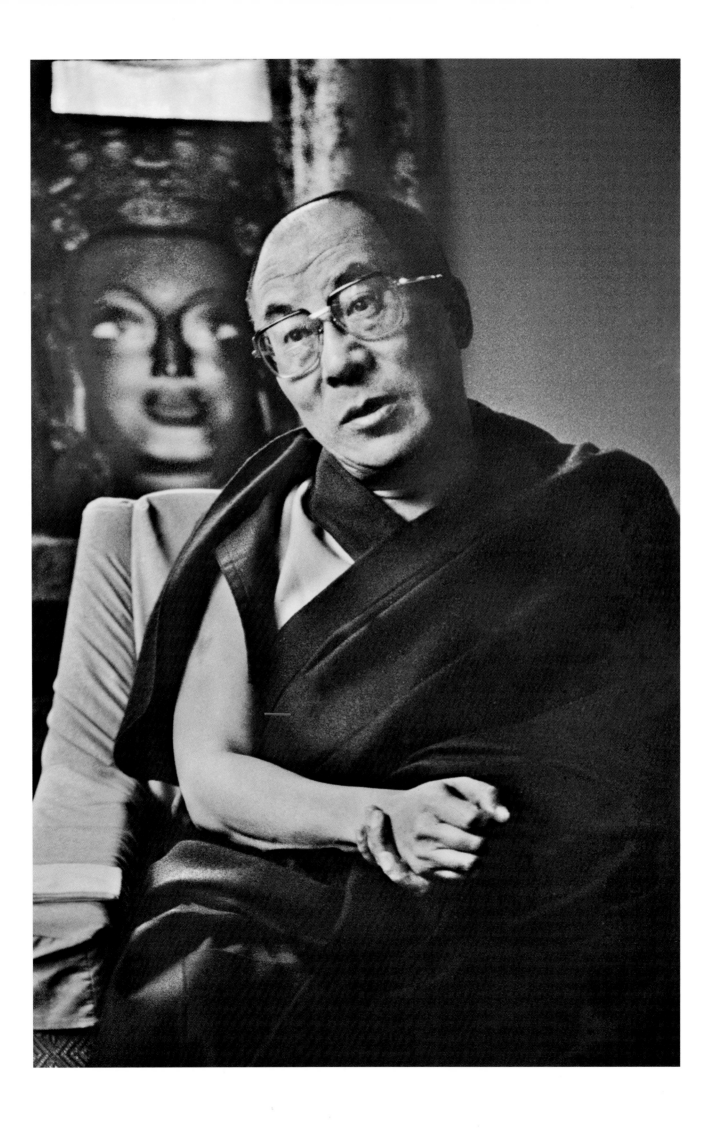

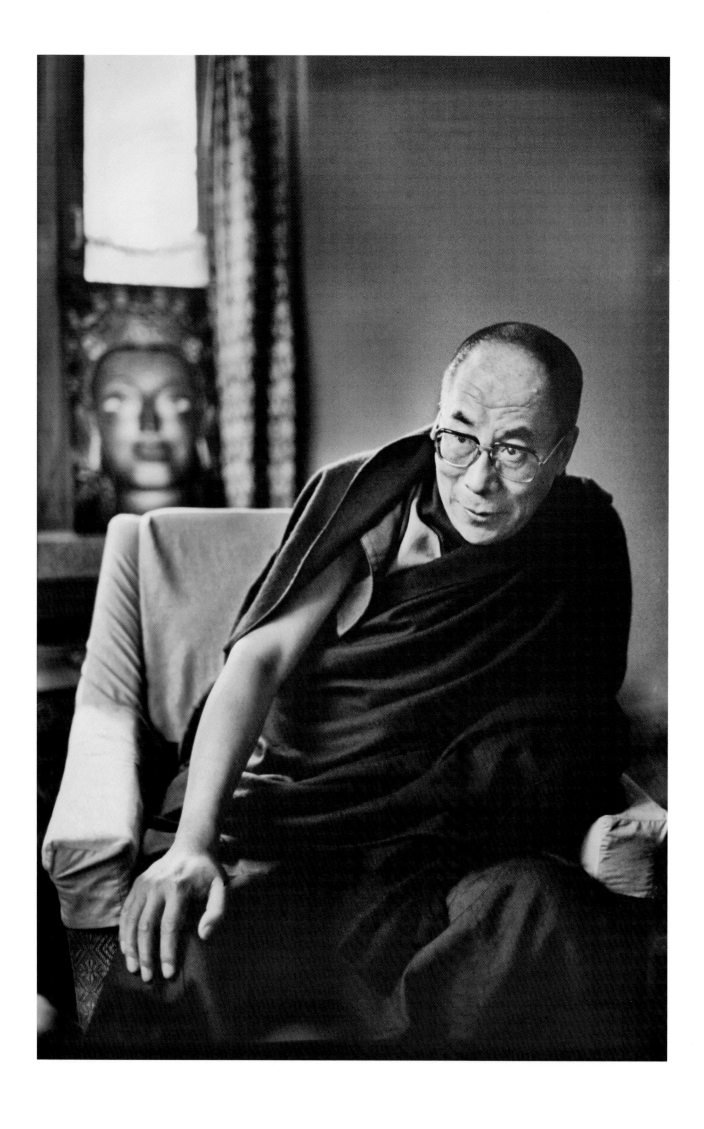

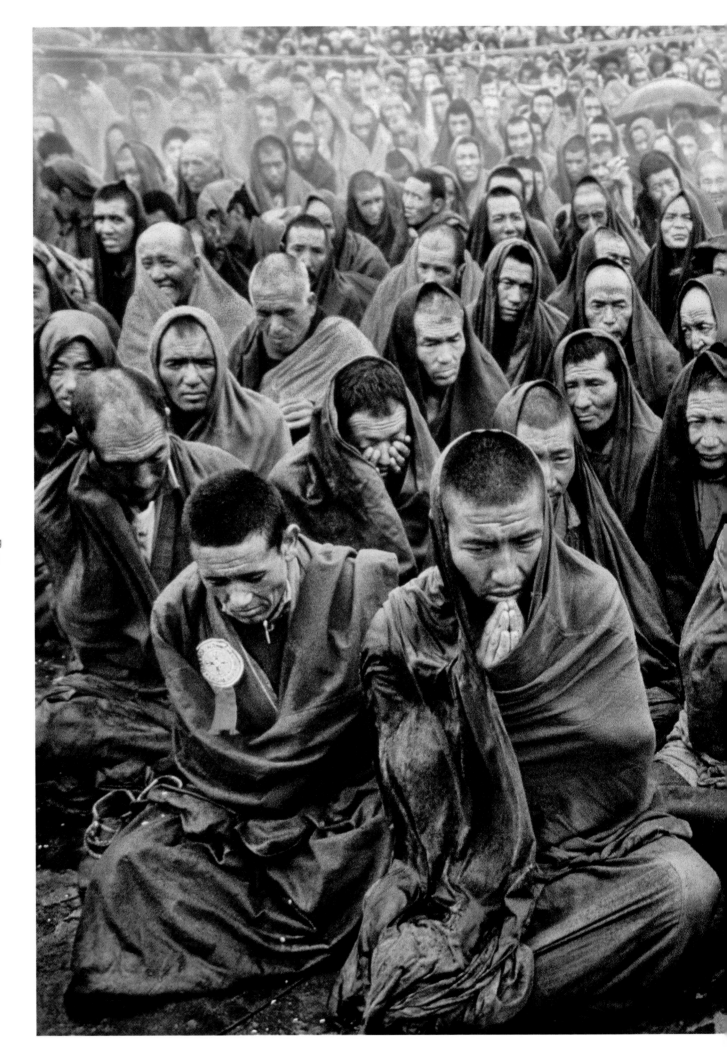

1975. Lamas soaked in continuous drizzle in Leh, Ladakh, during His Holiness's Kalachakra teachings.

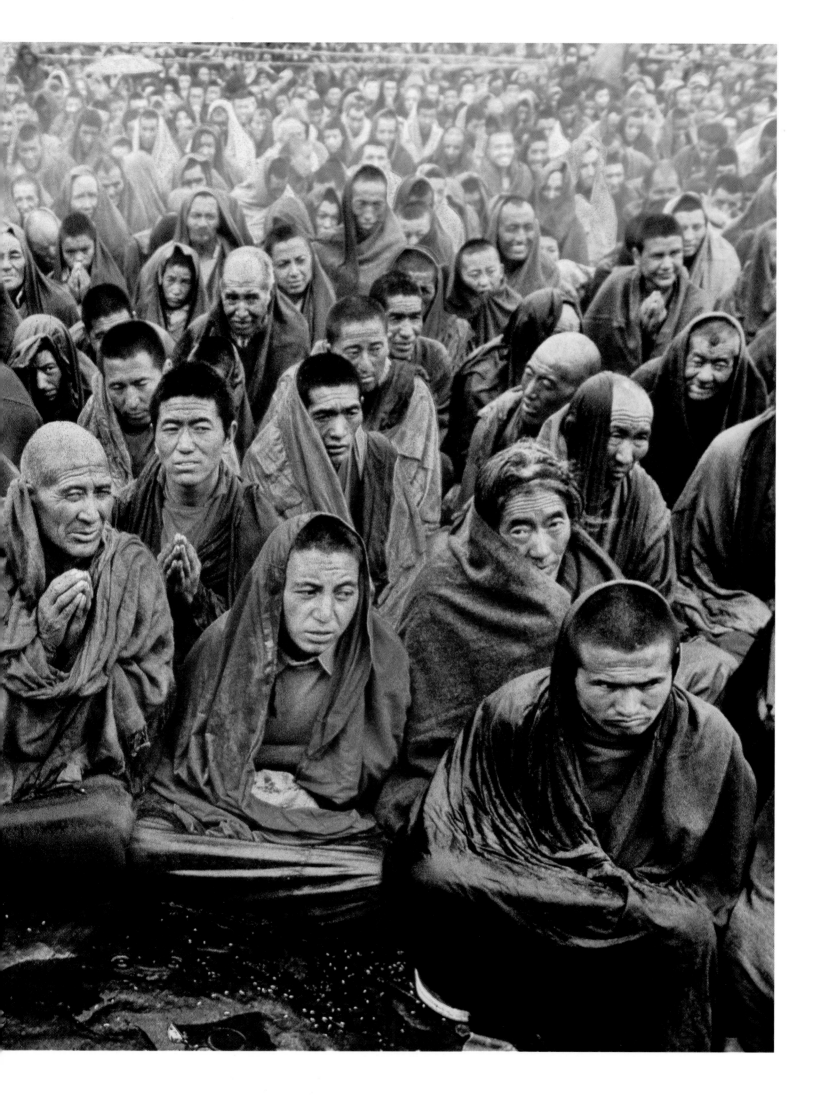

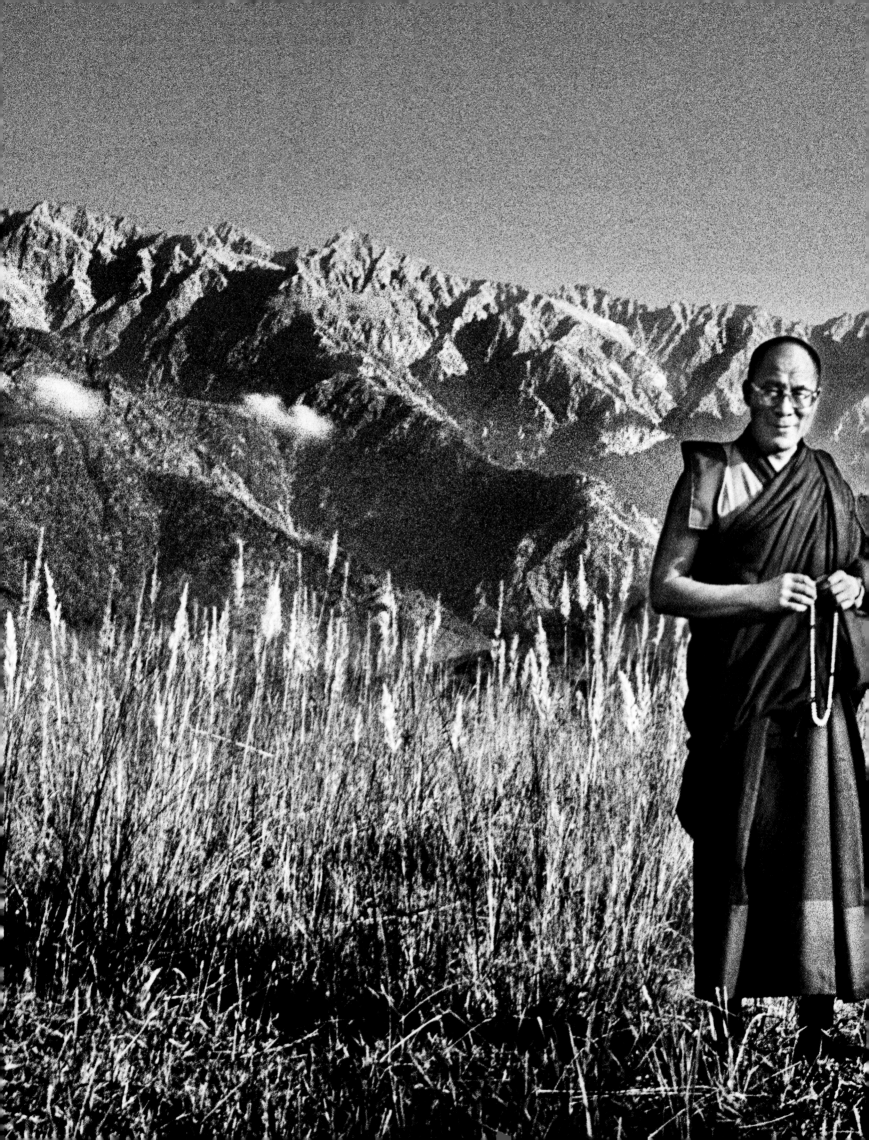

A GOOD SUBJECT

Later, he gave me the status and honor of being his friend. I'd say to him, "Your Holiness, the magazine wants me to photograph you doing various activities." Far from seeing him posing in special robes on a throne, I was welcomed, informally, into his private world. And without me explaining, he would do things that perfectly fulfilled the needs of the assignment. One moment it was looking at old Tibetan texts, and the next, moving on to repair a kerosene heater or a temperamental TV. Moments were spent watching a TV serial called *Mahabharat*, and moving out to the garden and the greenhouse, where he grew the most beautiful flowers. How else would I have known that His Holiness the Dalai Lama could fix a TV? Or that he treated his sick kitten with Tibetan herbal medicine?

This willingness to understand and joyfully fulfill your needs, just as a close friend might, is what was so wonderful about him, and remains so, even today, when he is a Nobel Peace laureate and the world loves and reveres him as an icon. He is a man who can be trusted.

Indira Gandhi was sharp and clear; if photographers were around at an interview she became a different person. But His Holiness remains the same: all-knowing, with gentle sincerity, sensitivity, and care for other beings.

Among the privileged opportunities given to me was photographing him receiving an initiation in his prayer room from an elderly reincarnate lama, His Eminence Chogye Trichen Rinpoche. His Holiness sat humbly on a low cushion while the Rinpoche was seated on a throne. My second encounter with the Dalai Lama was at Bodhgaya in December 1985. He was doing daylong preparatory rituals over the sand mandala for a Kalachakra initiation in a tent enclosure. Although the prayer ritual was private, I convinced the Tibetan security guards to let me shoot from behind curtains. As my camera lens parted the curtains, His Holiness suddenly looked at me, and with a warm, welcoming smile, extended his hand. I couldn't believe it. After a brief meeting ten years before, he remembered me. So I walked in, took his hand and kissed it.

Later, just to fulfill my urge, I requested His Holiness, "It's very important that I photograph you during actual meditation." He said, "Okay, I'll try." Then, for almost an hour, he sat absorbed in meditation. Beyond the unbelievable qualities of compassion and care, his powerful concentration makes it possible for him to slip into meditation even in the presence of others.

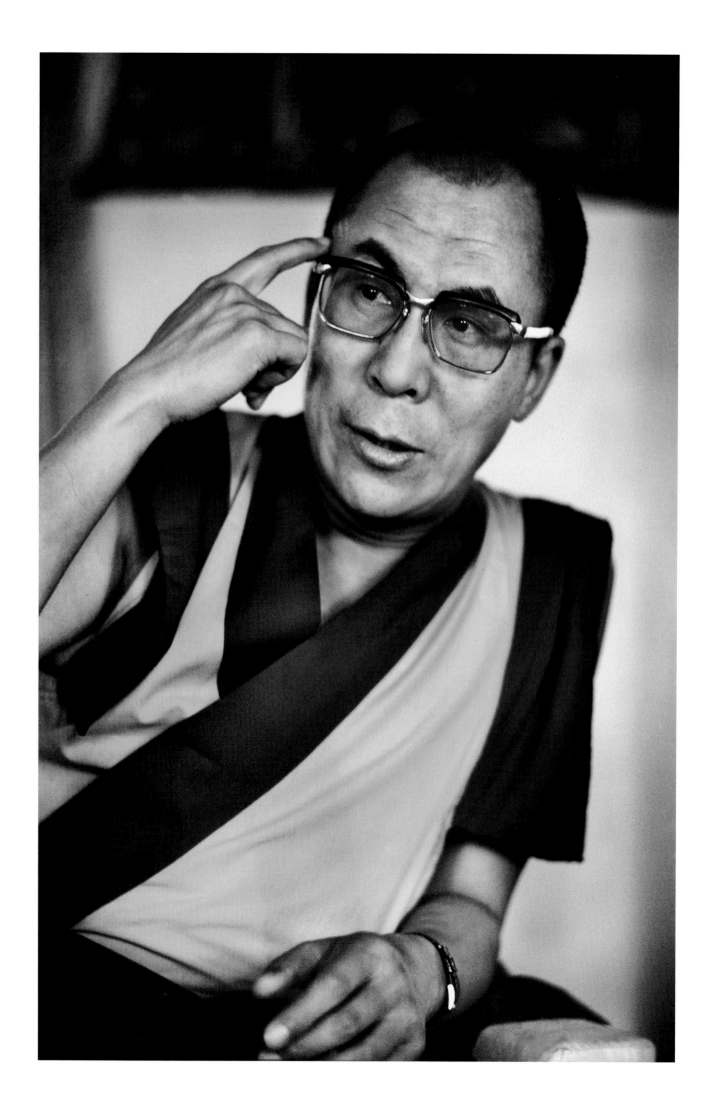

48

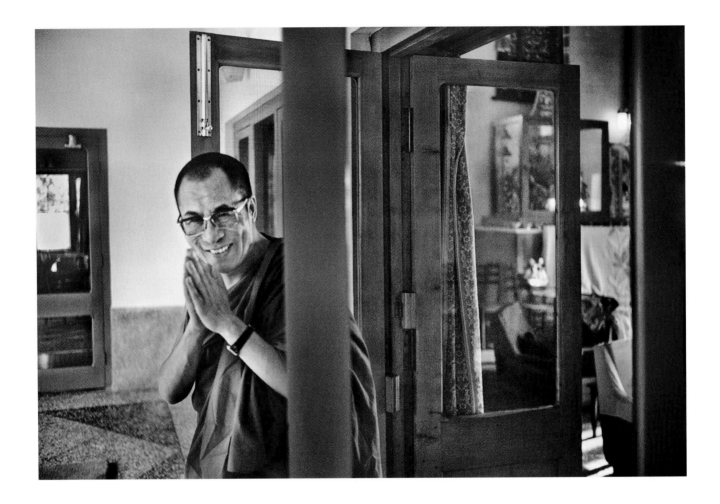

After an earthquake damaged His Holiness's
existing bungalow of earlier years, a new "palace" was
built in the late 1980s. He warmly receives us.

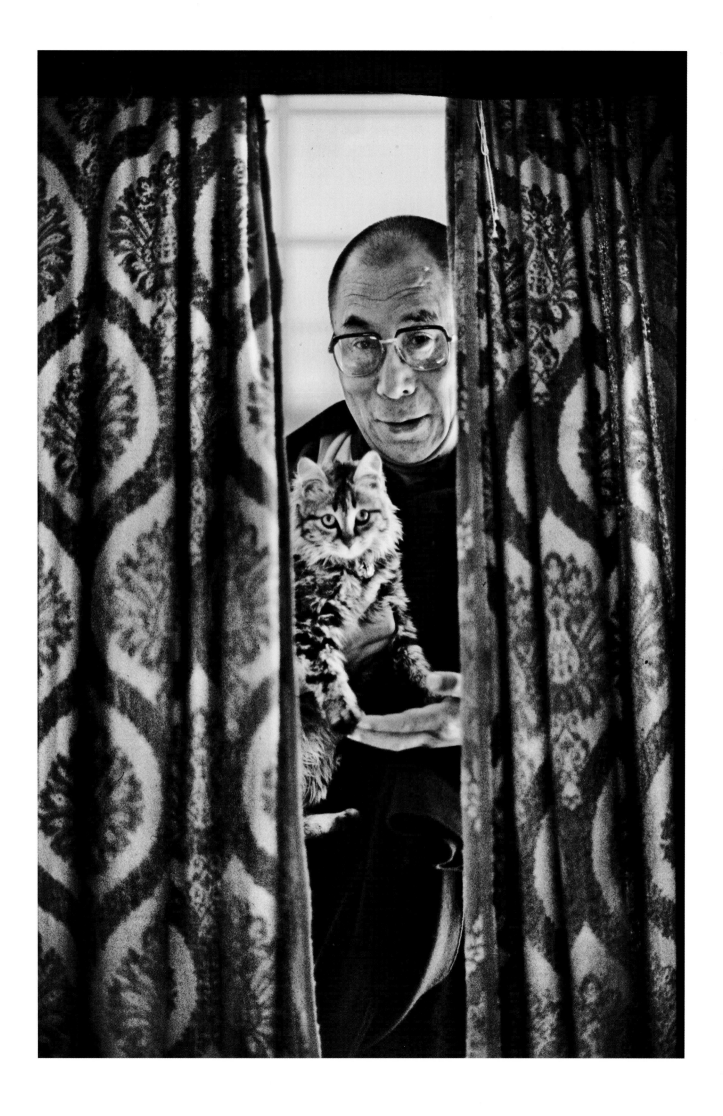

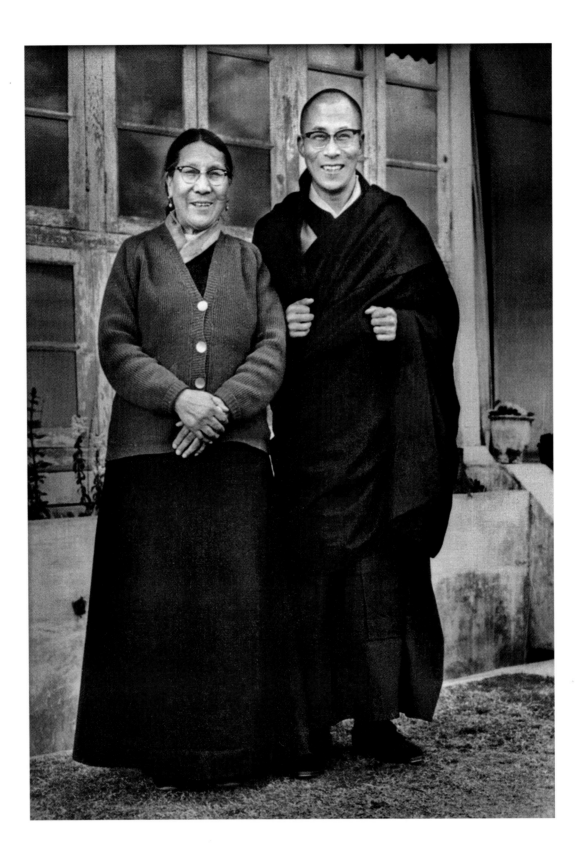

At the first temporary residence in Dharamsala, early
1960s, with his mother, the Gyalum Chenmo (the Great
Mother), Dekyi Tsering.

Facing page: Late 1970s, on the grounds of the
bungalow "palace."

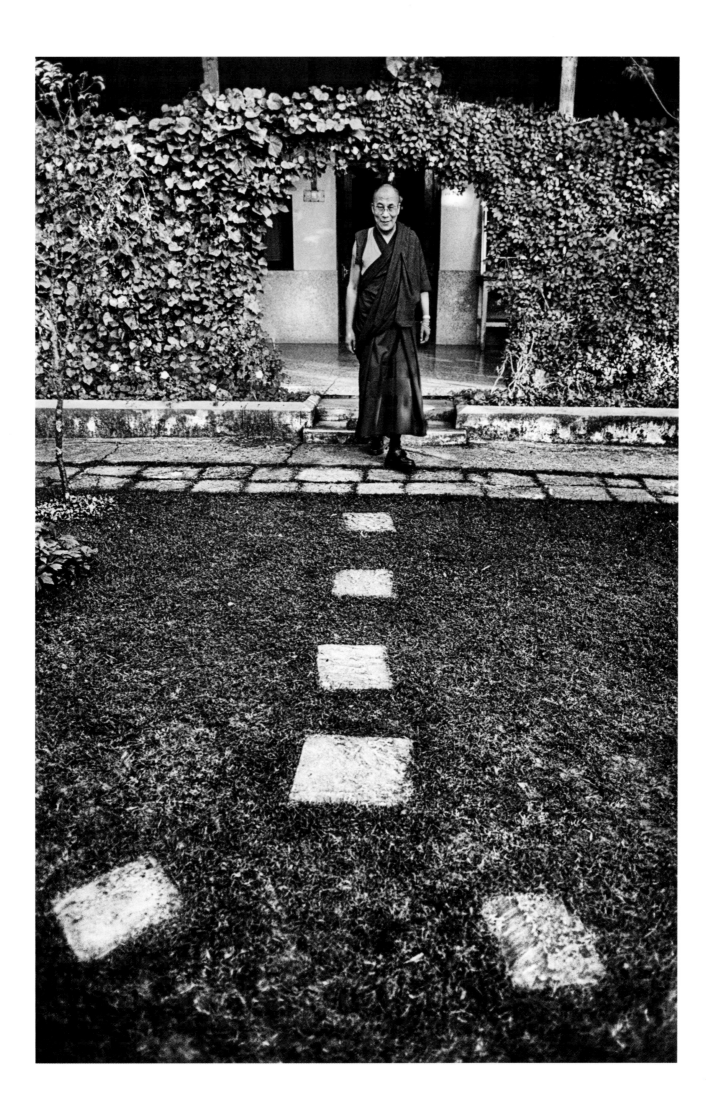

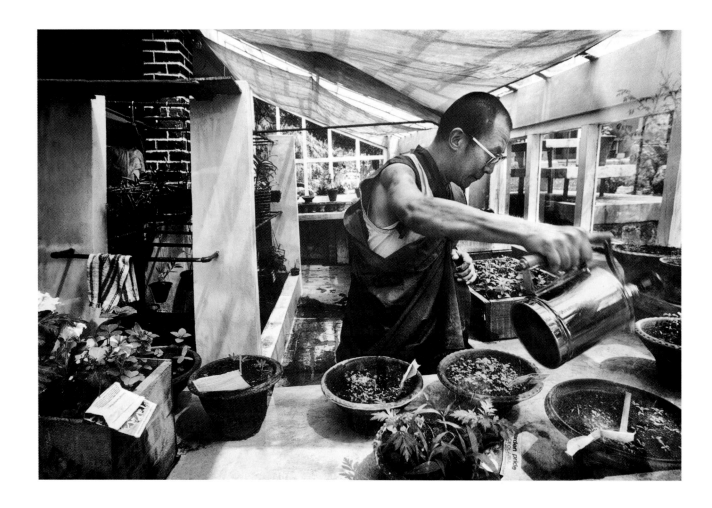

The Dalai Lama is the first Nobel laureate to be cited for his environmental advocacy. The conservation of nature remains to him an area of deep concern.

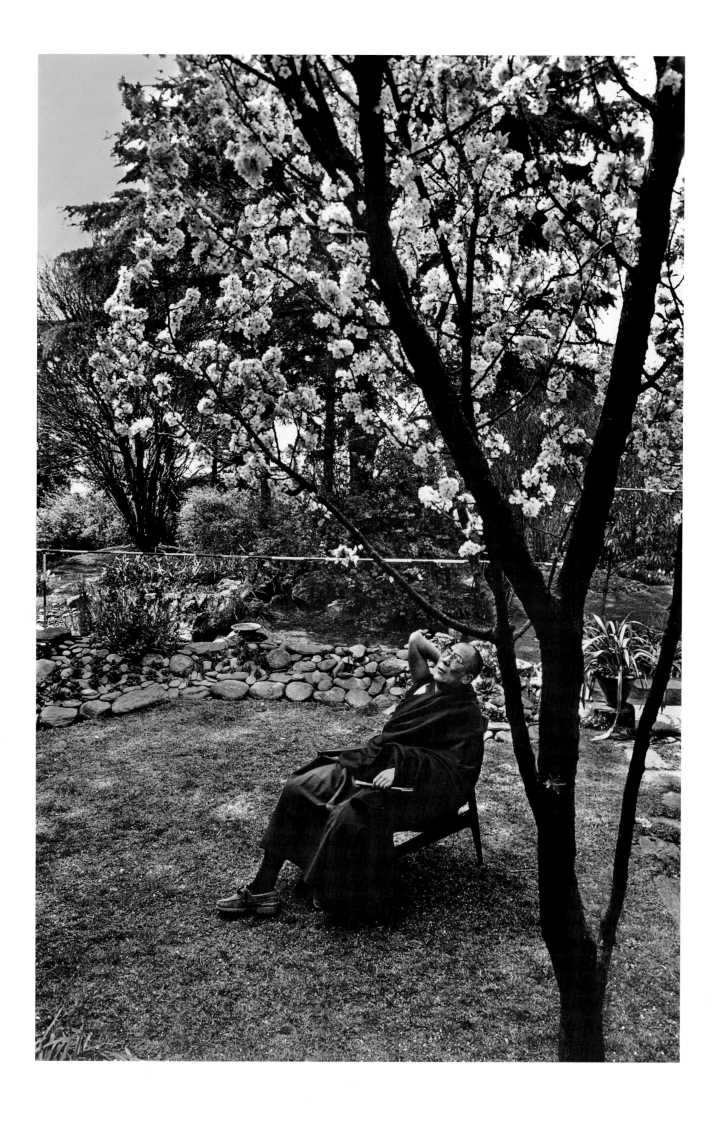

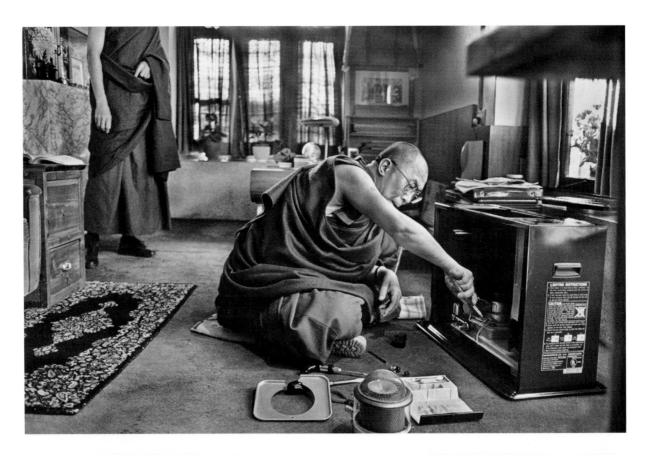

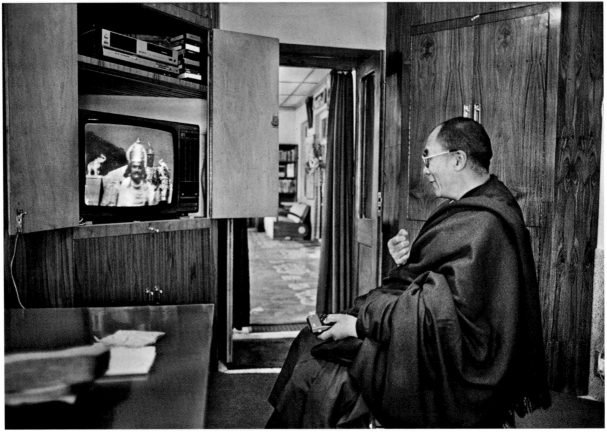

Spontaneous and innately practical, His Holiness turns
his hand and attention to myriad daily demands.
Here he watches *Mahabharat* on television.

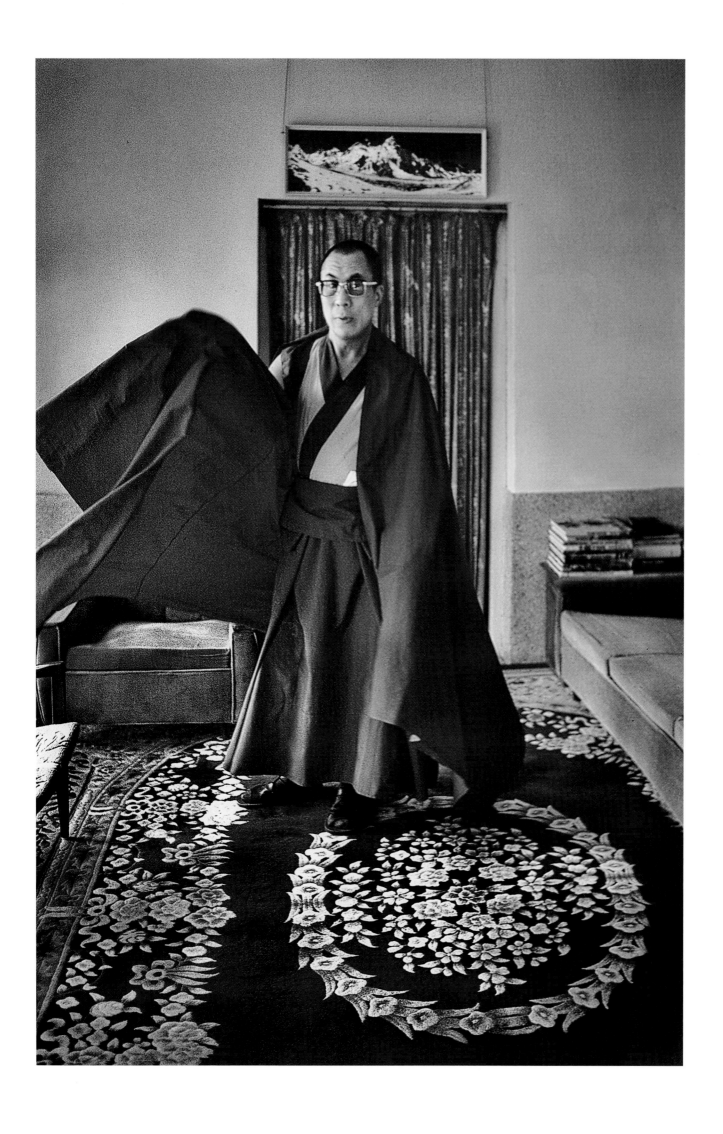

56

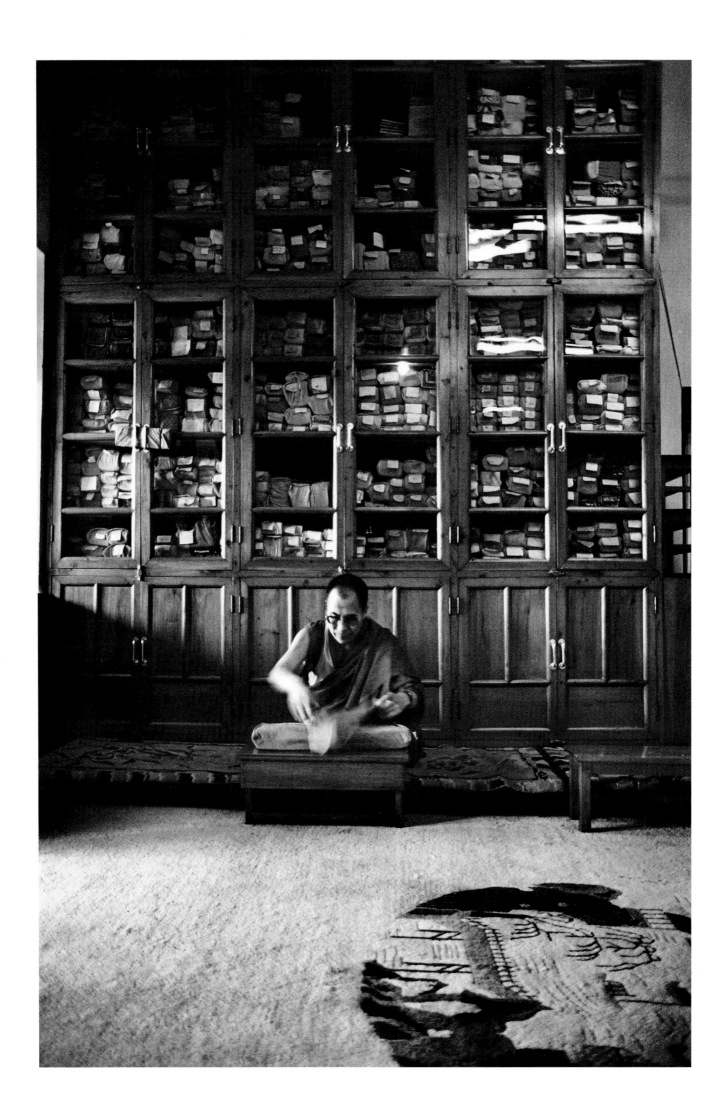

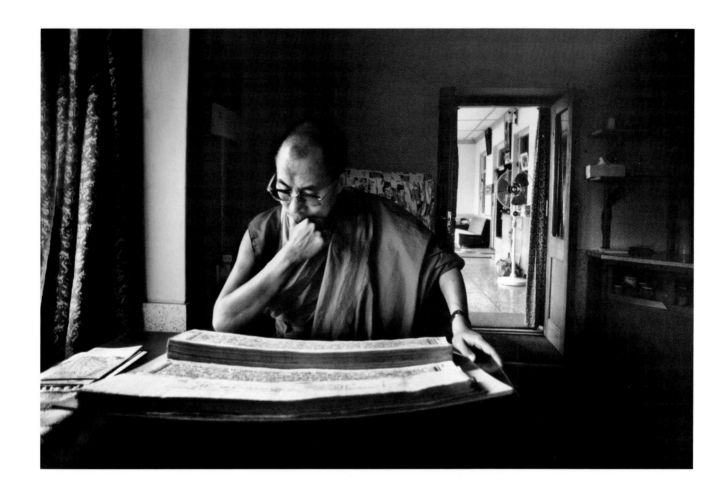

Ever the scholar, His Holiness's morning occupation
is often rereading Tibetan scriptures for new depths
of meaning.

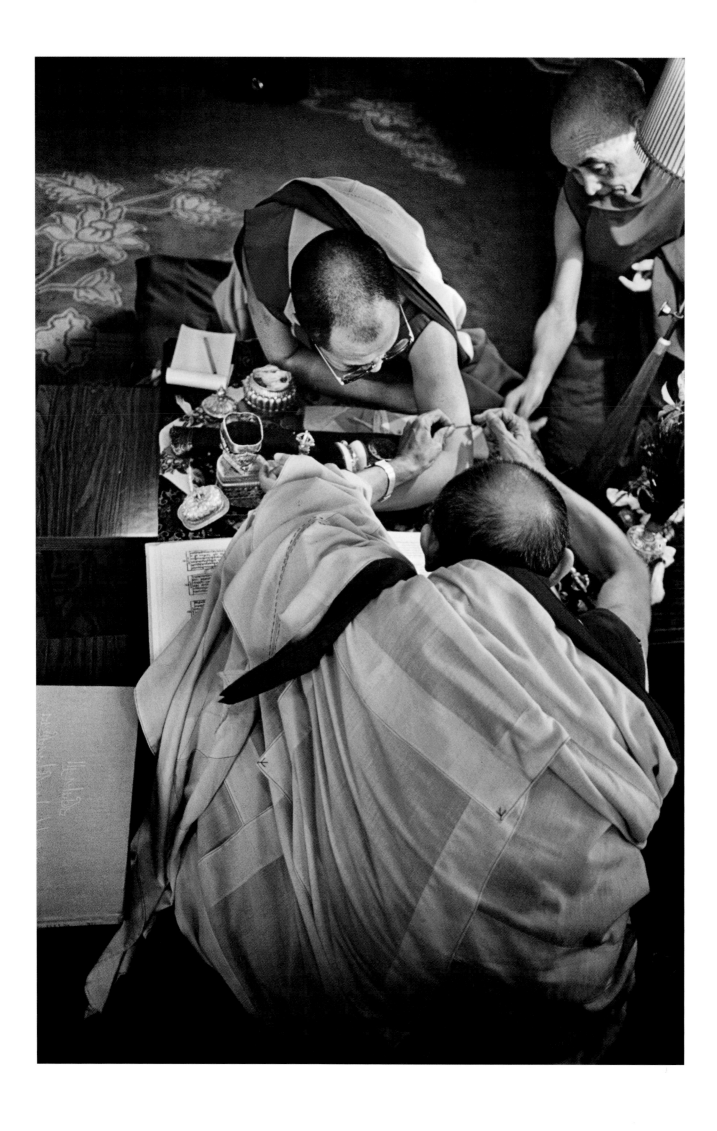

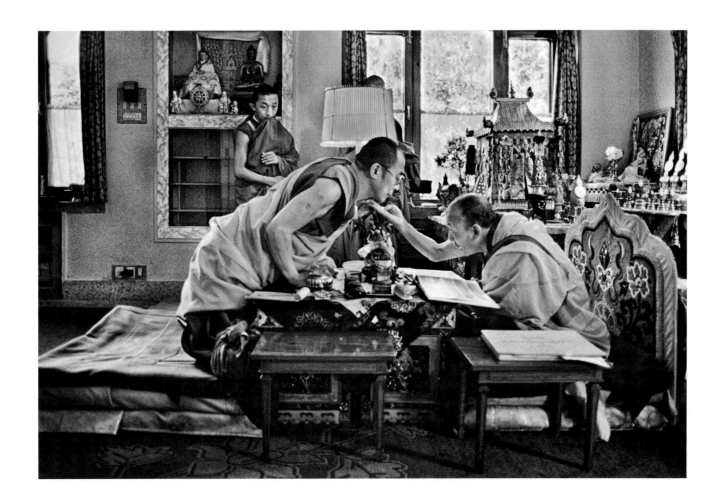

Guru-turned-student, the Dalai Lama receives initiations
from venerable lamas of all five traditions of Tibetan
belief, including the animist pre-Buddhist Bön.

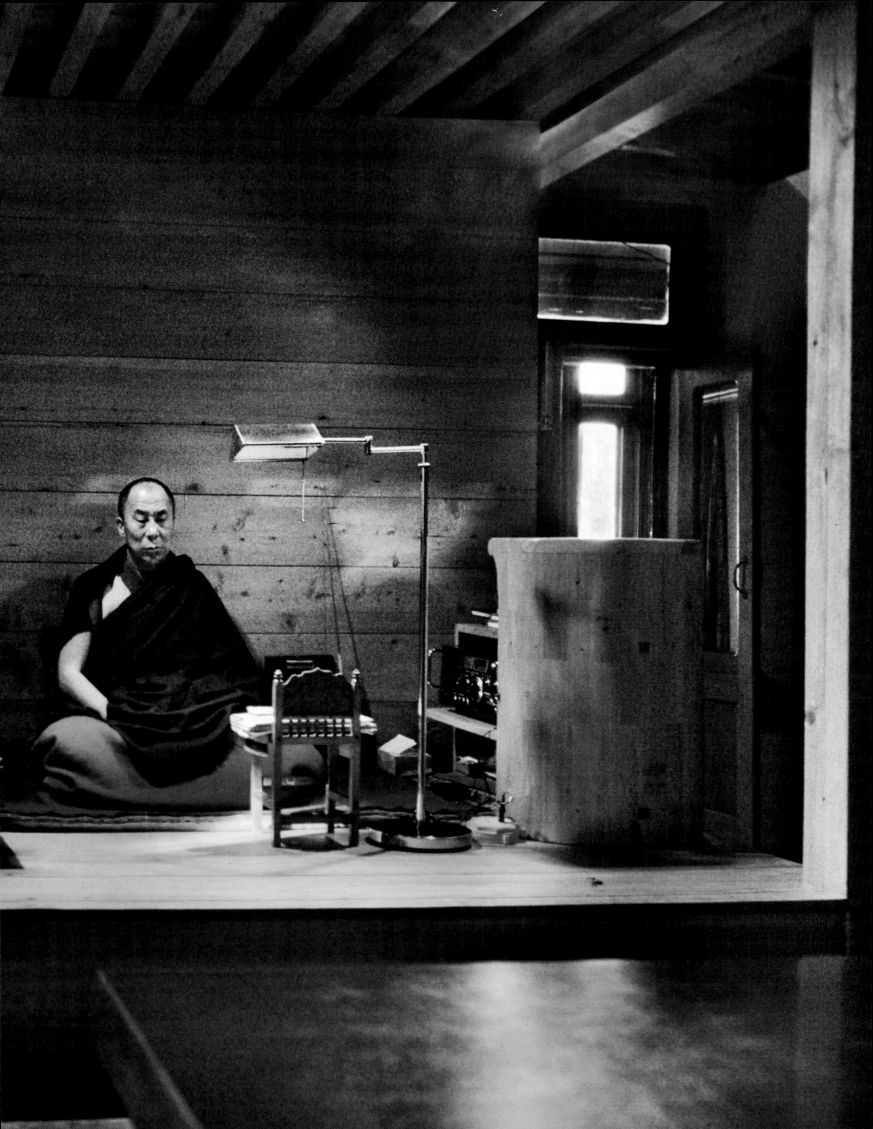

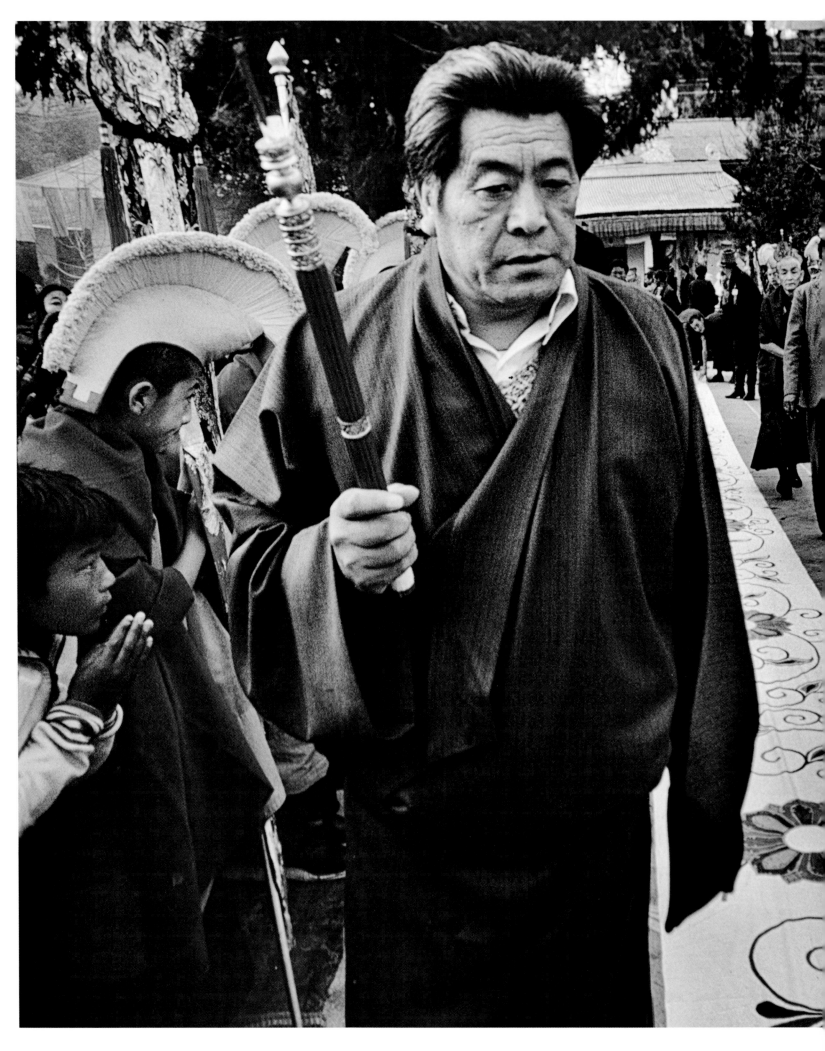

Life for His Holiness changed when the Nobel Committee awarded him the 1989 Peace Prize and planet Earth became his stage. Celebrations are held beyond the palace gates.

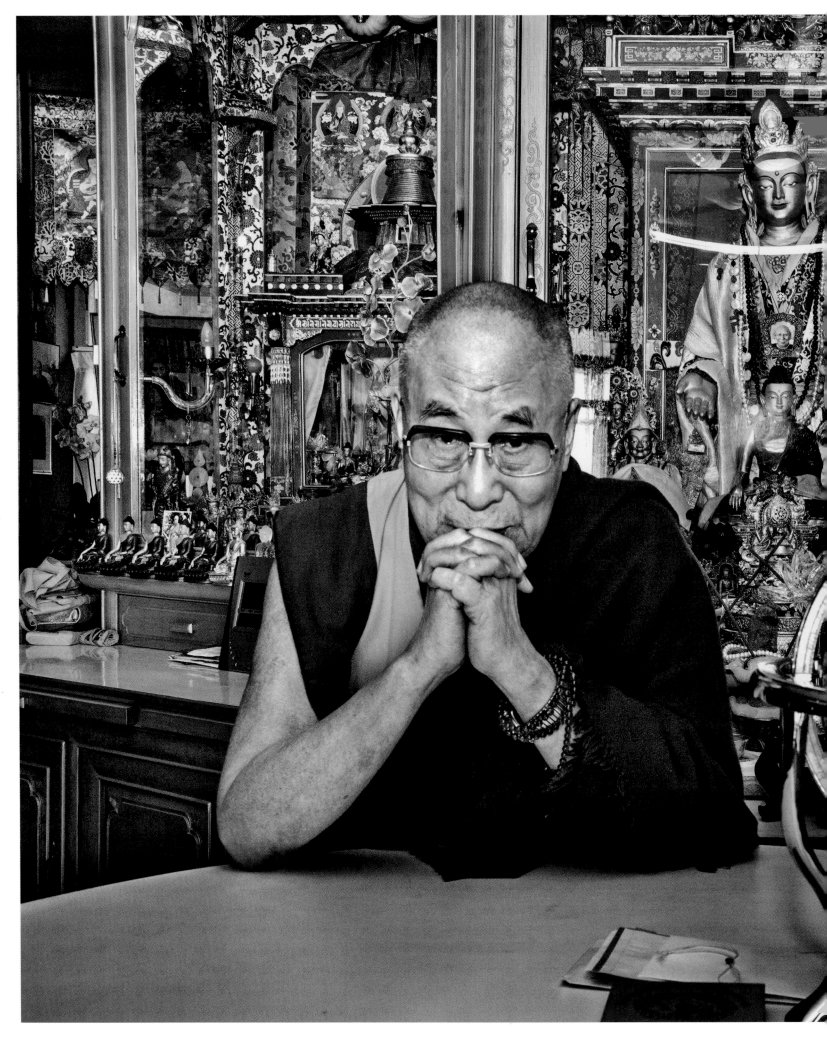

His Holiness's personal prayer room within the palace. For safekeeping, the precious central statue, the Kyirong Jowo, was carried out of Tibet in the 1960s and reunited with the Dalai Lama.

POWERS OF HEALING

Over more than forty years of photographing him, I have become very attached to His Holiness. Every time we met, he would extend his hand and I would kiss it, and then he'd pull me toward him in a hug, my head on his shoulder, and his head on mine. As he held me close, I could feel his wonderful spiritual energy pouring into me.

One time I was with the Dalai Lama for four or five days, doing a cover story on him for *Time* magazine. While I was leaving he said, "Wait . . . wait . . . you are my old friend, I must give you something." He picked up a yellowish stone with a hole in its center from his altar. He muttered a short prayer and blew on it before handing it to me. Sometime later I hung it on a thread and wore it around my neck, because by that time I felt a nagging need for some protection because I'd begun to feel very breathless during shoots. Once, when Jane Perkins was visiting New Delhi from Dharamsala, she convinced me to meet His Holiness's senior Tibetan doctor. He pressed down on the pulse in my wrists and instantly declared that my heart was in trouble. When I showed him the stone and told him that it was a gift from His Holiness, he said that the stone was possibly what had kept me safe so far.

In 2002 I had my heart checked by a cardiologist friend, Dr. Naresh Trehan. "Raghu," he said, "you have 90 percent blockages in your heart." Just two days before this diagnosis, for four hours, I'd been shooting the Sikh *gurpurab* procession in Amritsar, running around and stopping every now and then. The tests found that, even with 90 percent blockages, my heart was functioning at 100 percent.

After I recovered from heart surgery, my wife, Meeta, said we must thank His Holiness. So we went up to Dharamsala with our daughters. I said to him, "Your magic saved me, Your Holiness."

"Ho, ho, ho, ho," he responded, "you can say what you want, but I couldn't even save my brother."

When we stood up to leave, he reached his hand out to me. As usual, my head bowed down to his shoulder. But this time he put his head on my chest, gripping me tightly for some time. I gasped and felt breathlessly wonderful. Meeta was standing and watching all this. When I went to her, she said, "See what he has done to you again."

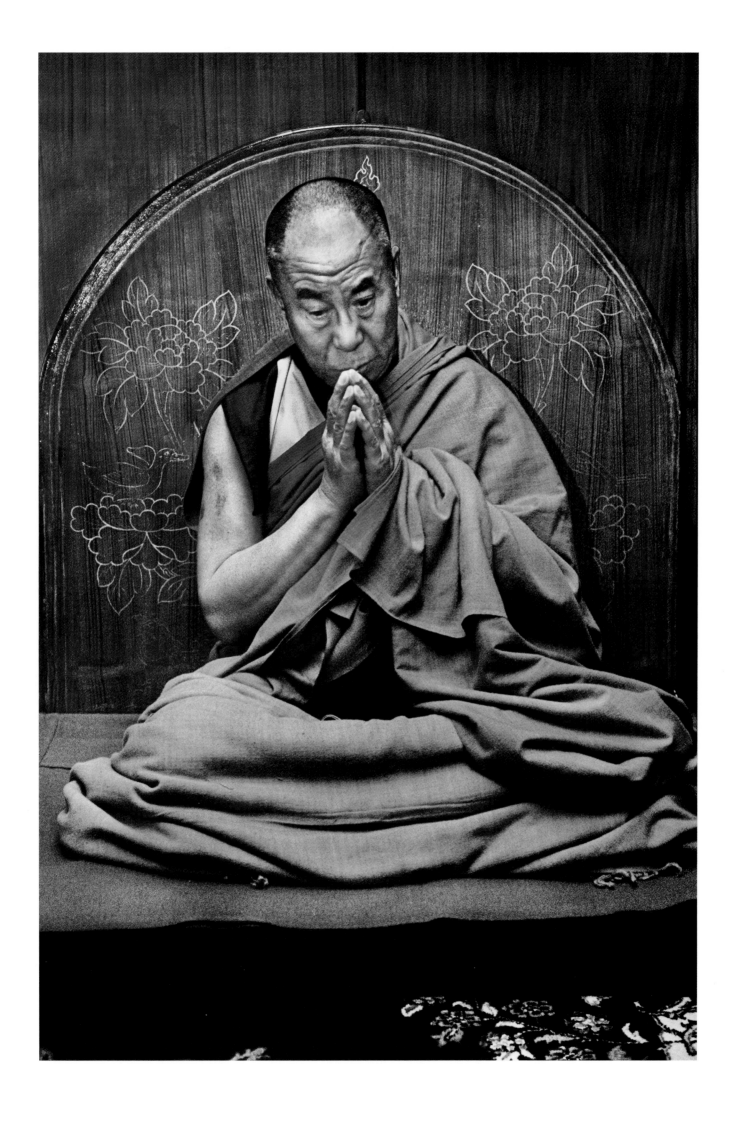

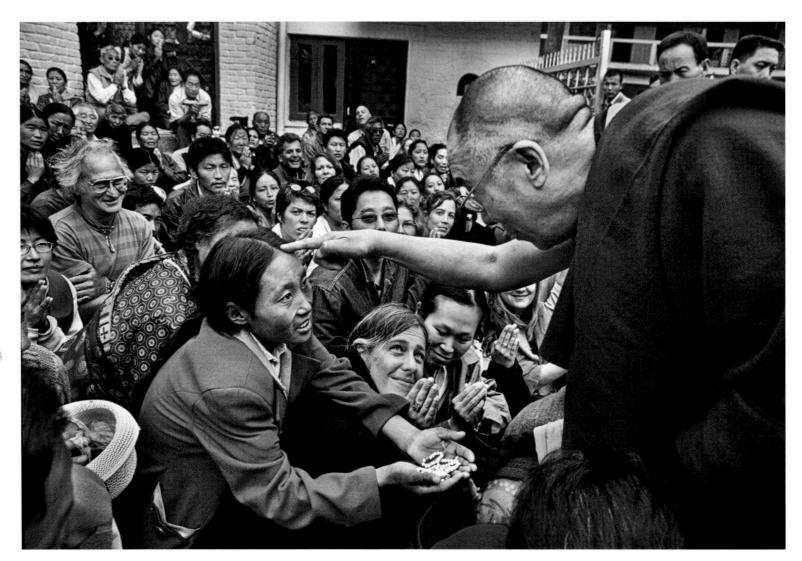

The courtyard between the temple and the palace complex is thronged with Tibetan worshippers and tourists. Here he talks to a Tibetan lady in need of a special blessing.

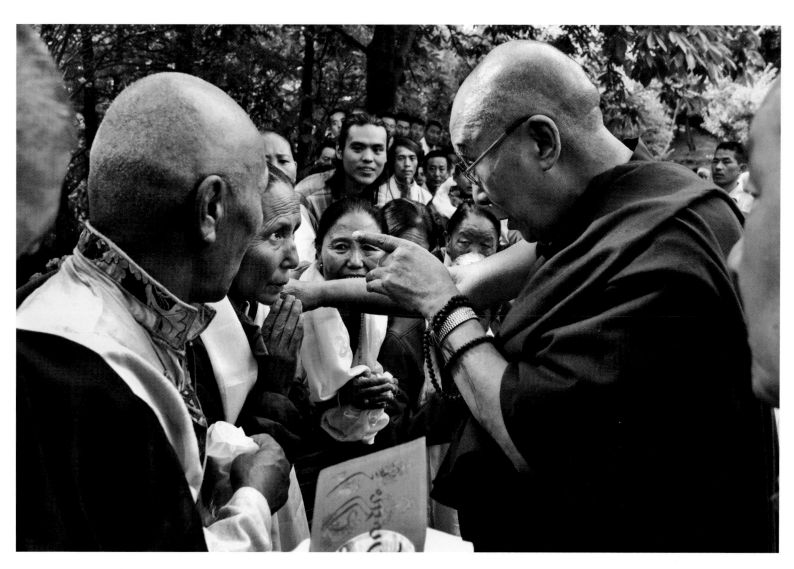

69

After thirty long years, His Holiness traces
the lady to check if things are better.
The Dalai Lama's focus is always watchful for
those in need.

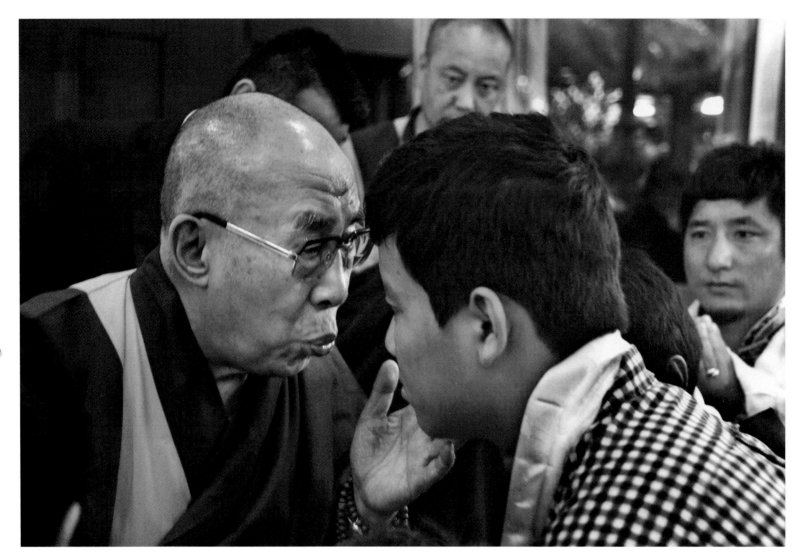

Whether for physical or psychological problems,
the Dalai Lama never misses giving a healing touch
when needed.

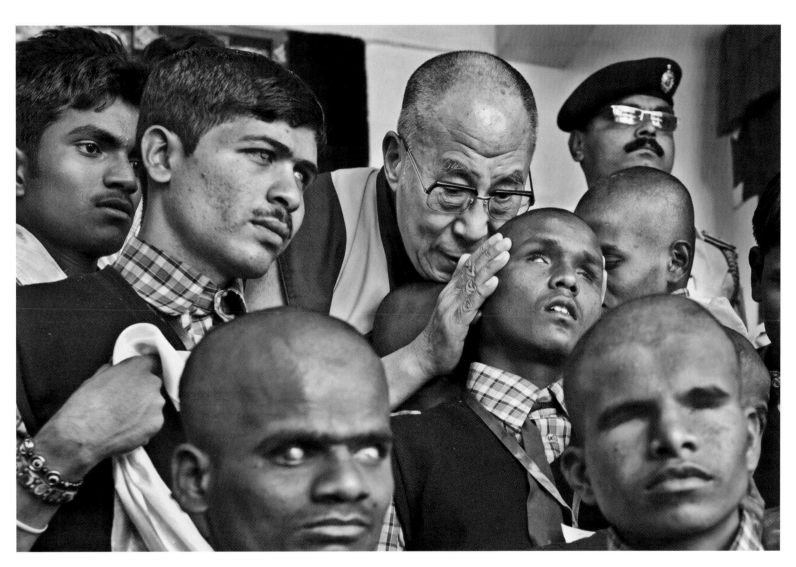

His Holiness gives head blessings and prayers for
students at a school for the blind at Mundgod Tibetan
Settlement, Karnataka.

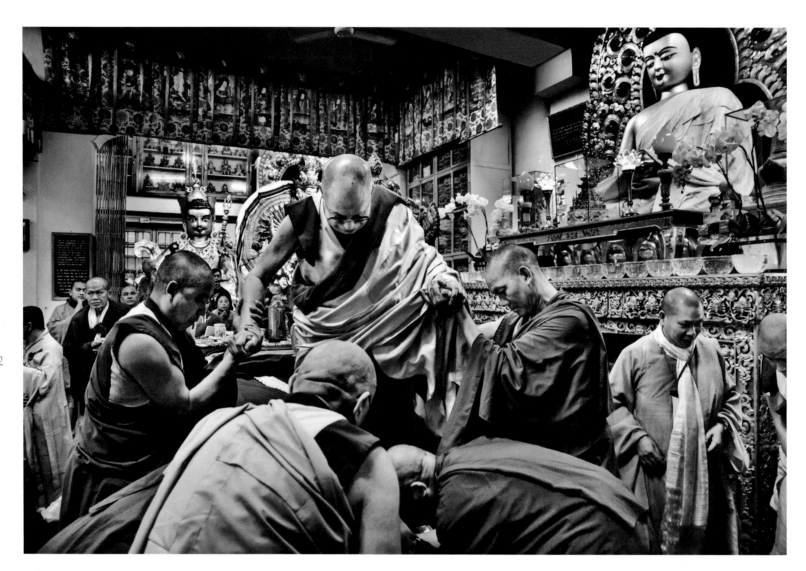

Leaving the Tsuglhakang, Dharamsala's central temple.

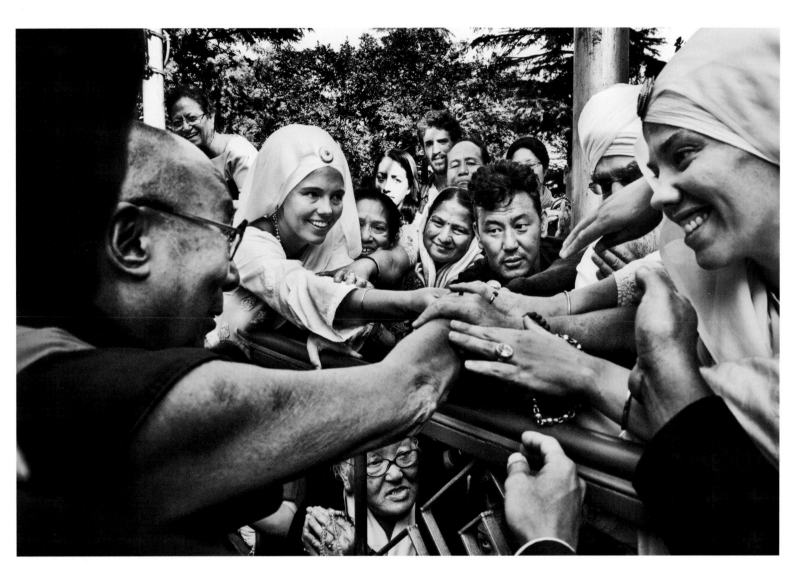

Reaching out to the eager crowds in the courtyard.

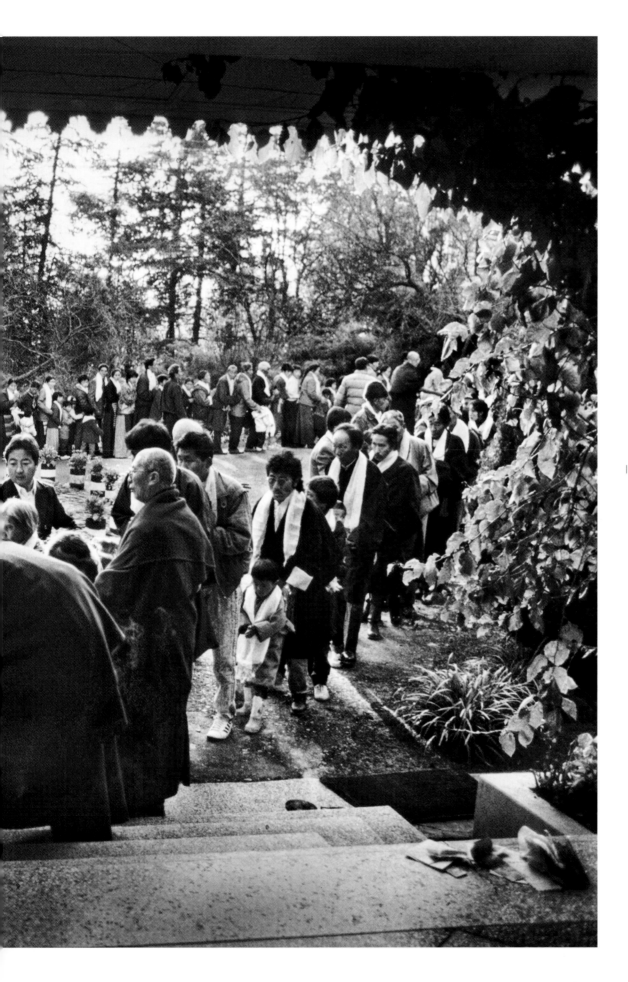

In earlier exile years, Tibetans queue within the palace grounds to be blessed on the morning of Tibetan New Year.

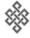

A GROWING INTEREST

When His Holiness first arrived in India, hardly anyone in the world cared about Tibet. Later, as China became more domineering and aggressive, interest grew in knowing the truth behind the story. I started getting assignments from French magazines, *Time International*, and other media to photograph His Holiness. At that time, in the late '70s and early '80s, his English was far from fluent, but the broken words and sentences he communicated with, and his evident honesty, touched the hearts of all who met him. There was intense uncertainty and pain in his eyes because he didn't know where the Tibetan situation stood, or was going.

During interviews, as I took pictures, I would listen to him trying to convince people of how things had gone wrong in Tibet under the Communist regime. His helplessness in the face of his people's suffering was clear. He would struggle to explain who the Tibetans are and why they were now refugees in India. These interviews gave me a lot of pain. When I encounter somebody who is genuine, sensitive, and so transparently spiritual, I become attached to that person. So I read his autobiography, *My Land and My People*—one of the few books I've read in my life. Apart from newspapers and magazines, I don't usually read. The text is so simply written and understated that you end up with the feeling that you also are responsible for the fate of the Tibetans. Their truth, honesty, and suffering come across so vividly.

Over the years, I've photographed diverse stories on the Dalai Lama, from the wife of France's President Mitterand walking hand in hand with him around his garden, to a feature on him with Karmapa. Going through Manuel Bauer's impressive book of photographs, *Journey for Peace*, triggered in me a sense of challenge and inspiration. Congratulating Bauer when we met in Ladakh at the more recent Kalachakra, I said, "Many of us have done a lot of work on His Holiness, but your photographs are better." And I resolved to reach new heights with my own photography.

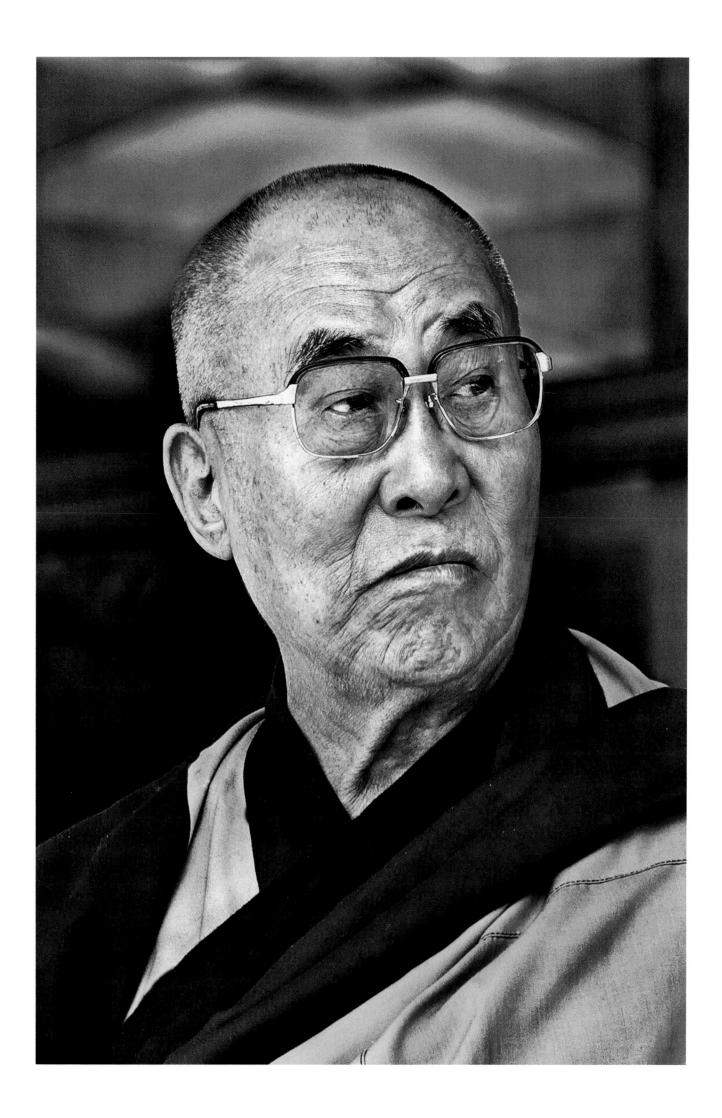

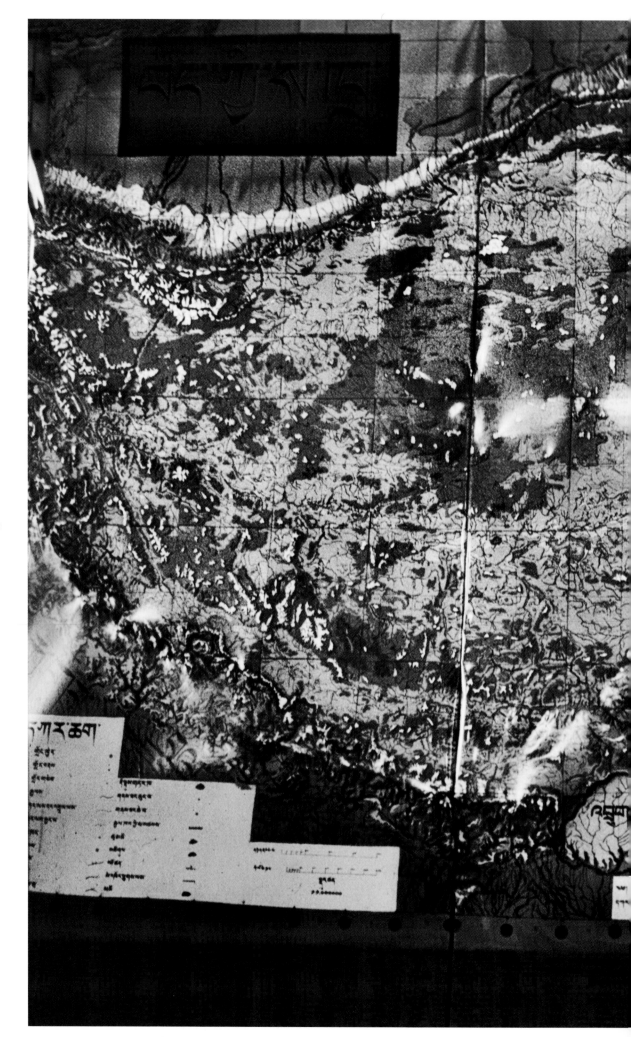

The map of Tibet before China invaded and annexed vast eastern territories to the "motherland."

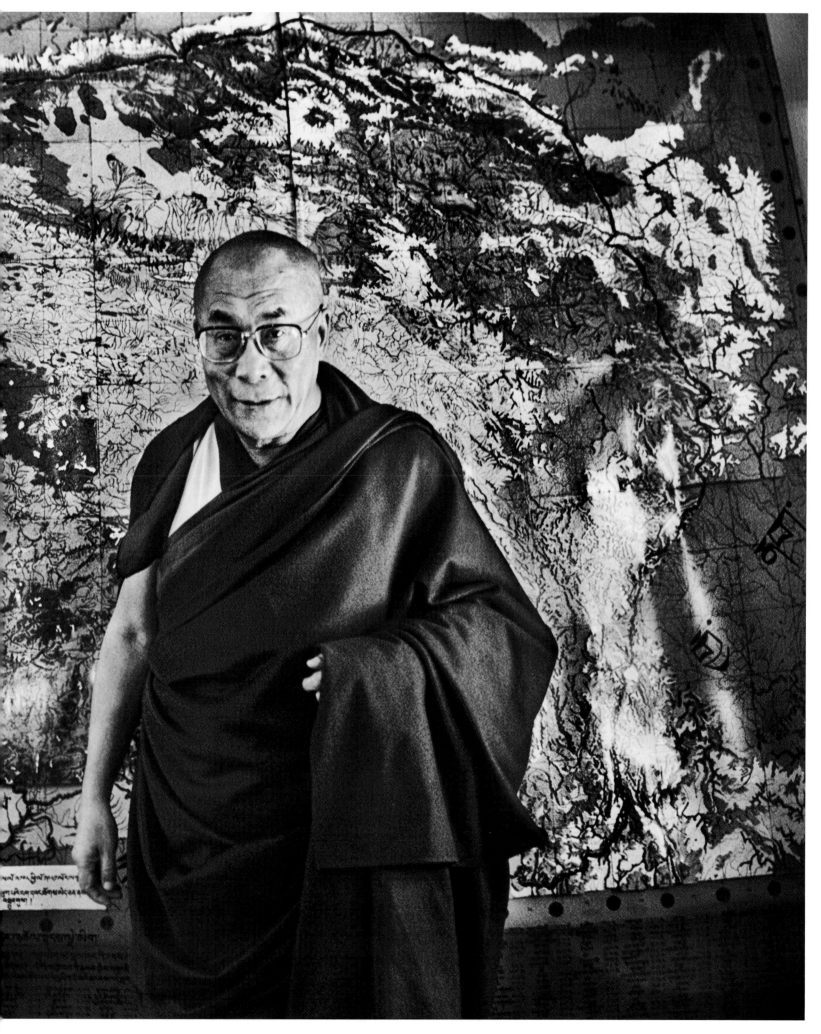
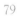

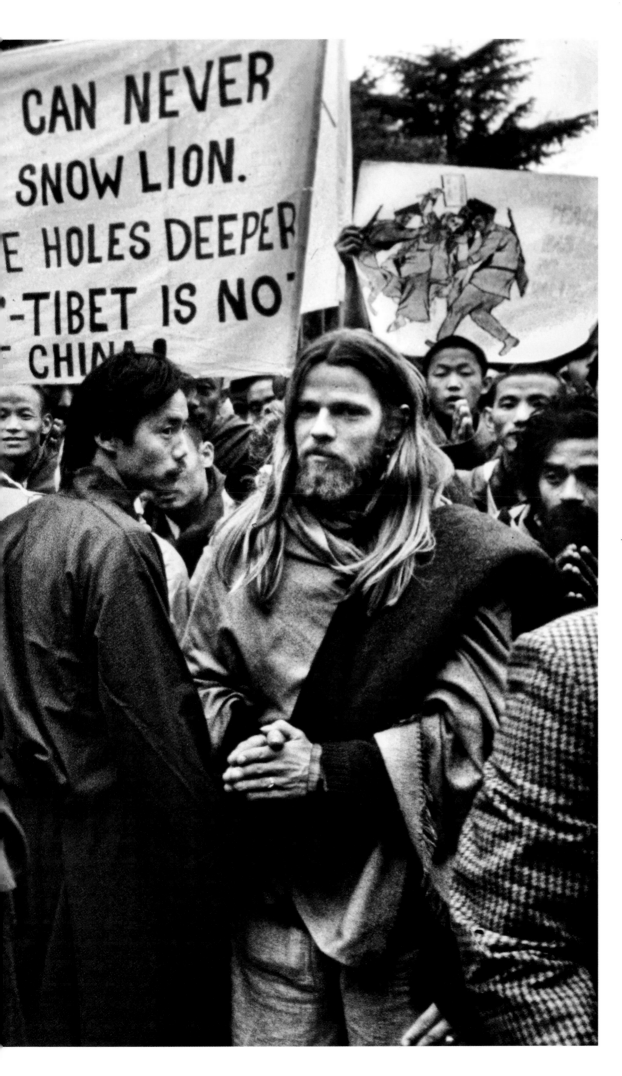

CAN NEVER
SNOW LION.
E HOLES DEEPER
-TIBET IS NO
CHIN

For His Holiness, an ideal future Tibet would be a nuclear-free zone of peace for all humankind.

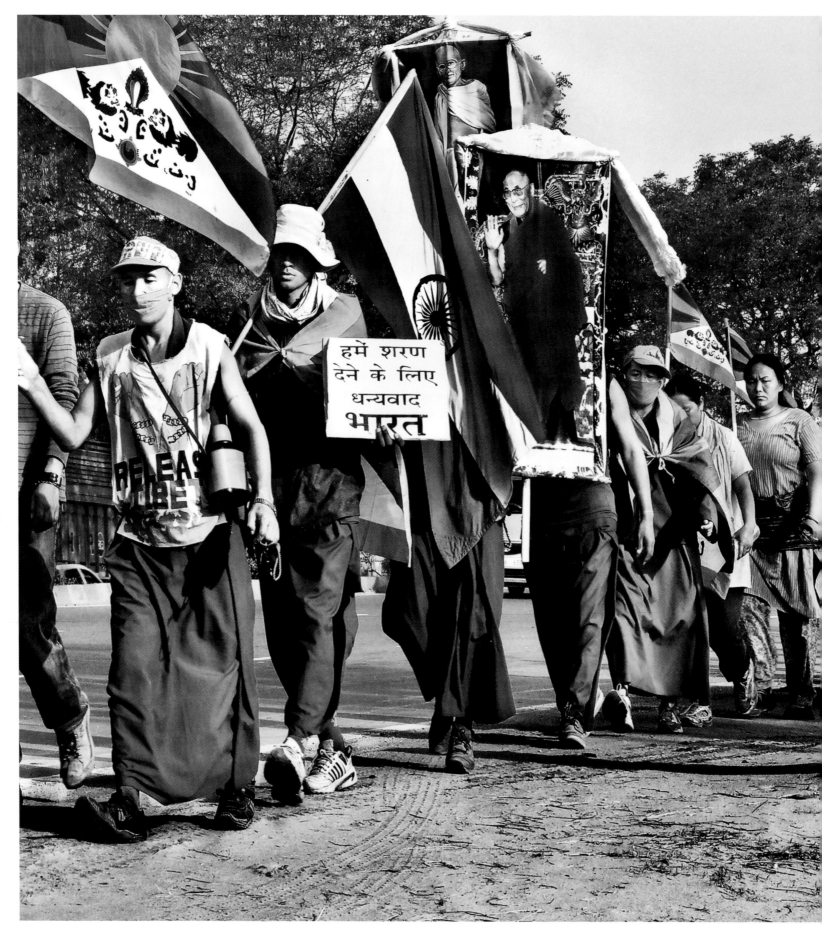

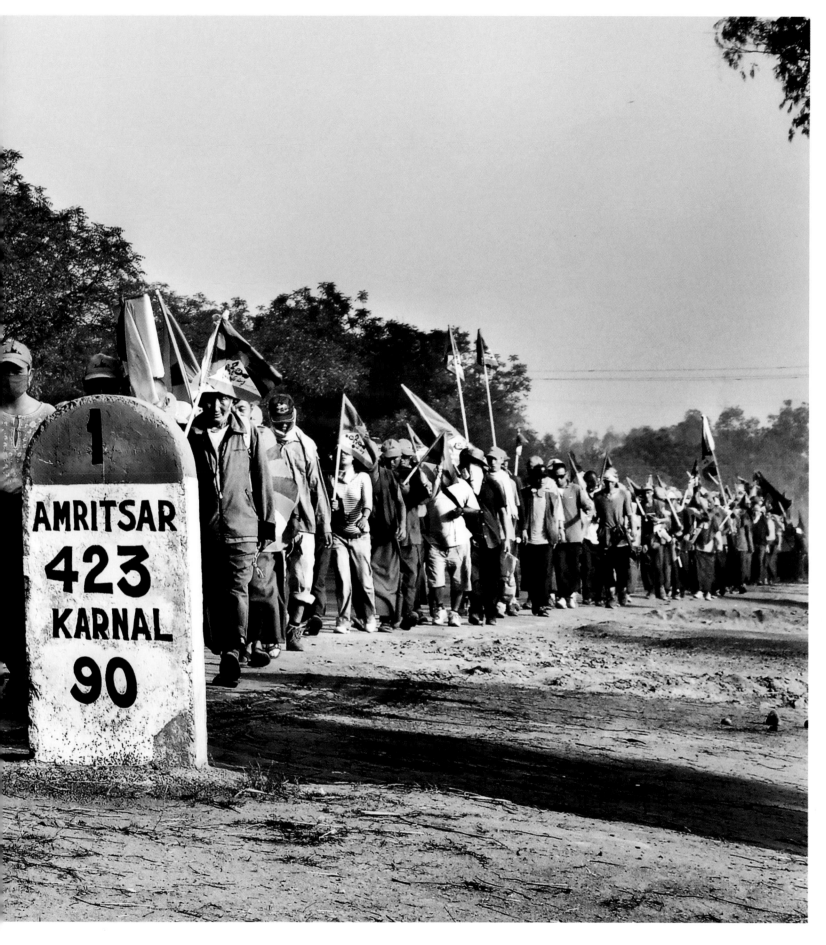

Before the 2008 Olympic Games in Beijing, exiled
Tibetans march in protest from Dharamsala to New Delhi
and then onward, attempting to cross into their homeland.

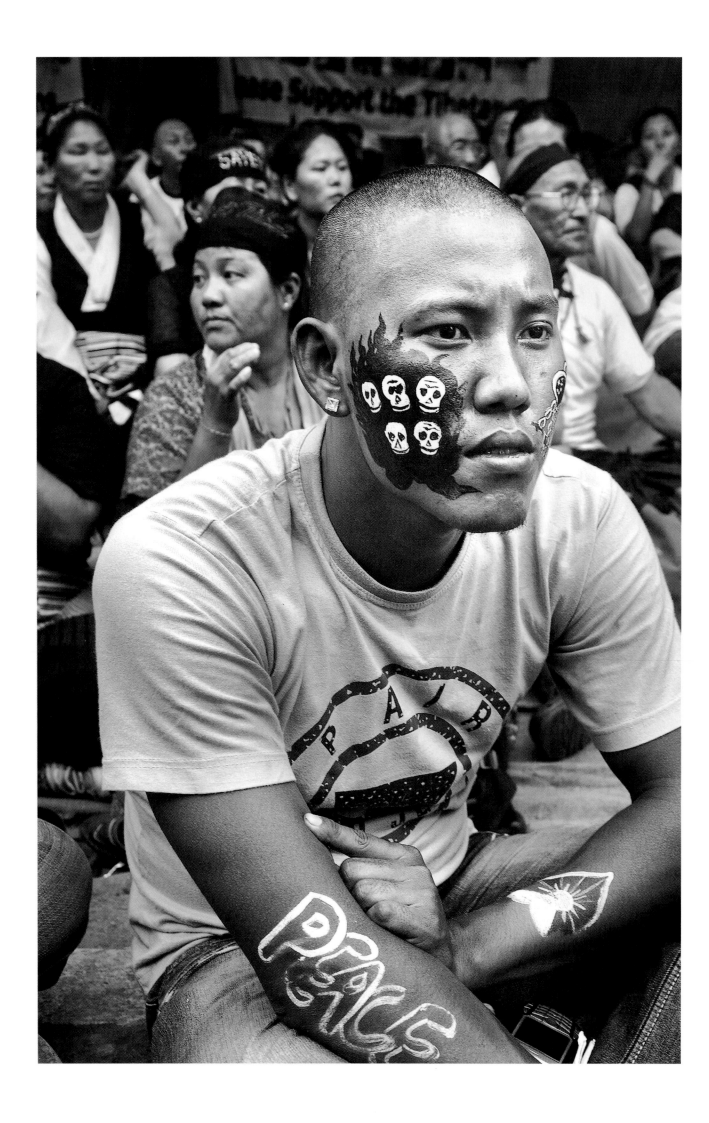

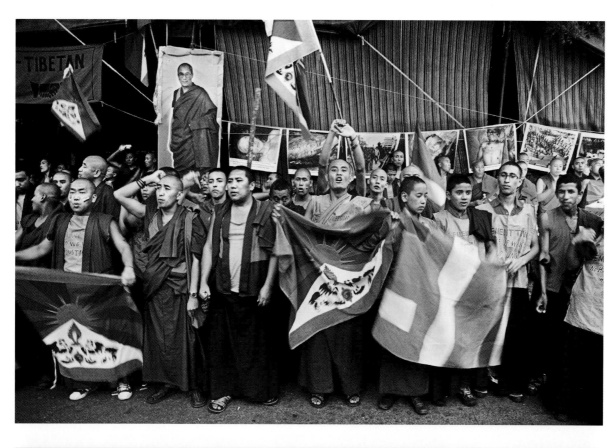

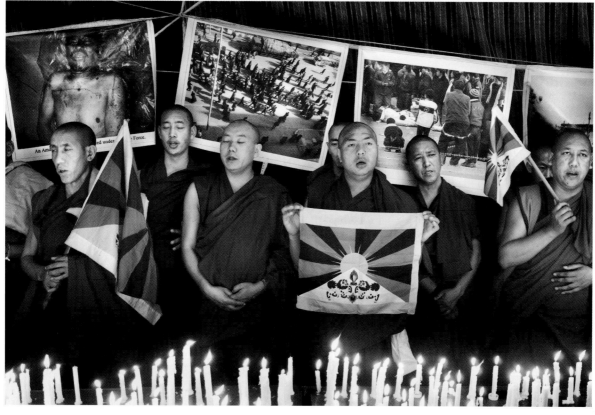

Images of repression and clampdown in Tibet line the streets
of Dharamsala. Evenings were for prayer meetings and candlelit vigils.

Facing page: Following the march within India, an unarmed uprising
across Tibet ended in bloodshed and slaughter.

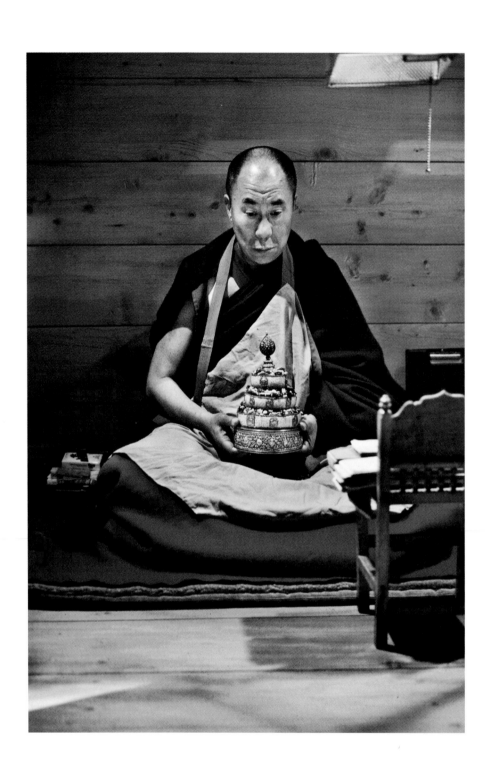

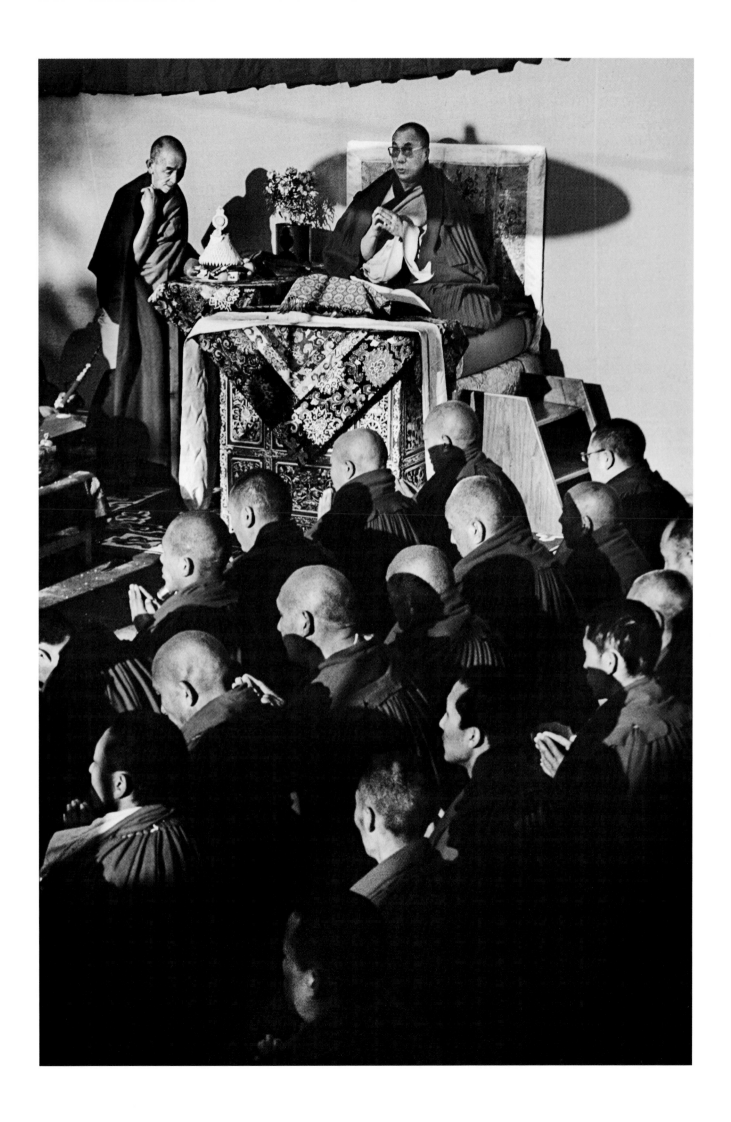

90

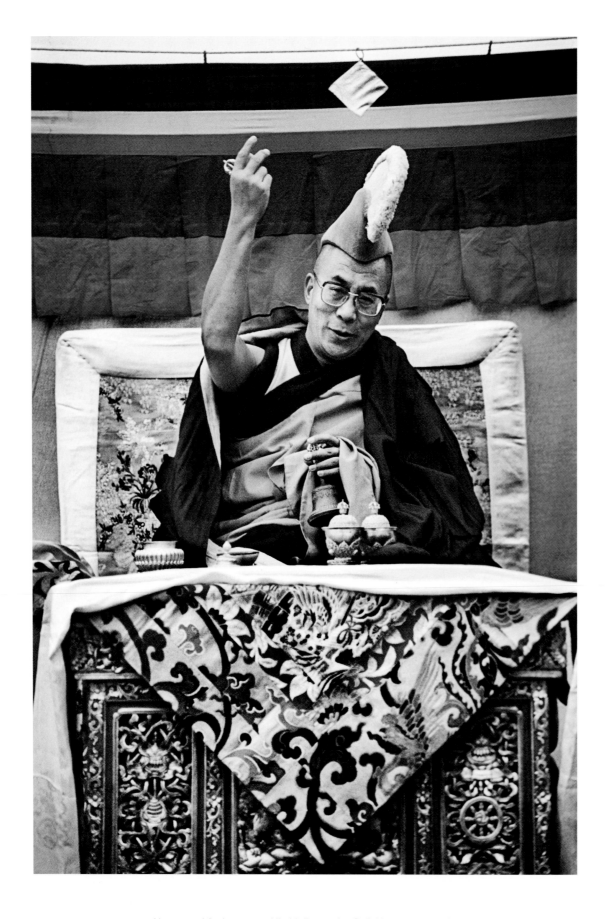

Above and facing page: His Holiness the Dalai Lama greets the Tibetan Lunar New Year before dawn on the roof of the temple, flanked by senior monks and government-in-exile officials. The solemn prayer cycle is there to dispel obstacles and ensure that the coming months are auspicious.

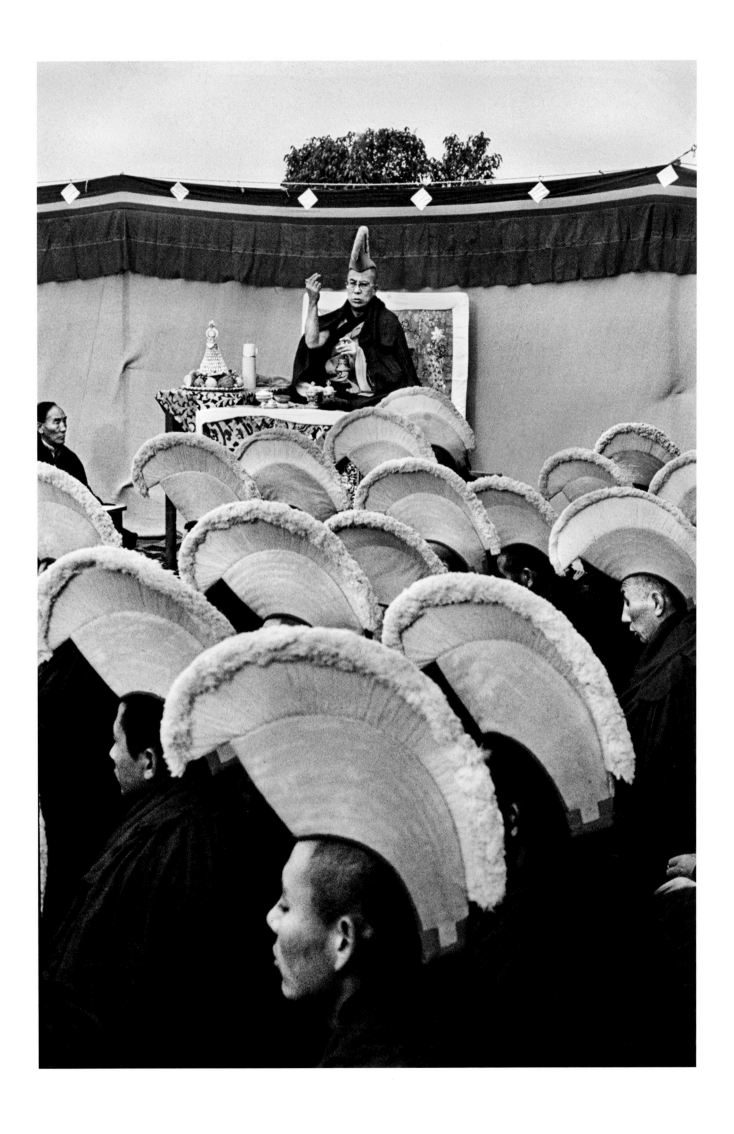

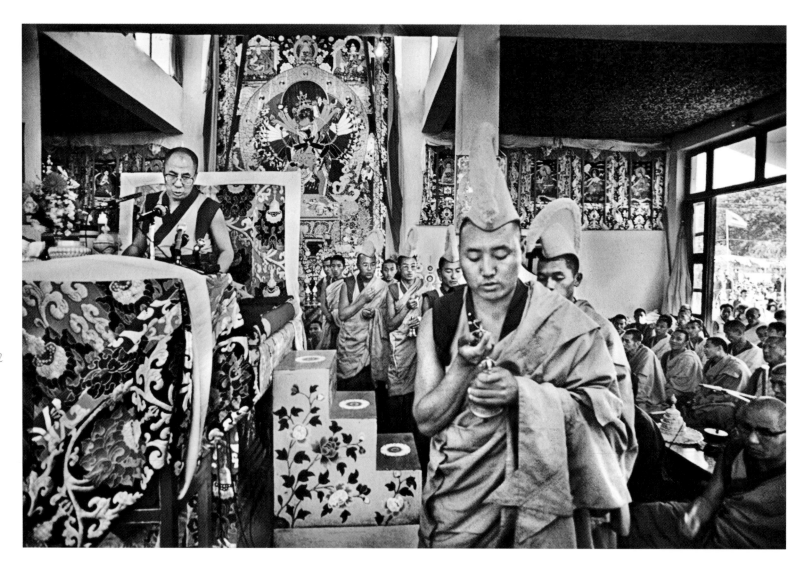

An intimate Kalachakra initiation held in Ladakh in 1975.

Facing page: Focus on the completed mandala at a
Kalachakra in Bodhgaya, 1986.

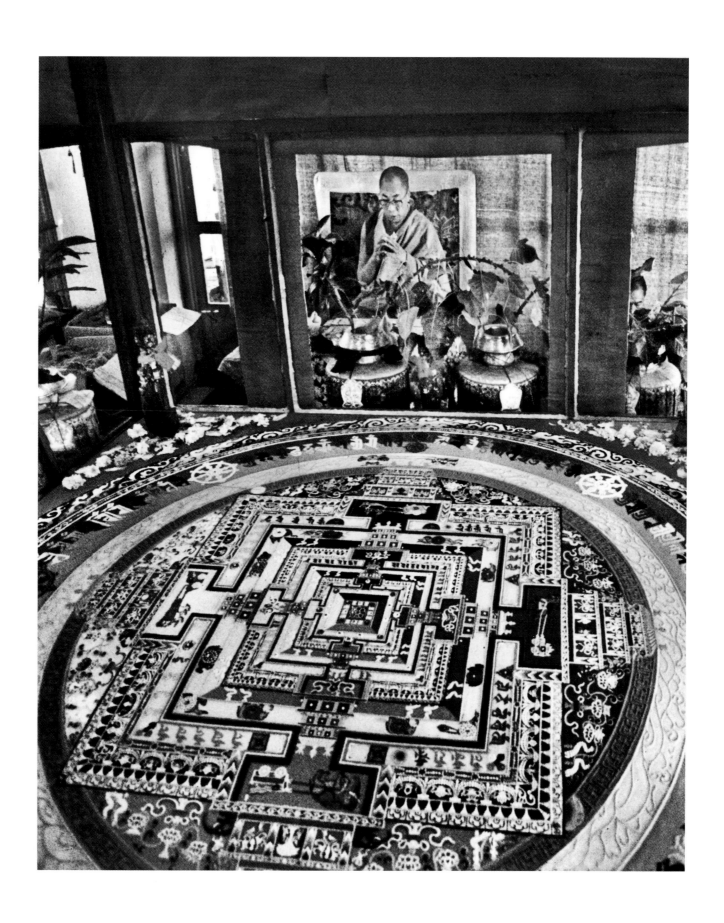

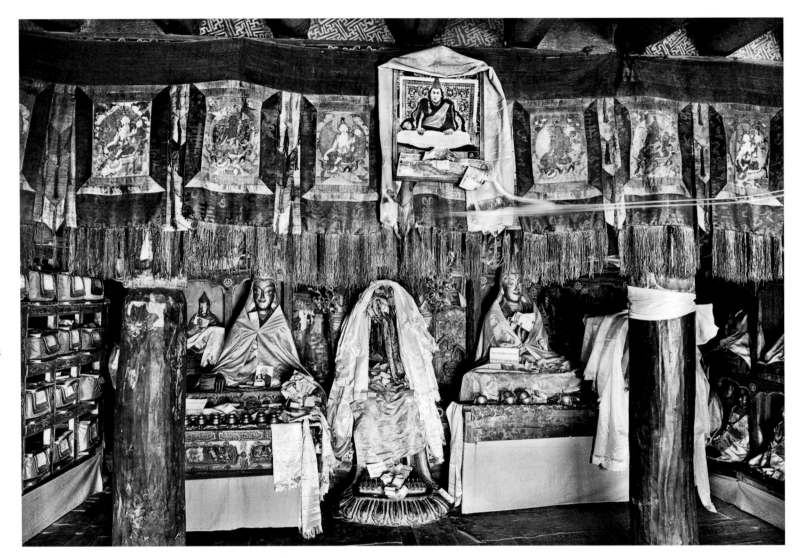

His Holiness's photograph dominates the prayer hall in
an ancient Ladakhi monastery.

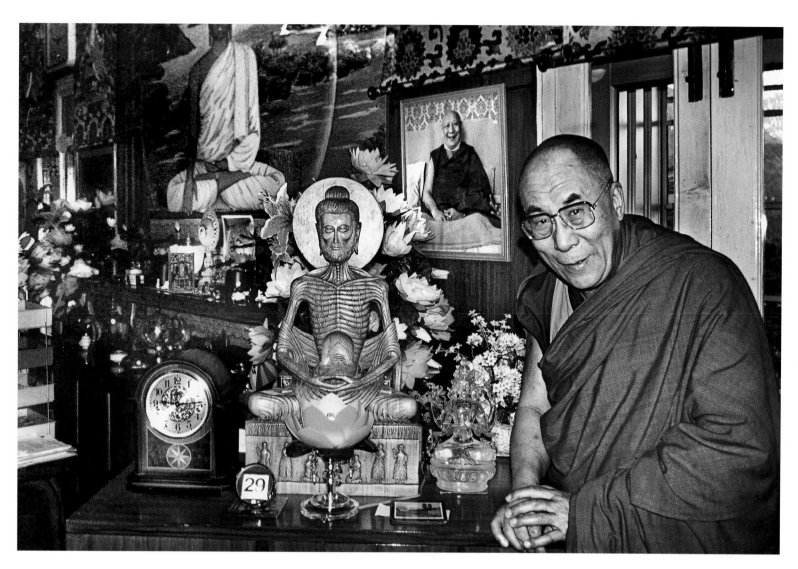

The Sakyamuni Buddha before enlightenment, in the
previous palace.

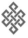

PLAYFULNESS AND BLESSINGS

When he was only four, His Holiness was recognized as the Fourteenth Dalai Lama of Tibet, Tenzin Gyatso. So he lost his childhood. But now, when he is with people he feels close to, he can respond to situations like an impish little boy, reclaiming his forfeited childhood.

After fifty years of living as a refugee in India, to say thanks for the hospitality and asylum, he invited ten of us—his "close friends," as he called us—to spend a day with him. The group included Kapila Vatsyayan, Dr. Naresh Trehan, Amjad Ali Khan, George Verghese, and myself. Our tour took us to a Hindu temple, a gurdwara, a mosque, a Jain temple, and a synagogue. At the synagogue he bowed to the twenty-five-year-old celebrant who was placing a yarmulke on his head and blessing him. And then we arrived at the Protestant Church of Redemption, where he was handed a crucifix to carry. He found it so amusing that he could hold Jesus Christ in his hands.

The last time I was photographing him, he looked at my shirt and said, "Oh! Too many buttons." I said, "Your Holiness, this is a designer shirt." He said, "Waste of buttons." And then, a couple of years ago, there was a teaching for Asians in Dharamsala. It was very cold, and I was wearing a nice new hat. The story was for the *New York Times* magazine. He was seated on his throne, five or six feet above other senior lamas and Rinpoches surrounding him. The venue was full of robed monks. After some hours I stood up to find a bathroom.

He stopped the teaching, looked at me, and said, "Are you going?"

"No, Your Holiness, just for a short break." I suddenly saw a twinkle in his eye. "Come here, come here," he said. "Come closer, come closer." I went right up to him. Leaning down, he said, "I want to see how much hair is left," and lifted off my hat. As he laughed, everyone around went into splits.

Can you imagine? No other spiritual or political leader would do something so spontaneous during a solemn or key speech. Putting the hat back on my balding head, he said, "Go. You're free to go. Utilize your freedom as much as possible."

These are his teasing gestures, showing love and affection. These are blessings—personal, playful, and spontaneous.

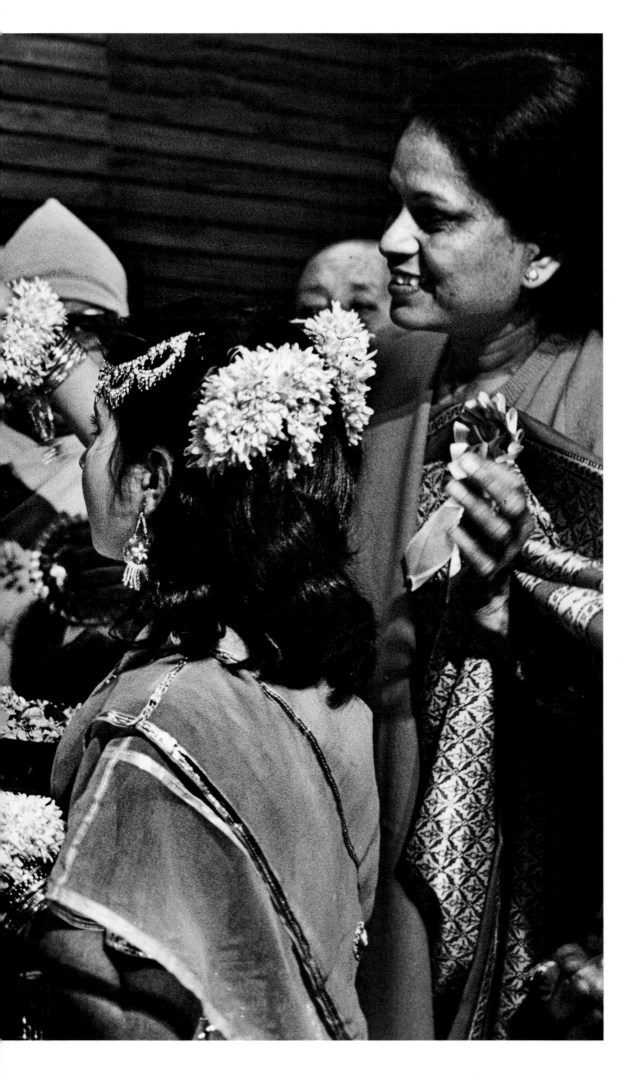

Bowing his head, the Dalai Lama receives a *tikka* blessing and *agni puja* greeting with curiosity and pleasure, showing that respect and compassion cross religious boundaries.

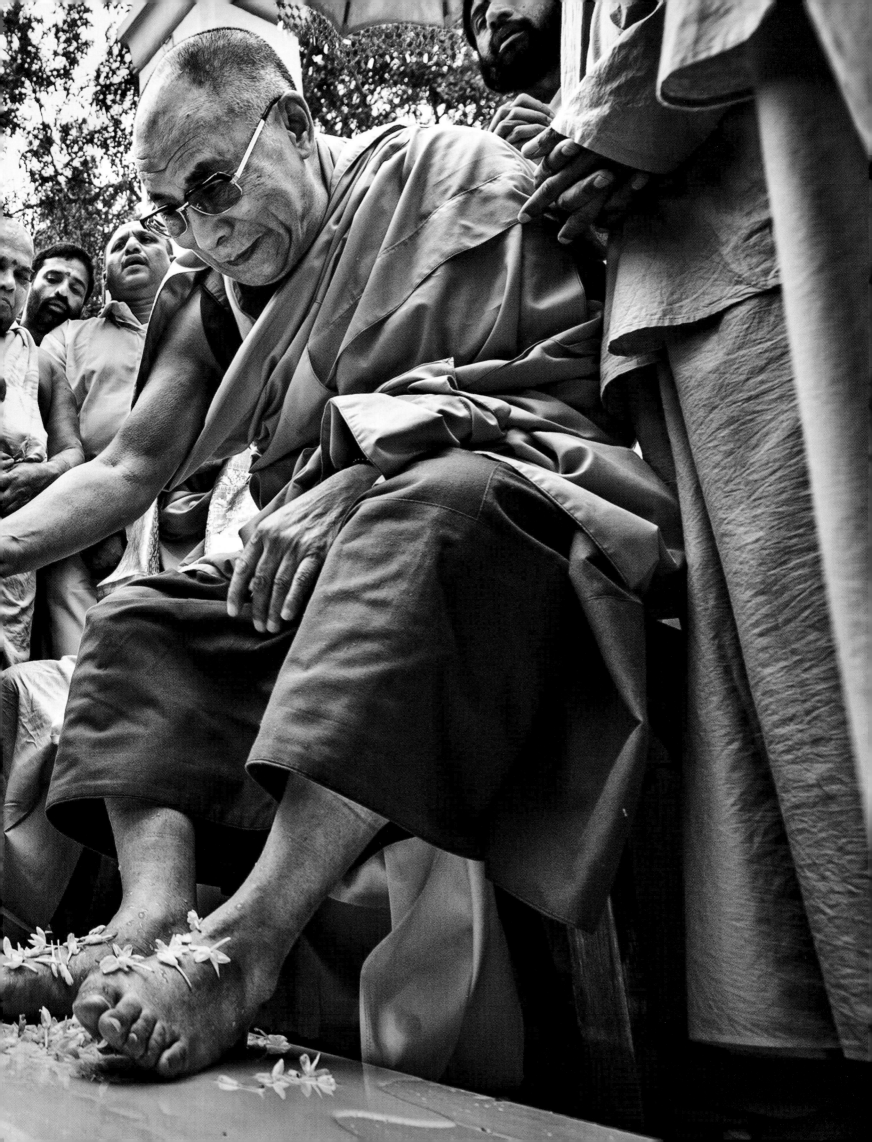

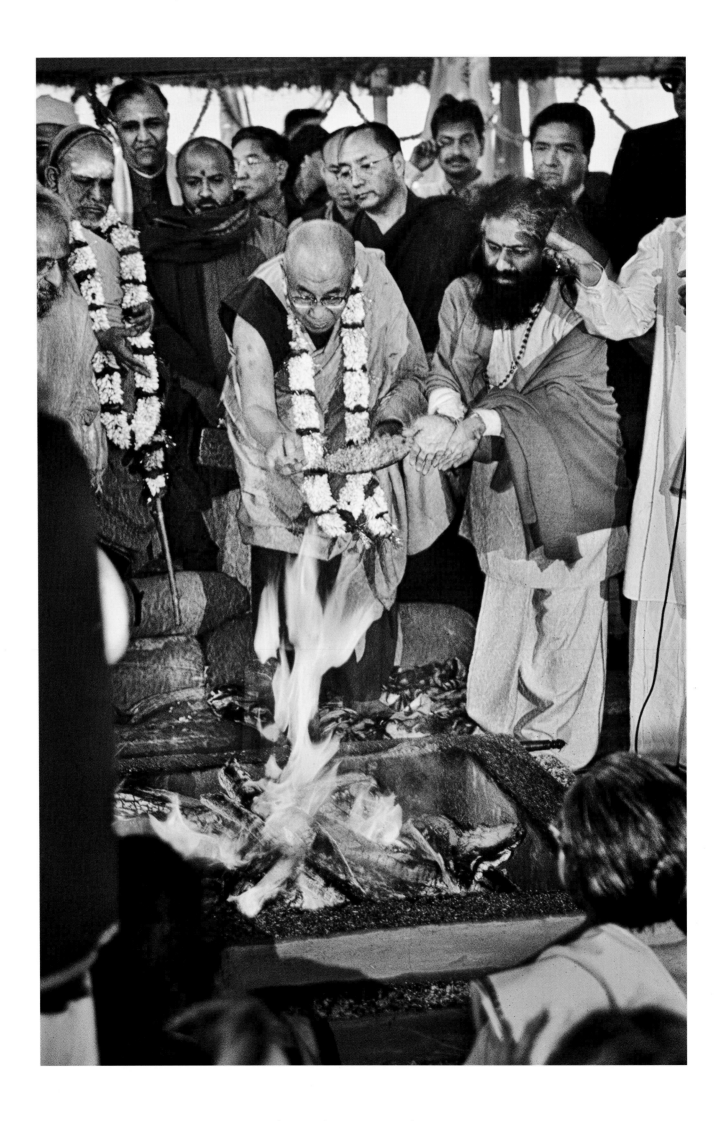

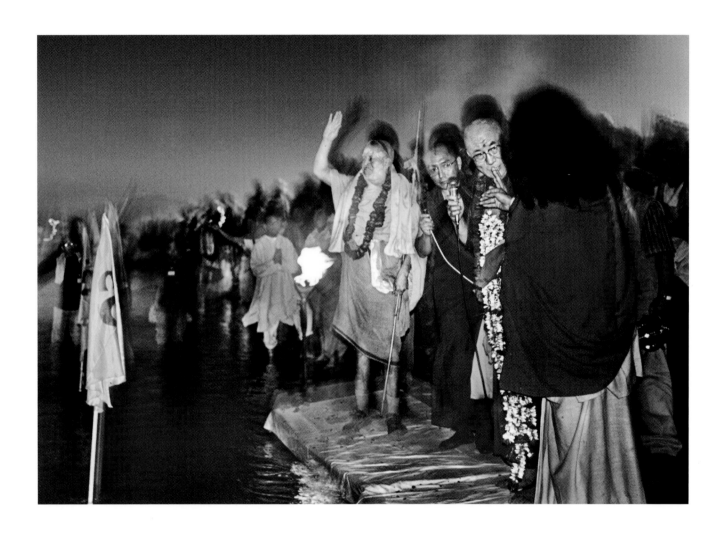

Always referring to India as his "guru," His Holiness participates enthusiastically in rituals of all faiths.

Previous pages (100–101): Ritual foot-washing of His Holiness before praying at Sivagiri Mutt, Kerala.

Above: At the 2001 Mahakumbh Mela in Allahabad with the Shankaracharya of Kanchi Peetham.

Facing page: Performing a fire puja yagna with a Hindu priest.

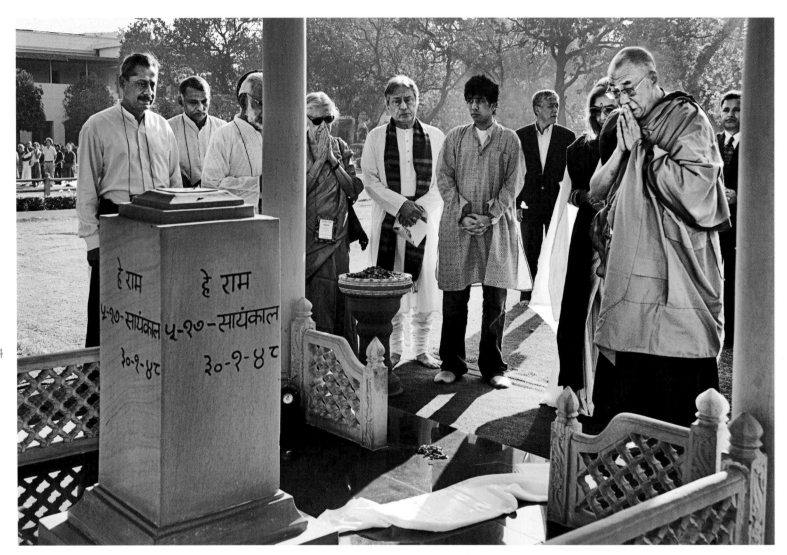

At Gandhi Smriti, Birla House, site of Mahatma Gandhi's assassination, with Naresh Trehan, Amjad Ali Khan, and Kapila Vatsyayan. A one-day visit to worship at religious places in New Delhi in 2009, during a "Thank You, India" festival, reflects the Dalai Lama's commitment to interfaith harmony.

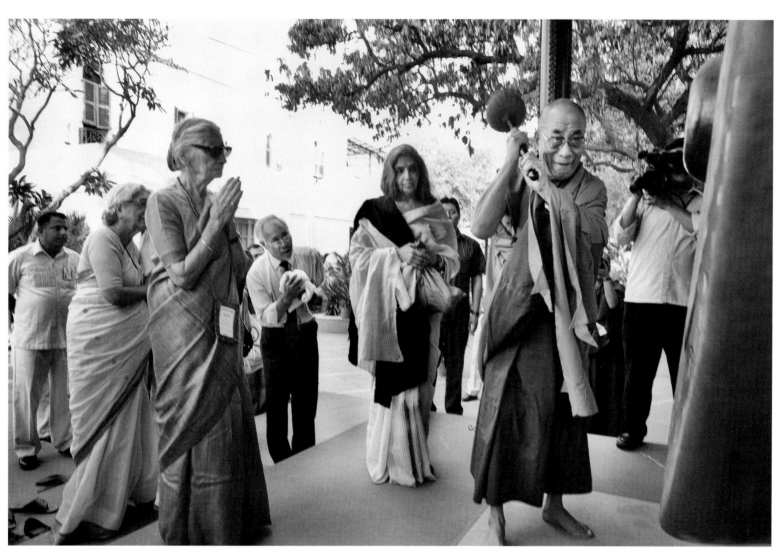

Striking the World Peace Gong
at Birla House, with Kapila Vatsyayan.

Leaving the Laxminarayan Temple, also known as the Birla Mandir, built in the 1930s by the Birla family.

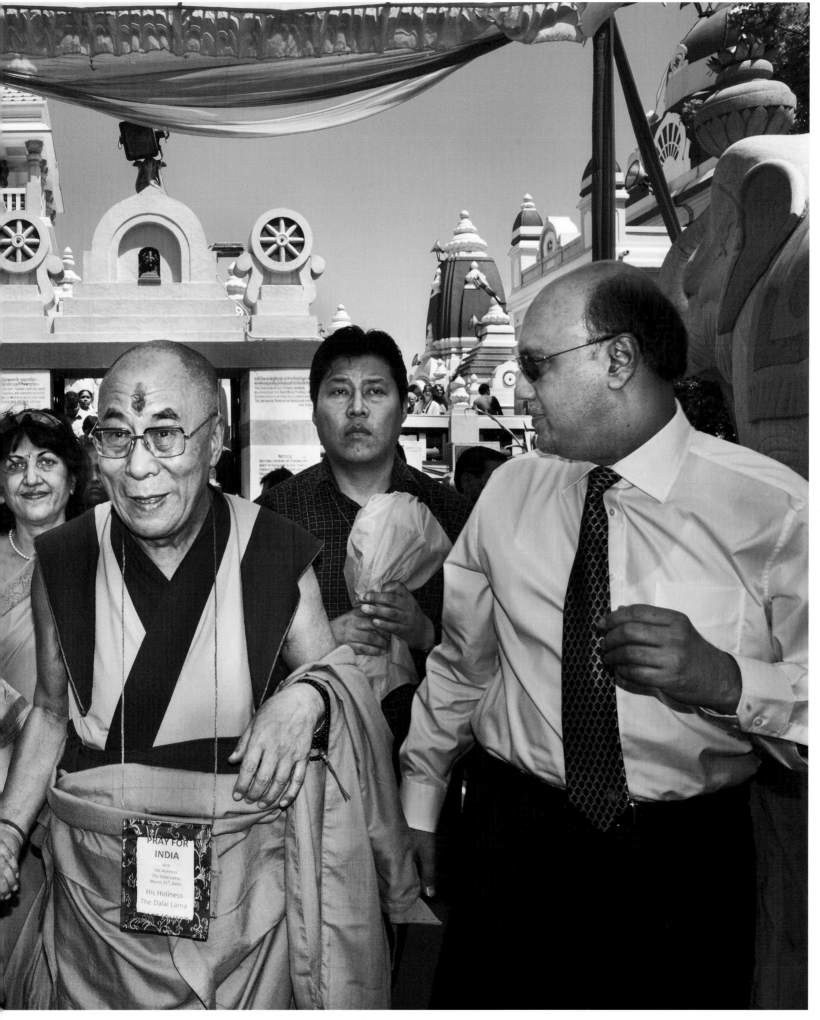

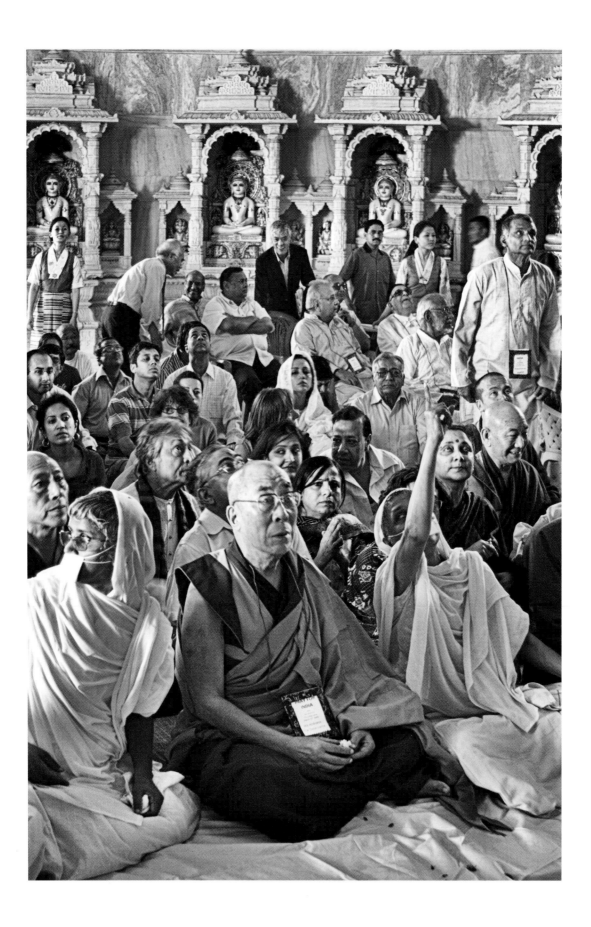

Seated with Jain worshippers.

Facing page: Offering namaaz at Nizamuddin Chilla
Mosque, shrine of the fourteenth-century Sufi saint
Hazrat Nizamuddin Auliya.

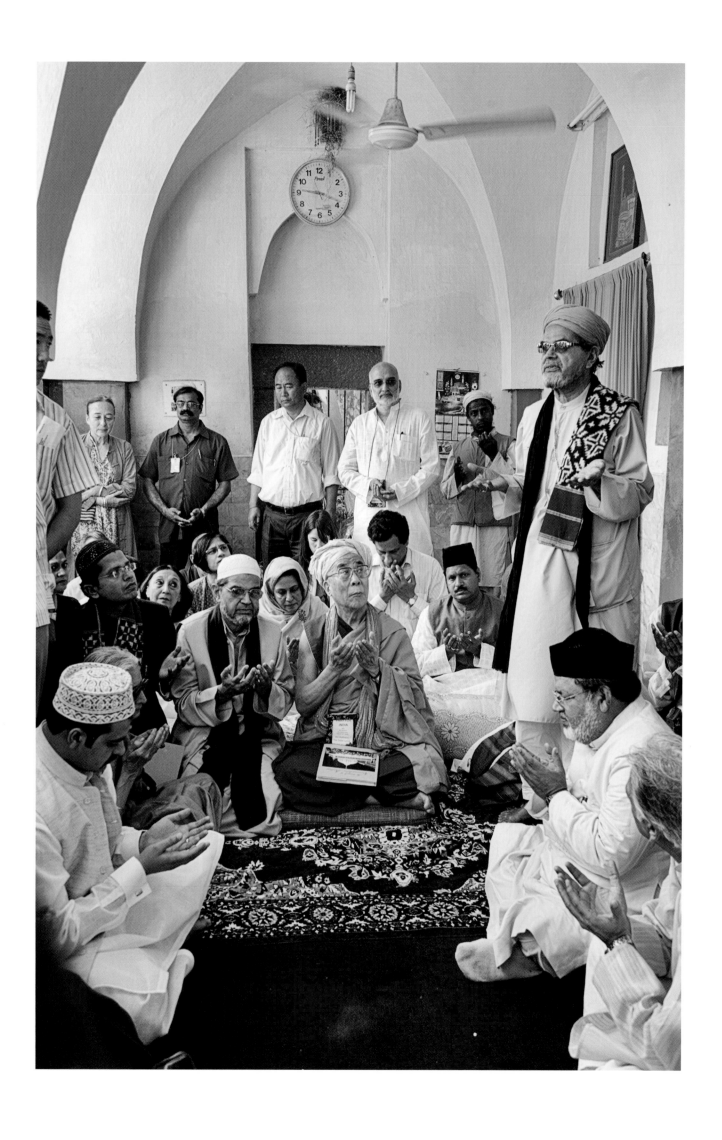

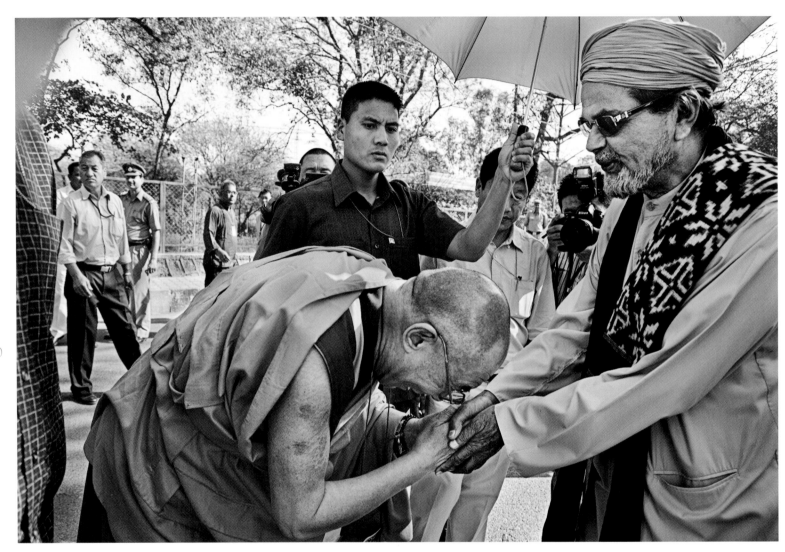

With the imam of the historic Nizamuddin Chilla Mosque.

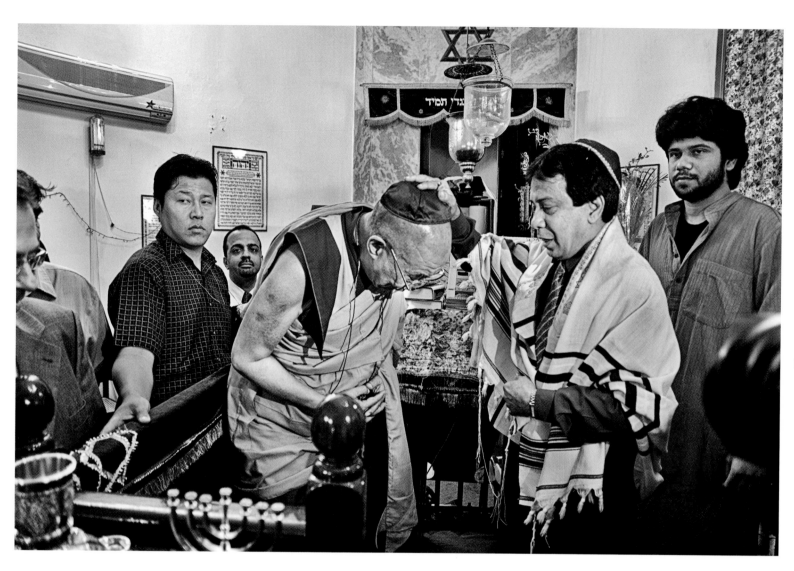

Being blessed at Jud'ah Hymn Synagogue, wearing a yarmulke.

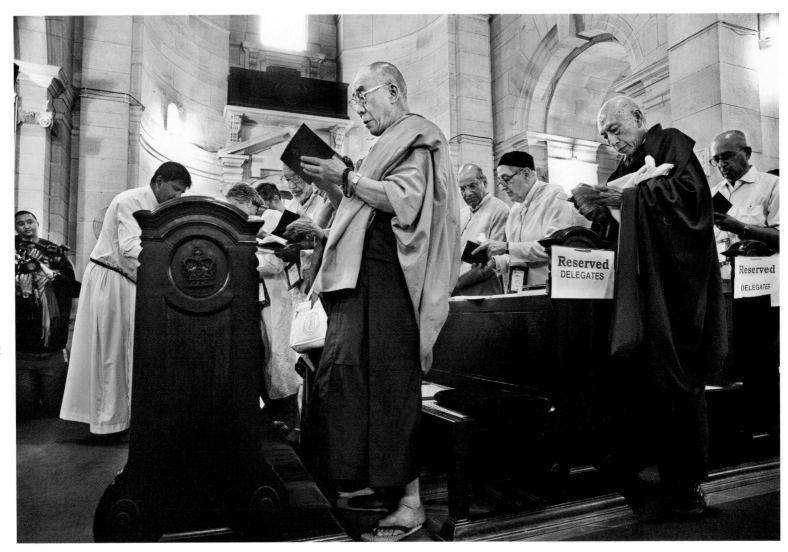

At the Cathedral Church of Redemption, also known
as the Viceroy Church—the premier Protestant place of
worship in New Delhi.

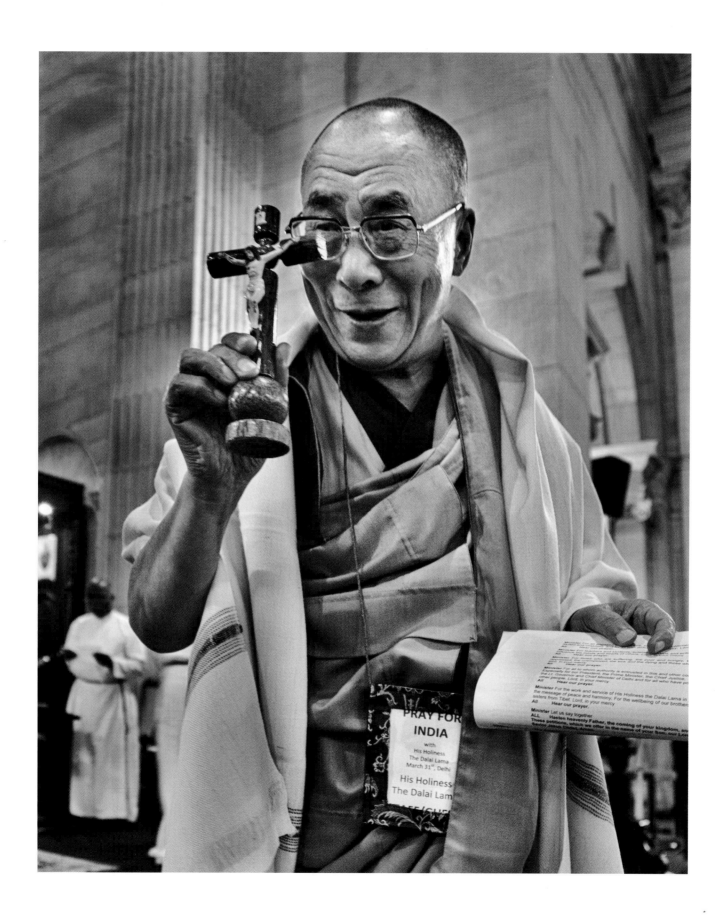

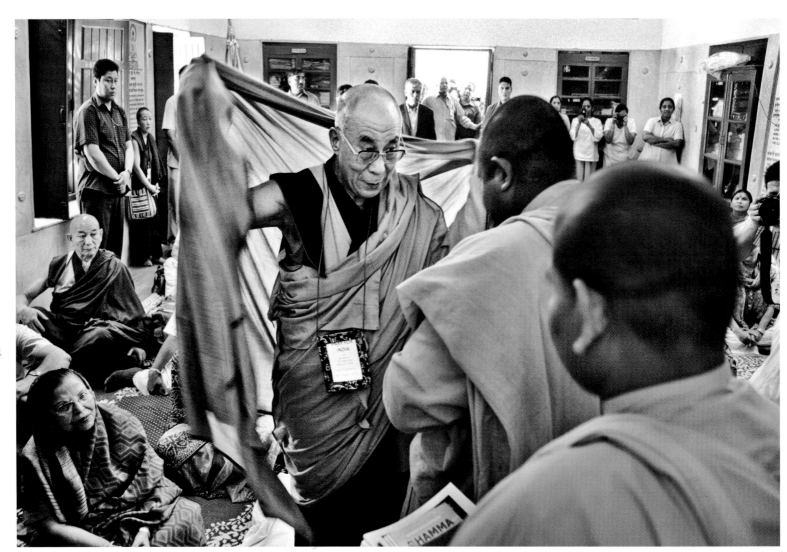

Visiting the Mahabodhi Society, inaugurated by
Mahatma Gandhi in 1939.

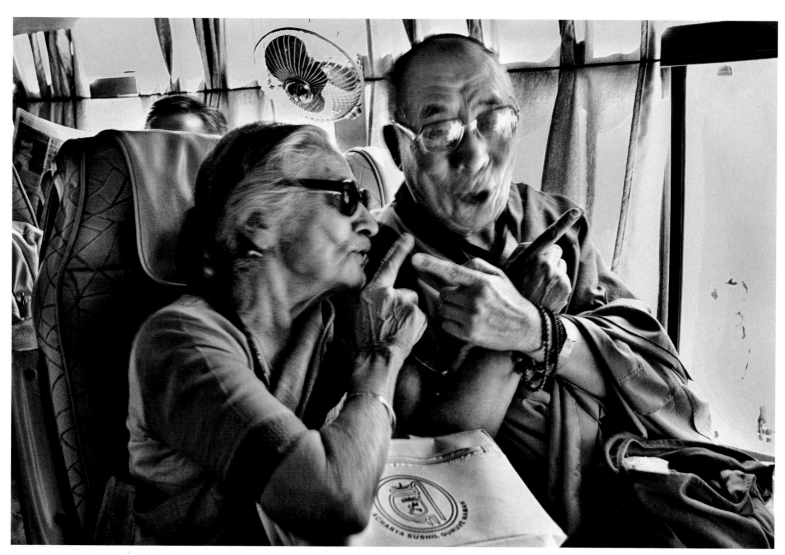

An animated exchange with his old friend, the iconic
public intellectual Kapila Vatsyayan.

BECOMING THE HIMALAYAS

Many years ago, when the Dalai Lama was still living in the British-built bungalow everyone called the "palace," I had gone to Dharamsala with a special panoramic image in mind. When I told him, "Your Holiness, it's a very important assignment," he simply said, "What do you want me to do?" I said, "Just let me find a spot where I can see the mountains in the background." He instructed one of his secretaries, "Take him wherever he wants to go."

So I climbed up on the roof of his residence and walked around, this way and that, checking the view of the Dhauladhar range. Then I spotted a room a floor higher than the roof. When I asked if I could go up to the roof, the secretary told me there were no steps to get there. "Should we get you a ladder?" he asked. When I clambered up the ladder, I found a position where I could place His Holiness and still see the vastness of the Himalayas as a backdrop.

After a big cushion-mattress—we call it a *gadda*—was carried up for him to sit on comfortably, His Holiness climbed the ladder and started to settle down for the shoot. I saw that I should immediately make use of this moment. Informal. Natural. I instantly shot several frames in succession, some with a flash, some without. Remember, those were the days of film and processing. Now you can see right away what you've clicked. Then, you didn't know exactly what would come out. And I got this image.

Here I see His Holiness is as strong and handsome and magnificent as the Himalayas themselves. A few years later, after he had been through a surgery, the moment we met, he asked me, "How do I look?" It reminded me of this situation, so I immediately answered, "Your Holiness, you look as strong and magnificent as the Himalayas."

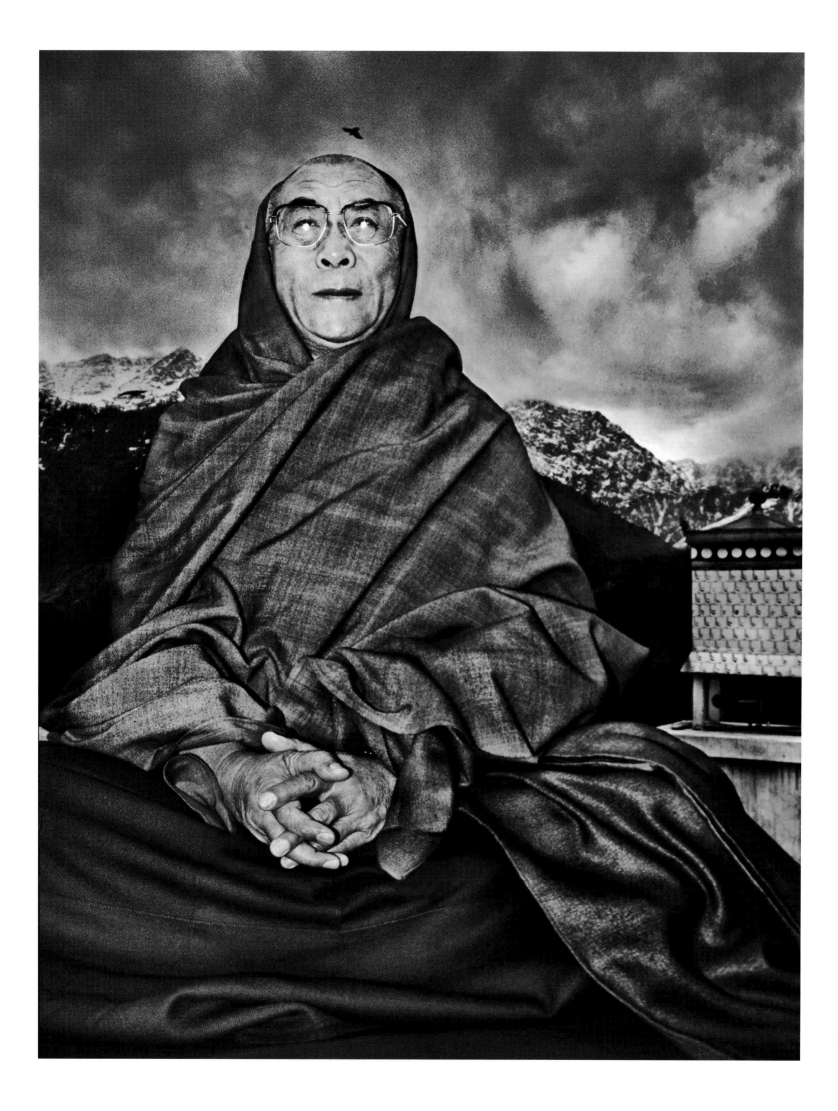

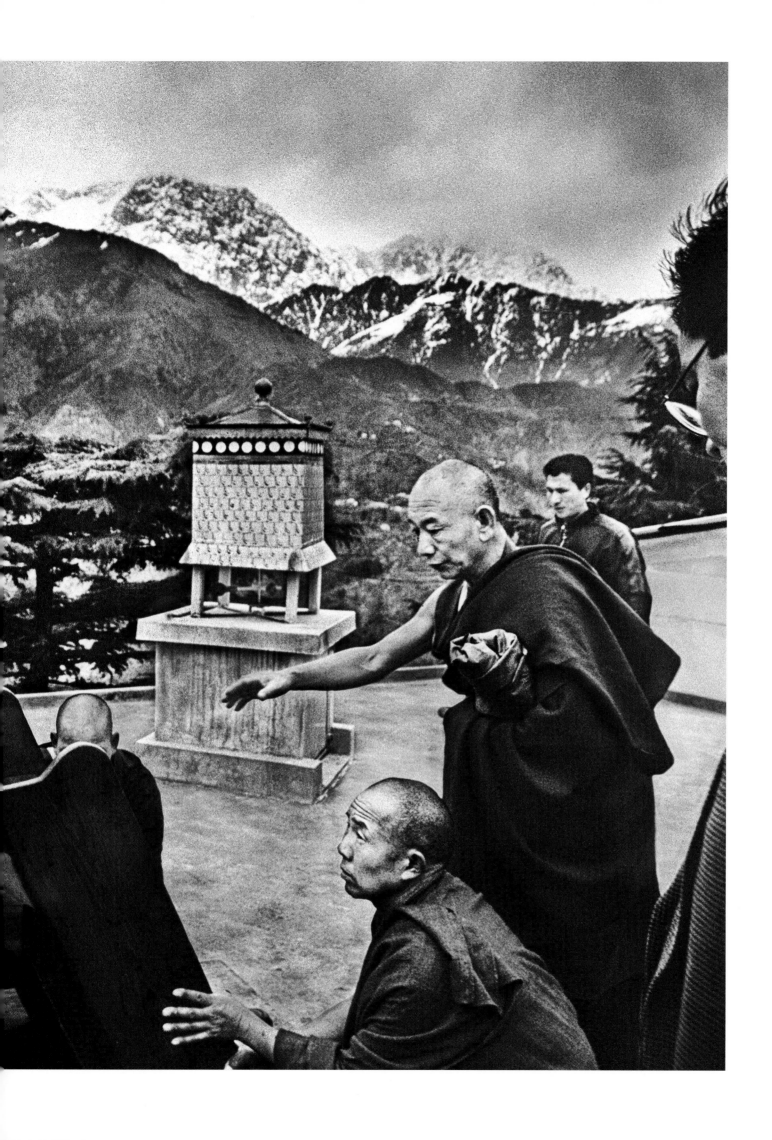

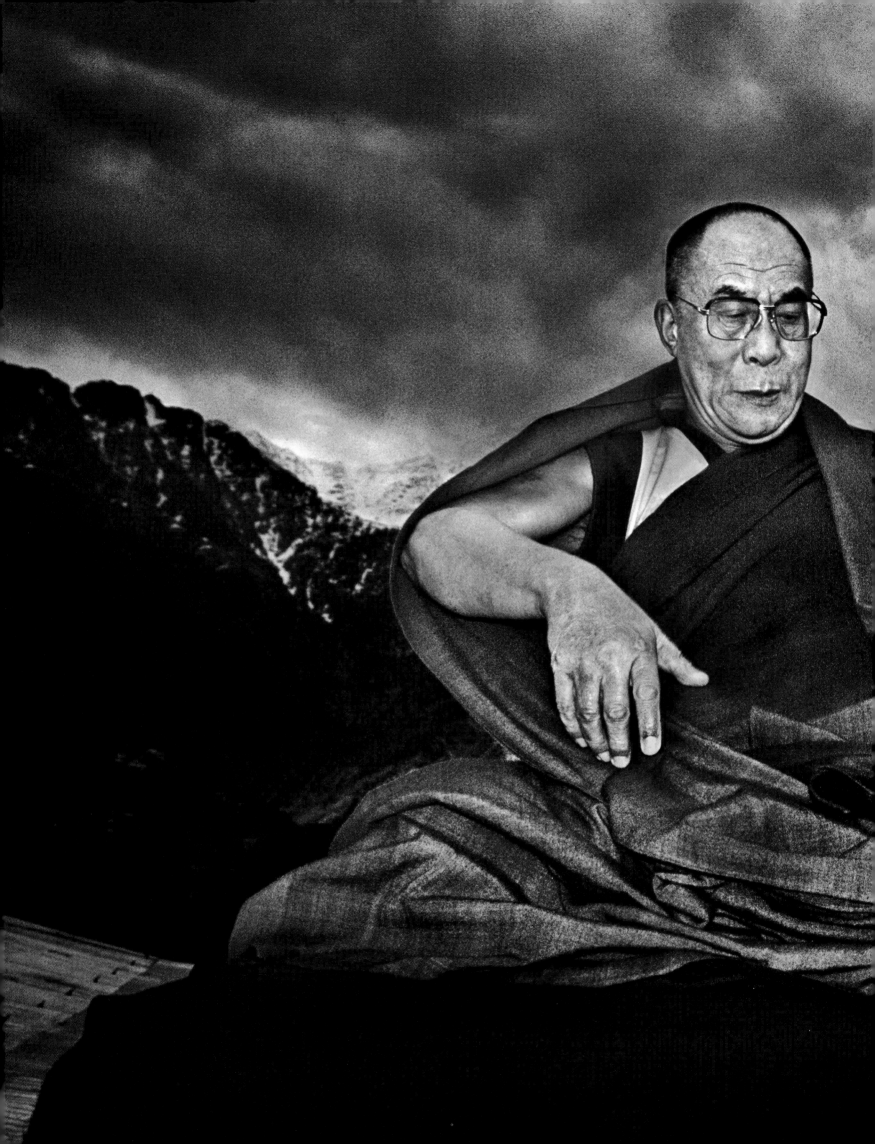

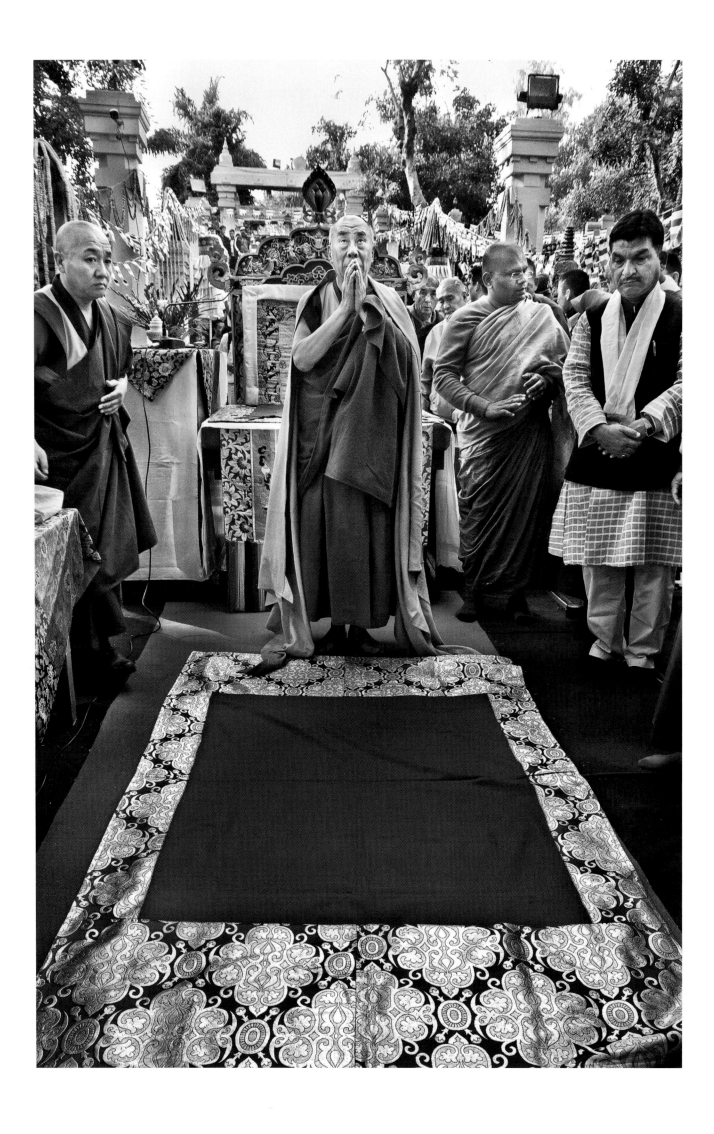

122

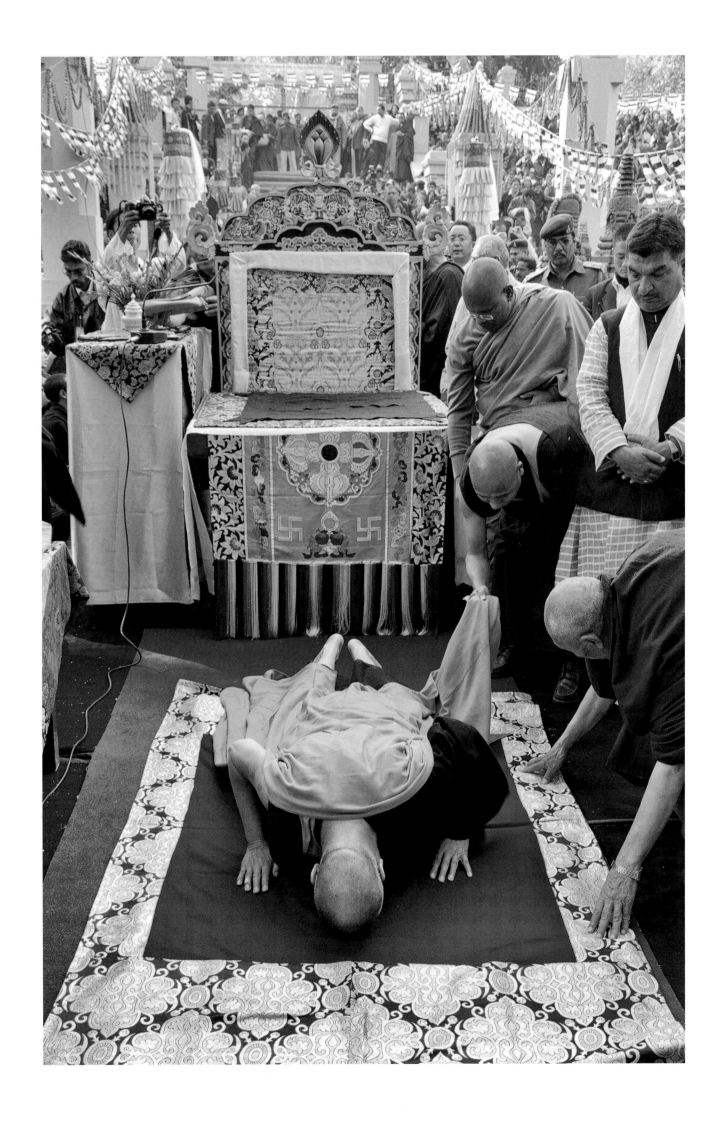

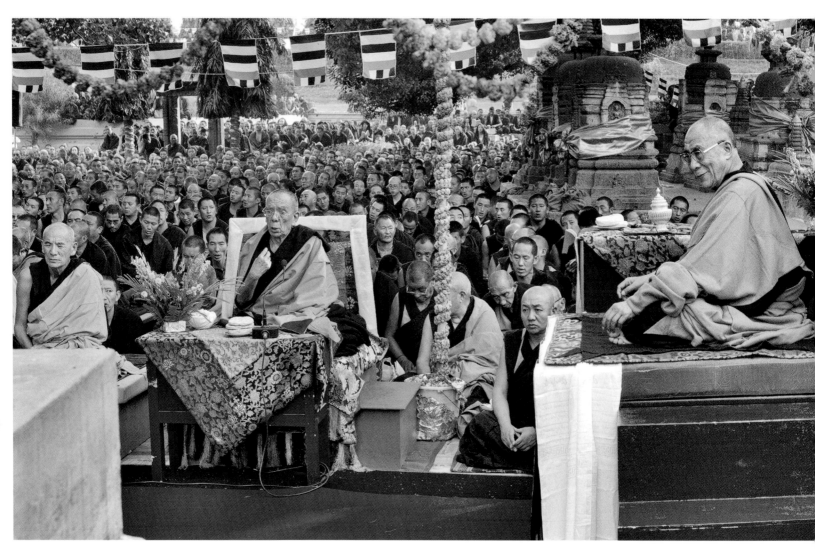

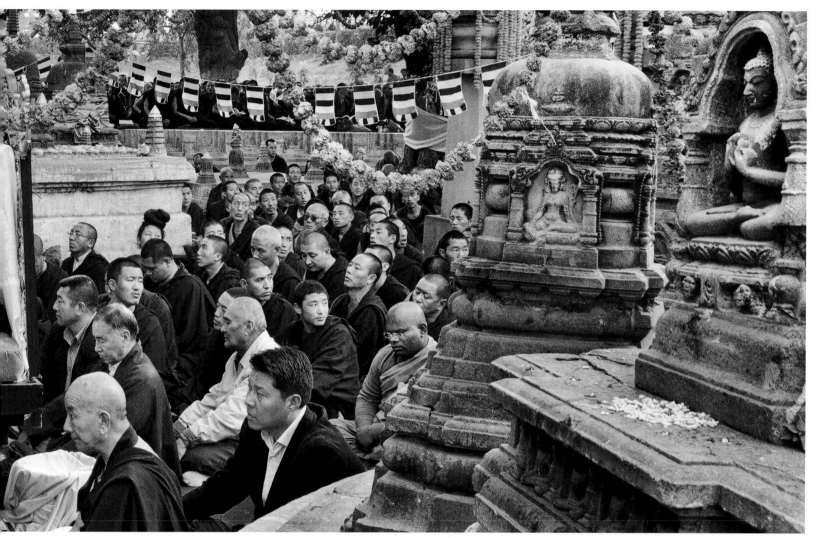

For both lay Tibetans and those in robes, Bodhgaya
is the place to congregate in winter for massive prayer
rituals and spiritual renewal.

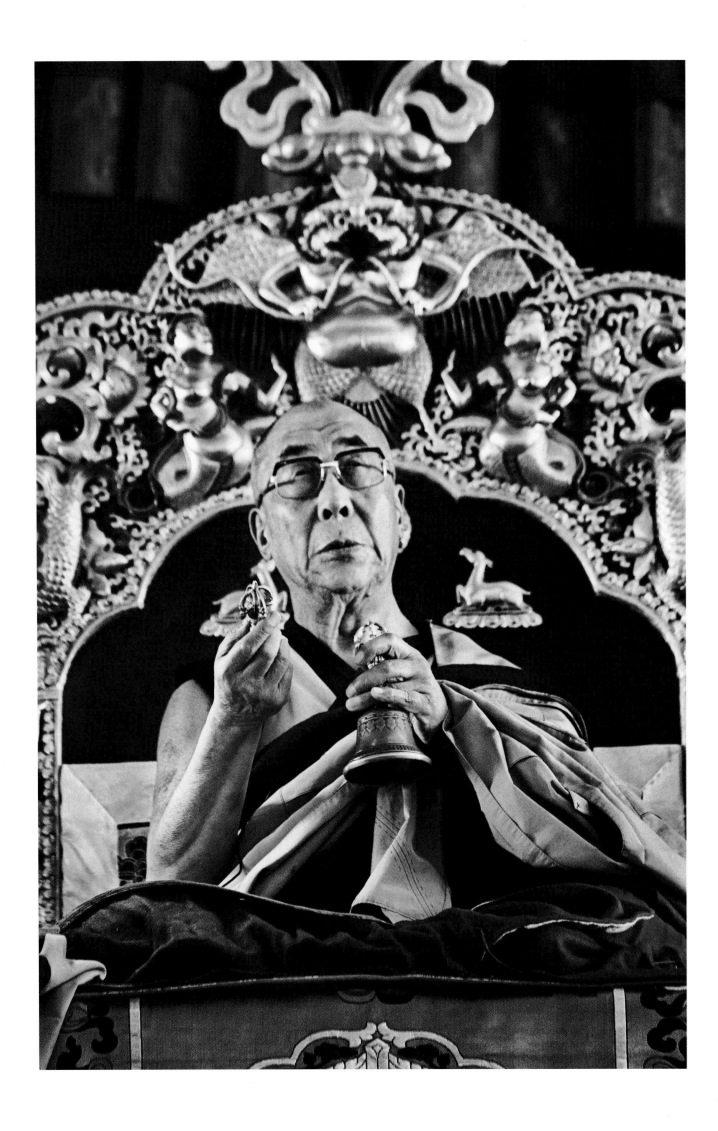

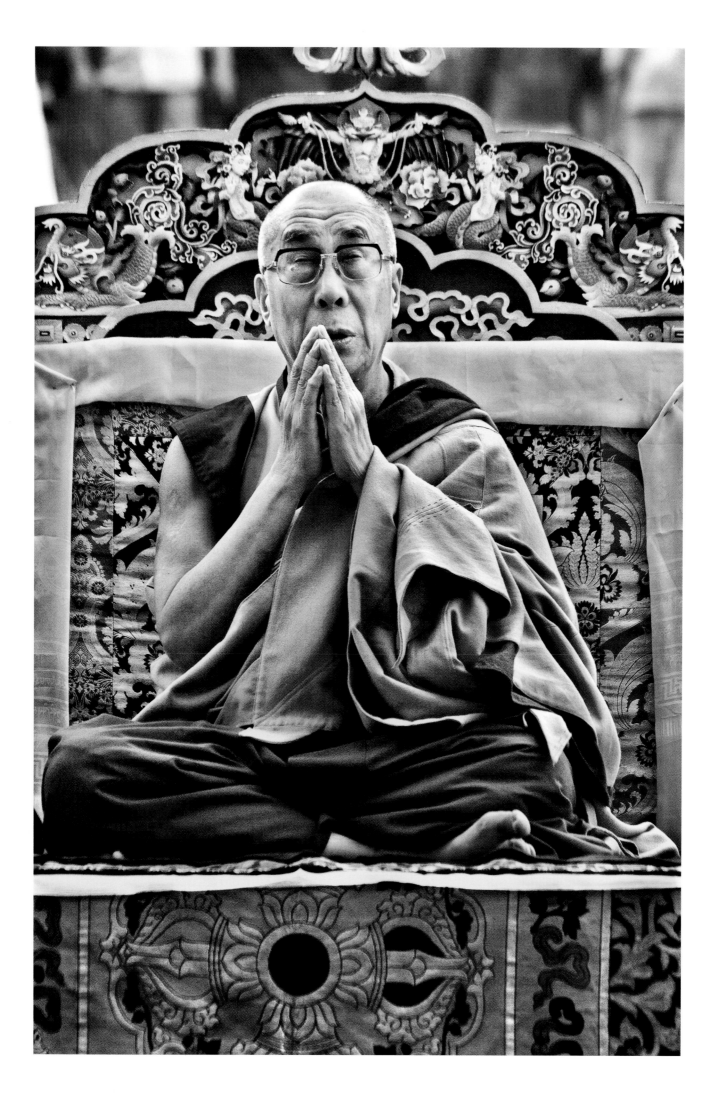

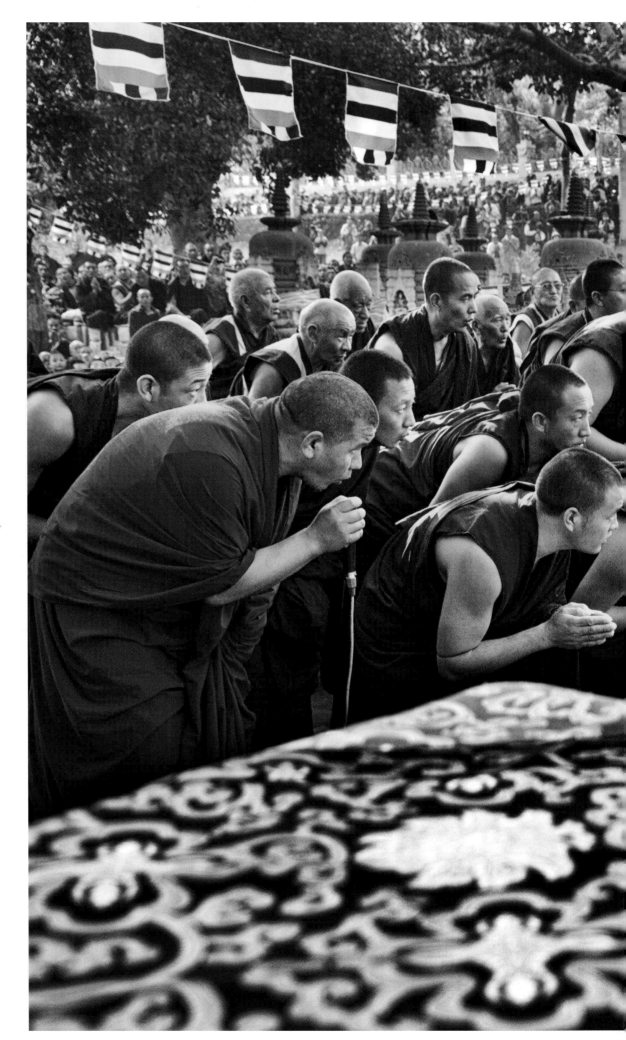

Bodhgaya, the place where the Buddha became enlightened under the Bodhi tree.

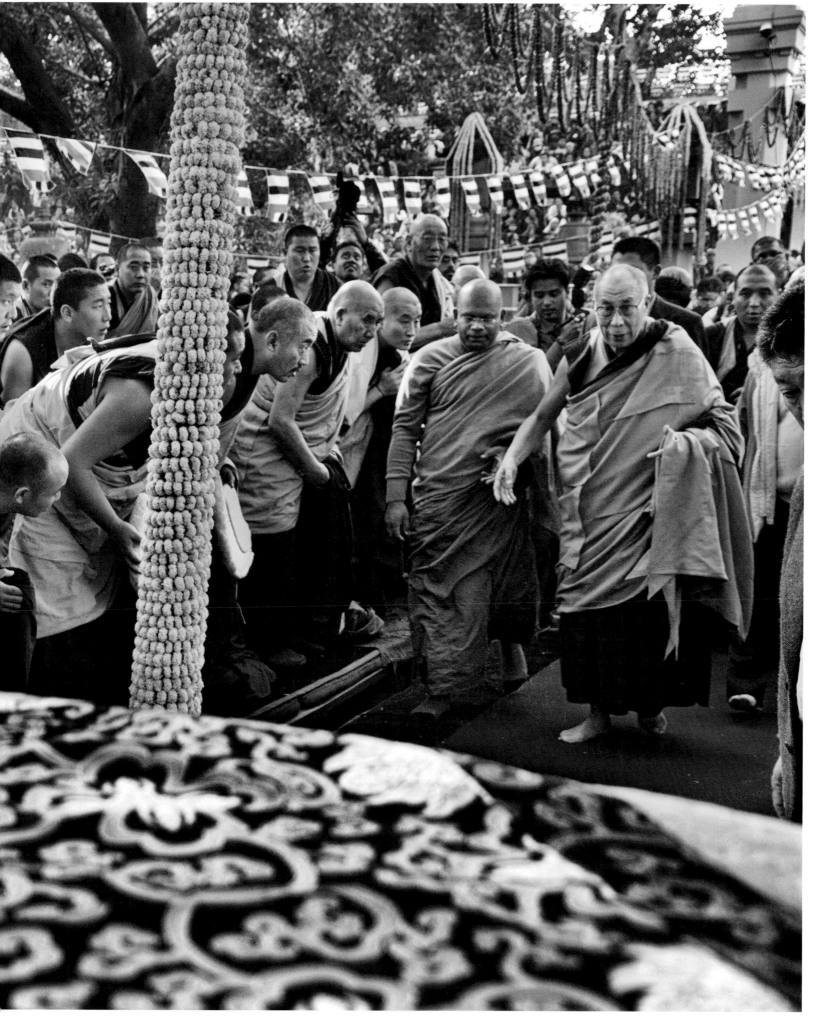

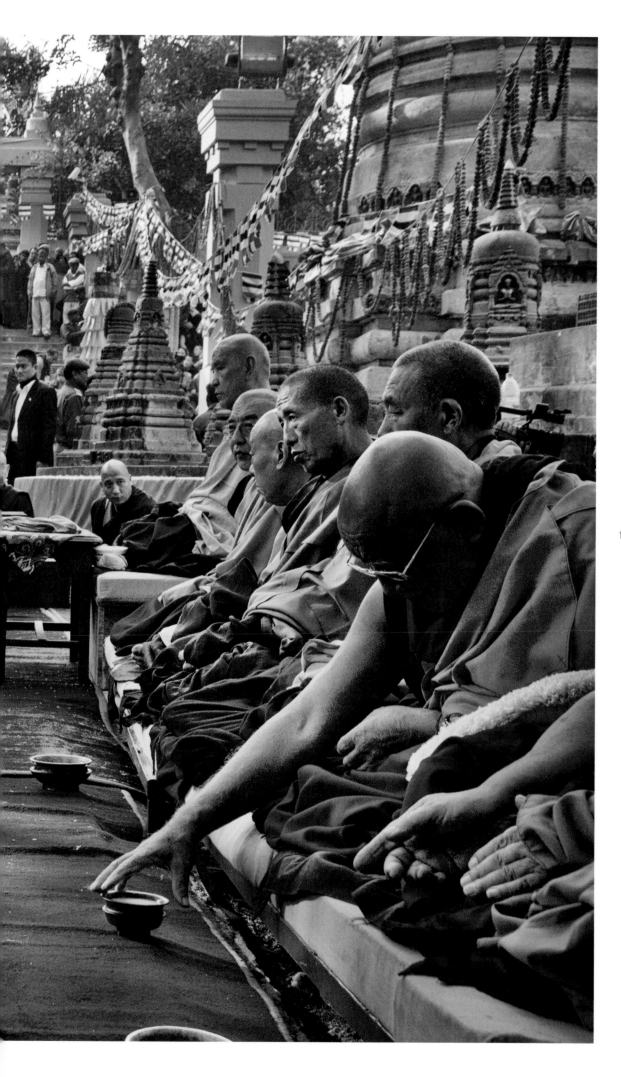

When the Dalai Lama presides over teachings, prayers, and tantric rituals in Bodhgaya, audiences throng the venue by the thousands.

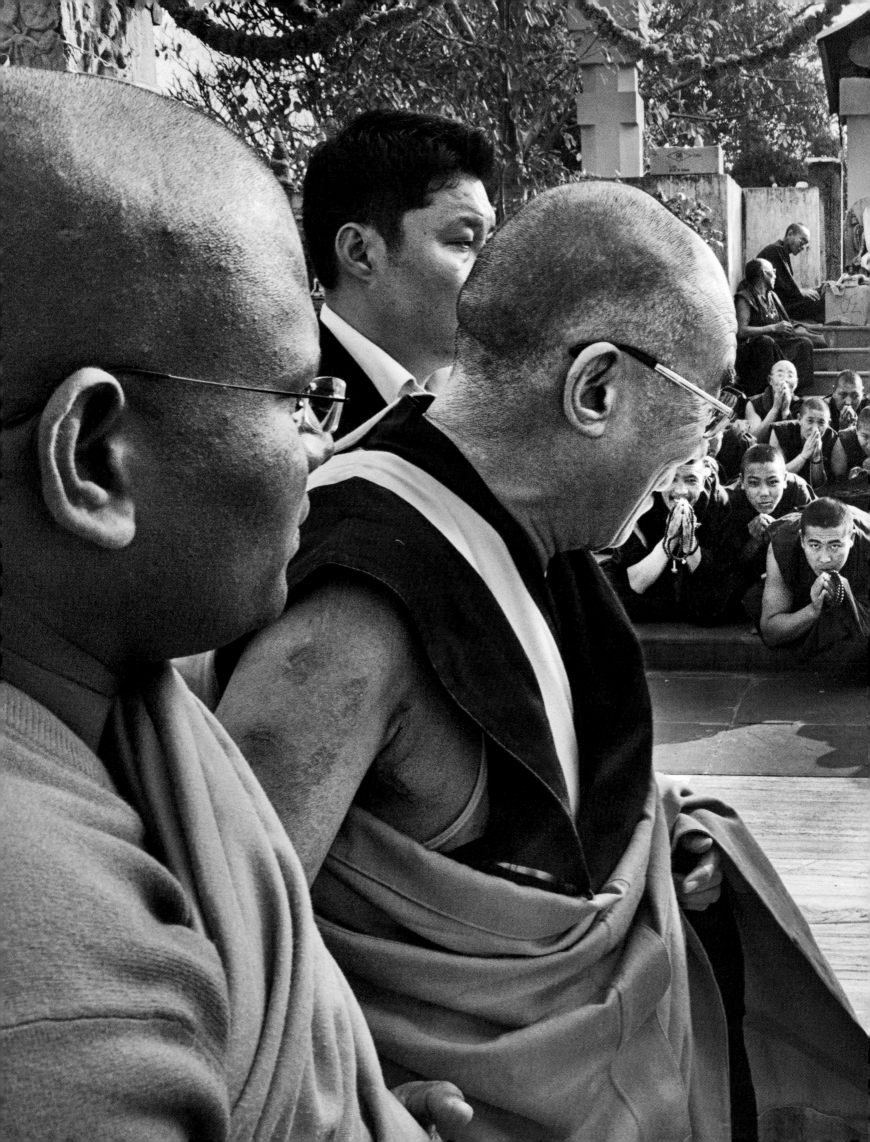

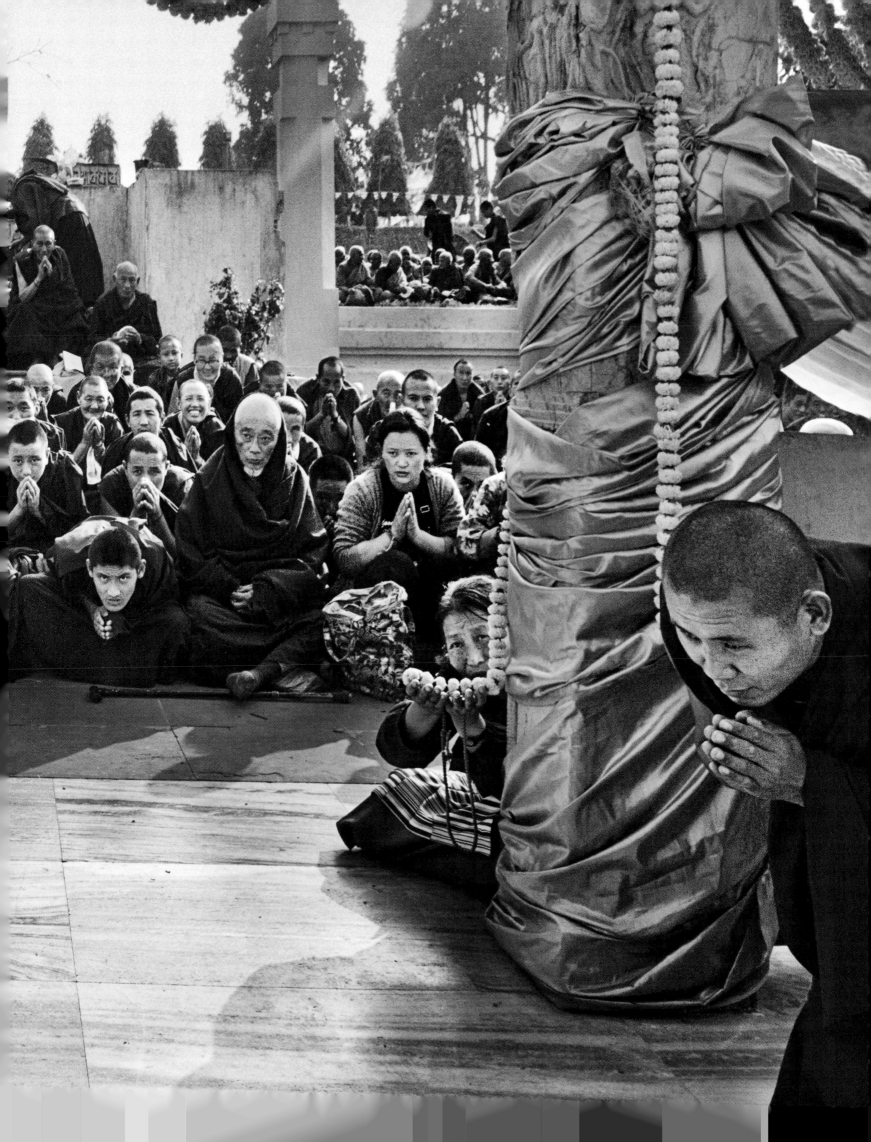

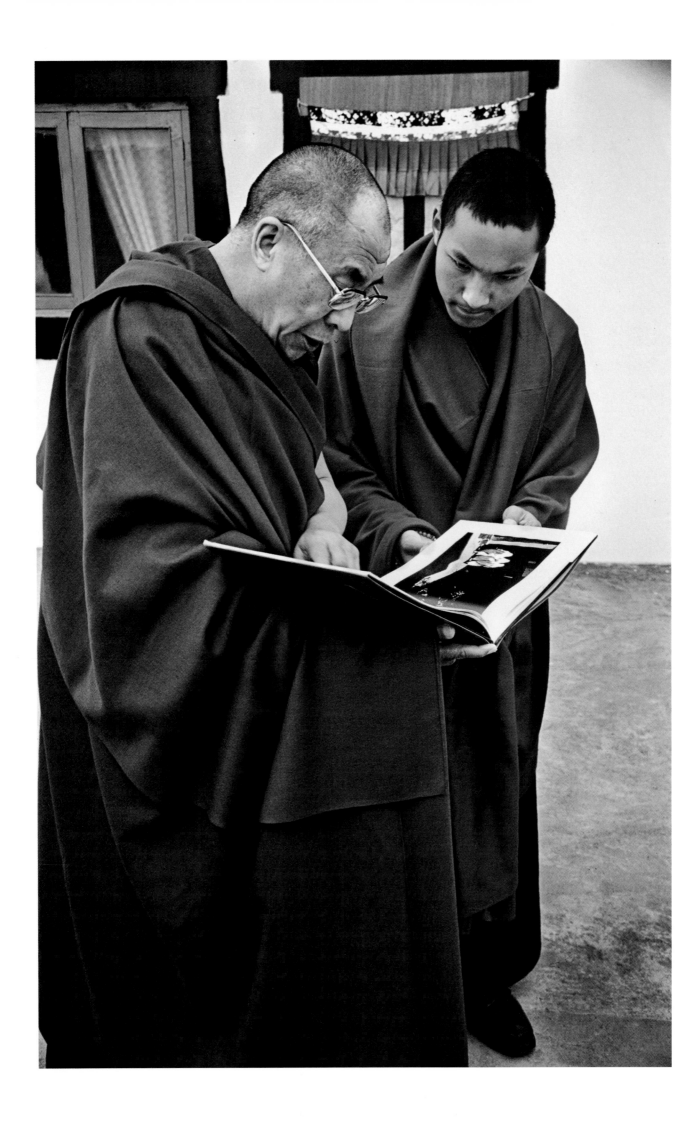

134

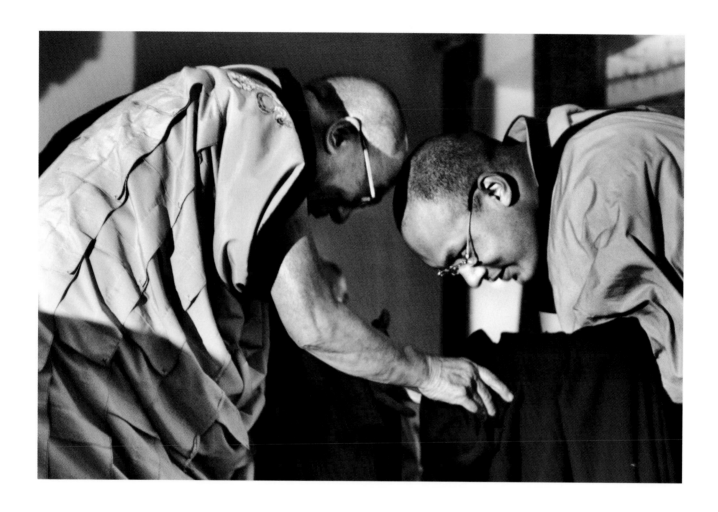

At age fourteen, His Holiness the Seventeenth
Gyalwa Karmapa escaped from Chinese-occupied Tibet to join
the Dalai Lama in exile on the eve of the millennium.

Following pages (136–137): The Karmapa, head of the Karma
Kagyud tradition, stands at left, with leaders of the Gelug and
Sakya schools of Tibetan Buddhism, the Ganden Tripa, Rizong
Rinpoche, center, and His Holiness Sakya Trinzin, right.

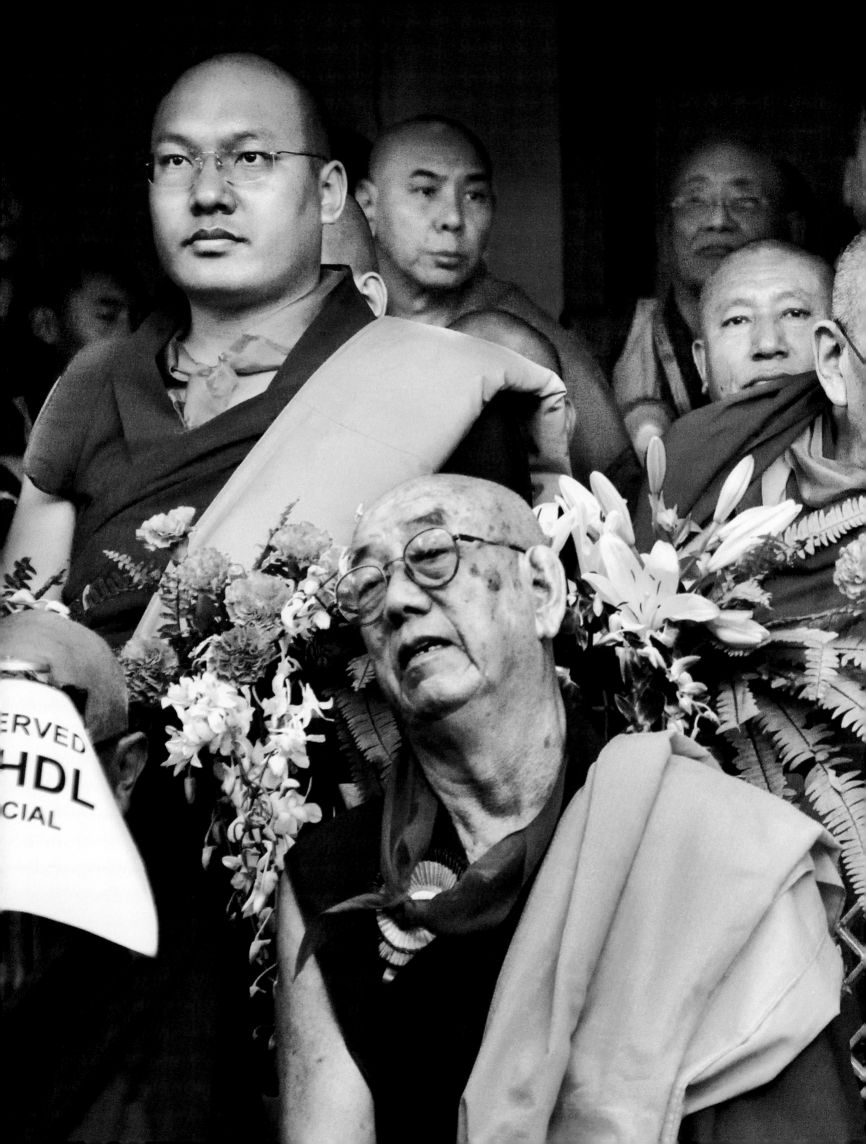

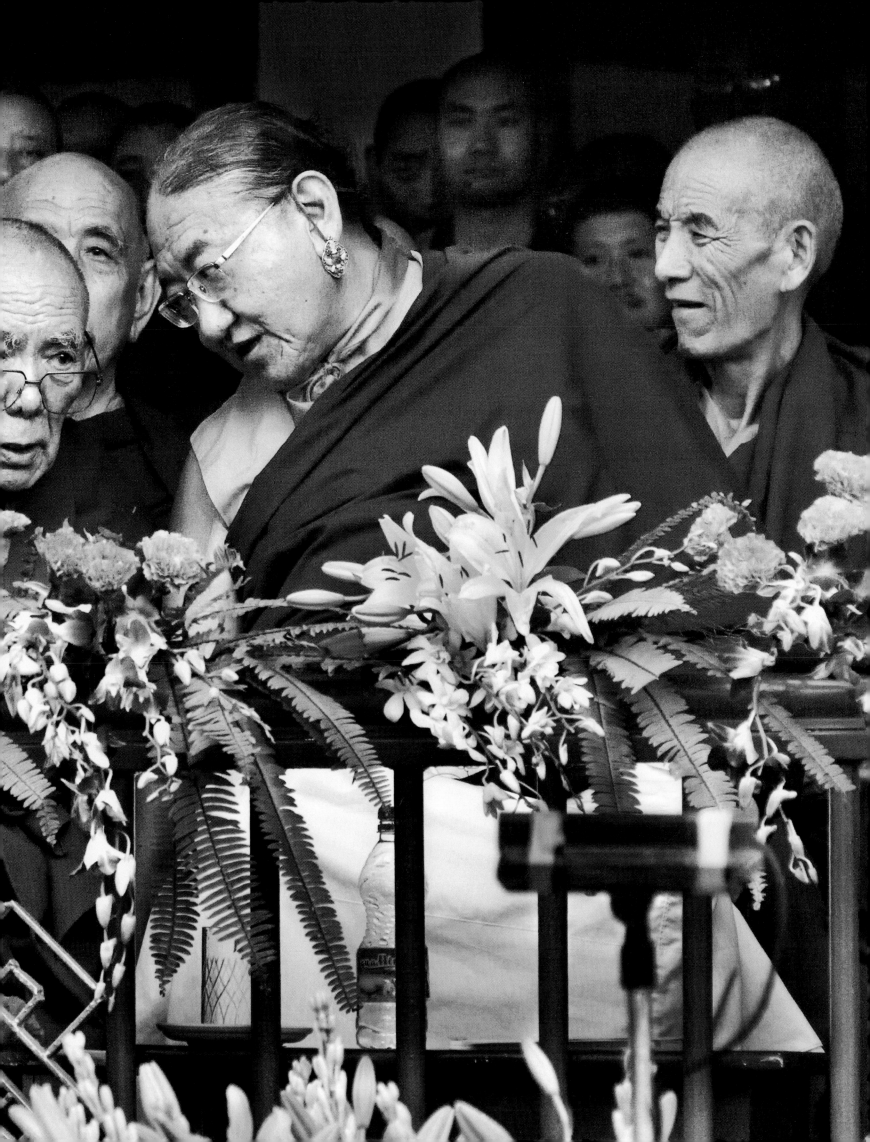

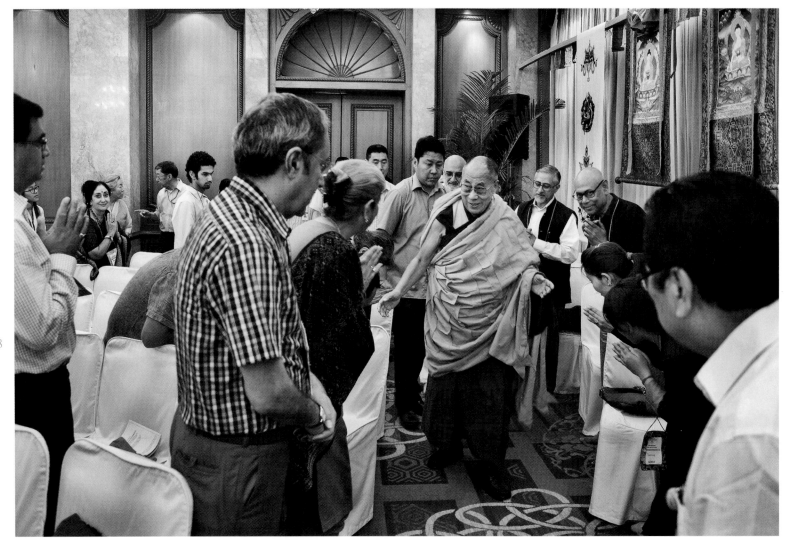

Greeting friends and disciples in New Delhi, 2014,
during teachings from selected Tibetan texts, organized
by the Foundation for Universal Responsibility.

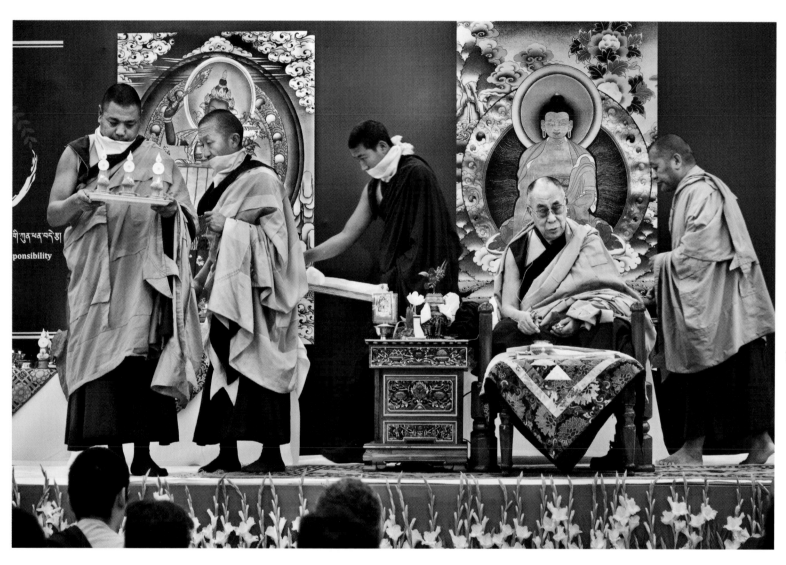

During his teachings in New Delhi, 2014.

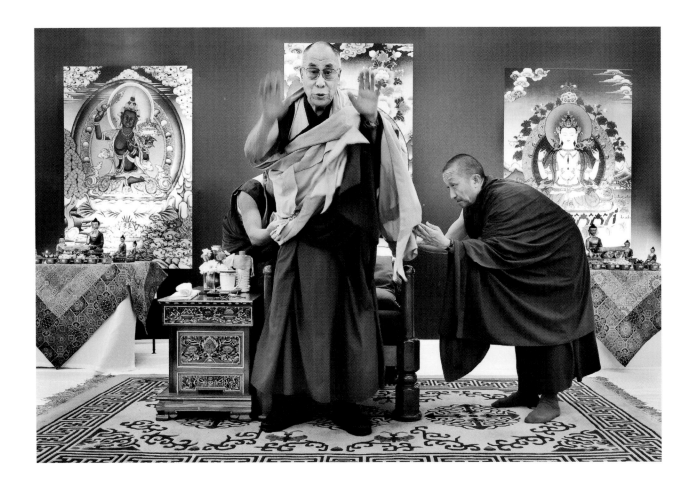

At the request of his Indian friends and students
from the Foundation for Universal Responsibility,
His Holiness gestures everyone to sit down.

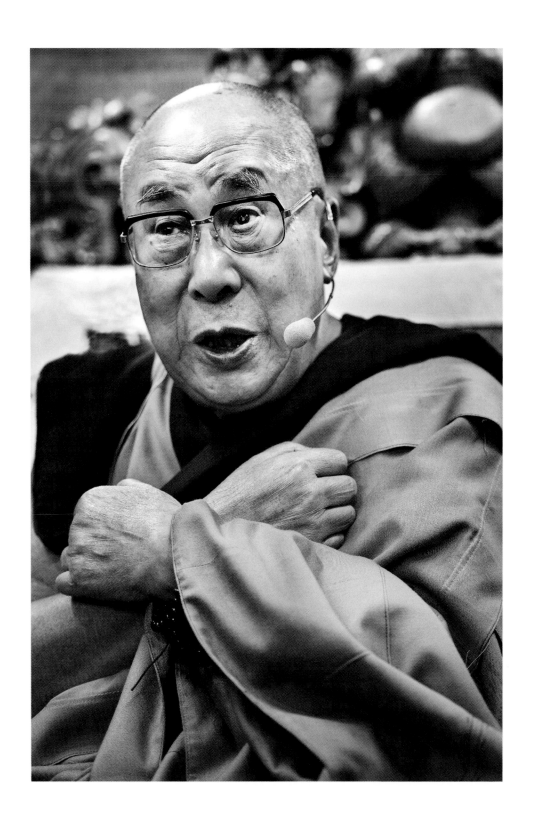

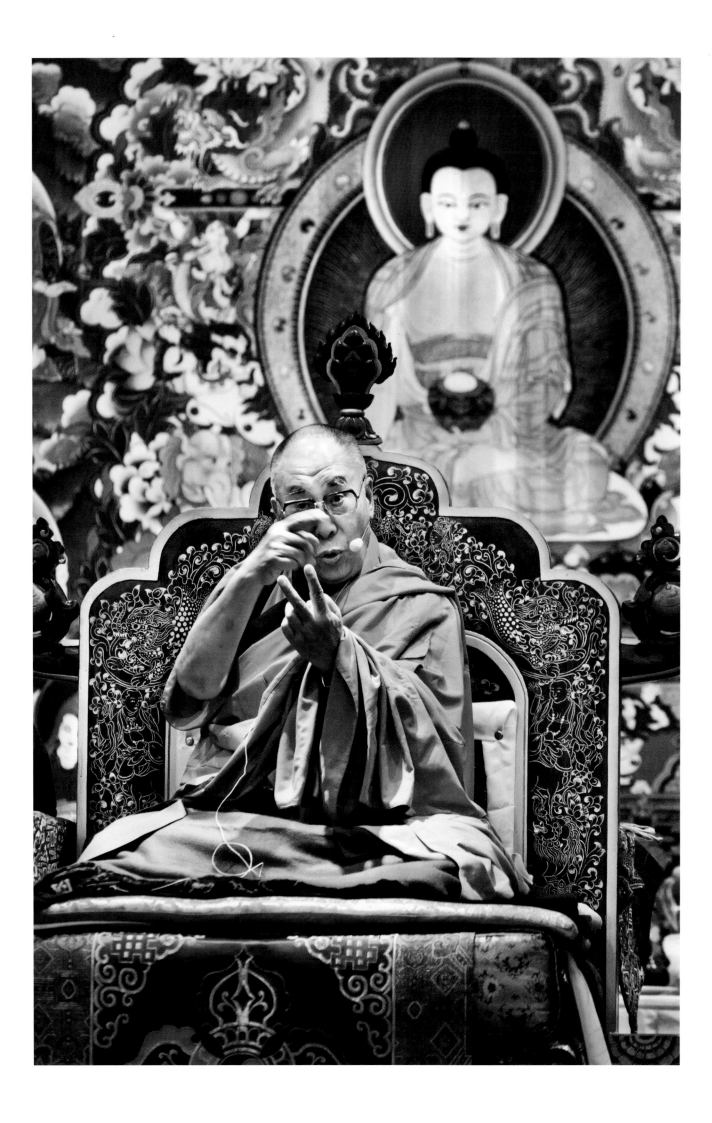

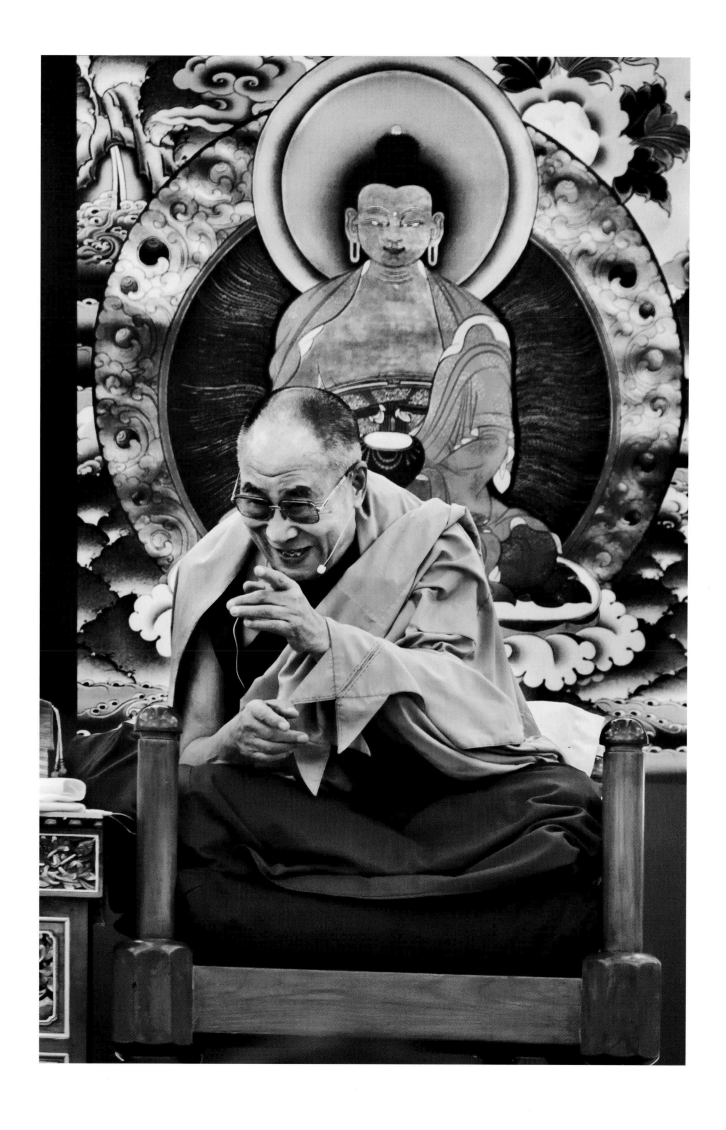

A CLOSE RELATIONSHIP

When His Holiness hugs me and I hug him back and keep kissing his shoulder, I don't pause to think whether I'm polluting his shoulder or whether he's experiencing my love. What I do know is that, as a photographer, my job is to reflect truthfully what I see and what I experience. As a photographer, I receive and reflect, and he reflects back in response.

His Holiness is an uninhibited, wonderfully loving man. How gracious of him to say he is my friend. That he comes down to that level to be with you is amazing—and he's like that with everybody: reaching out, holding your hand, giving you his undivided concentration.

In Hong Kong, a couple of years ago, I met a Chinese photographer, Yang Yan Kang, who spent ten long years in Tibet and published a sensitive black-and-white book of his pictures. He sent me a copy for the Dalai Lama in which he wrote: "Your Holiness, your people and your land are waiting for you." Later, at a get-together in New Delhi, the organizers told me that His Holiness was too busy, but as he walked in and saw me, he gave me a prolonged hug, and everything came to a standstill at that moment.

I was able to deliver the book, and His Holiness said, "Wonderful. Thank you very much." His people in Tibet, and also the Chinese, matter to the Dalai Lama a lot.

For Tibetans in India, in occupied Tibet, and around the world, *Yeshe Norbu* (the "Precious Jewel the Dalai Lama") is the center of their everyday lives. Although well into his eighties and retired from being their political leader, he travels much. His traveling schedule, to keep the awareness and cause of Tibet alive and to fulfill the need of those institutions abroad who revere him, would be exhausting even for a younger man. But, as he keeps reminding his people, never give up.

The fact is that Buddhism was born and flourished here in India, and it almost died here because of Brahminism. His Holiness has brought it back to us in a living form that is highly relevant today.

"My religion is the Nalanda tradition," he reminds his audiences at teachings, referring to the great Nalanda Buddhist university, "so India is my guru and I am its *chela*—a student."

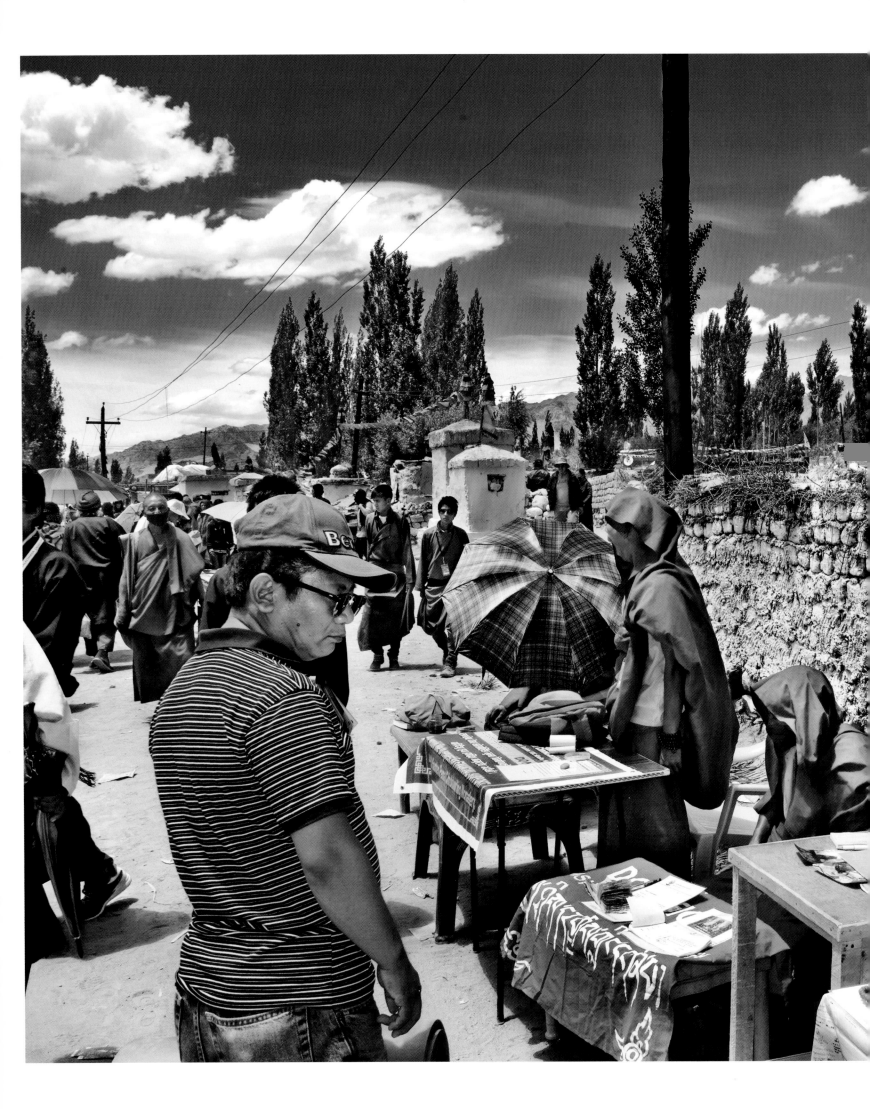

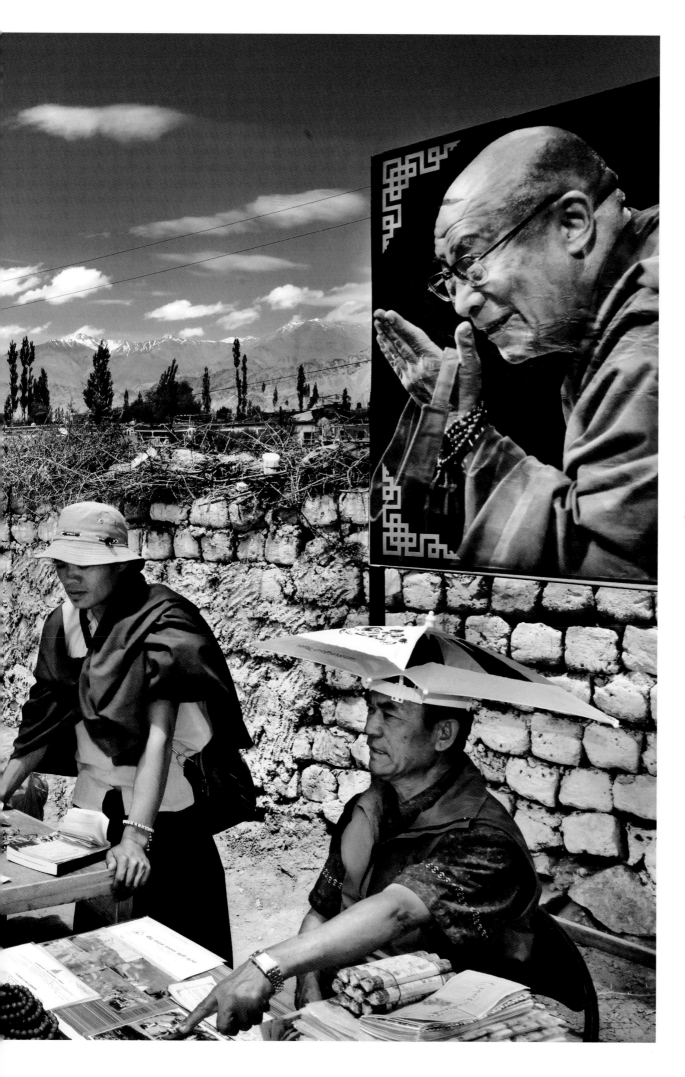

Kalachakra initiations given by His Holiness the Dalai Lama draw audiences by the thousands from all over the world, including China. As the apogee of yoga tantra, first taught by the Sakyamuni Buddha to a king of Shambhala, this extensive ritual is believed to connect to a future golden age of Buddha dharma affecting all universal beings.

Following pages (148–149): Addressing an international congregation at the 2014 Kalachakra in Ladakh.

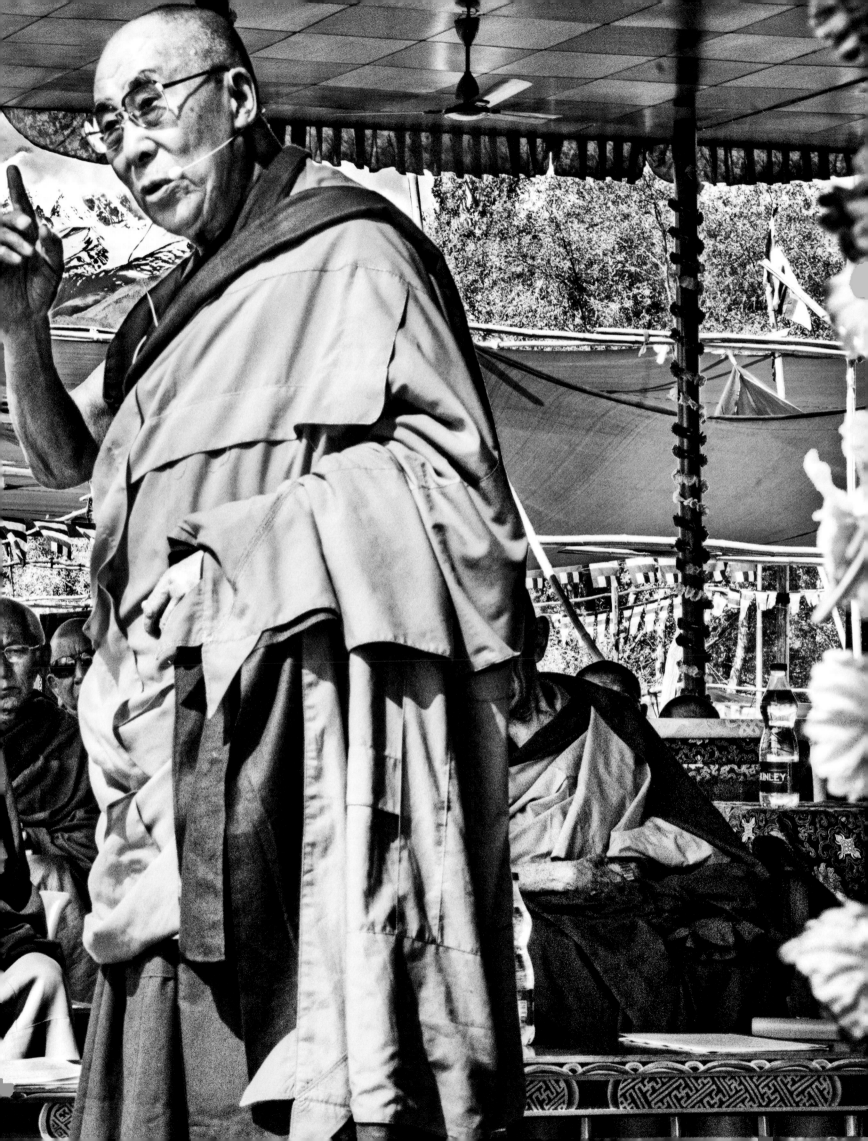

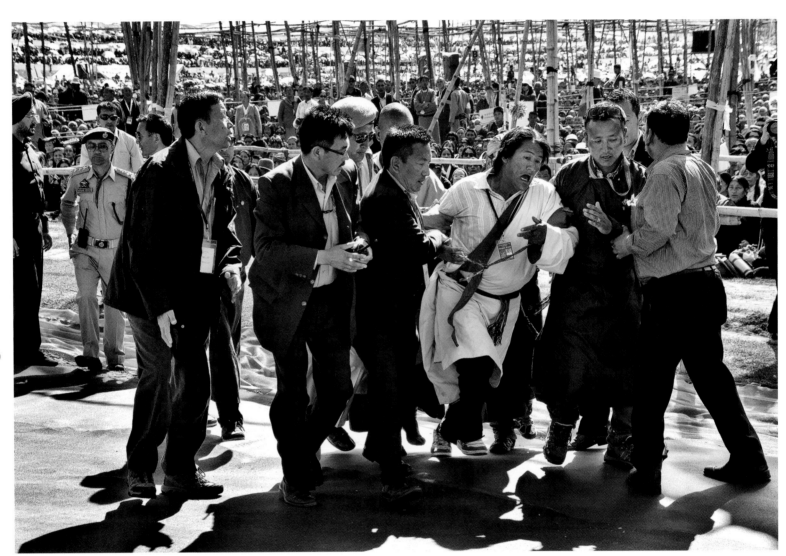

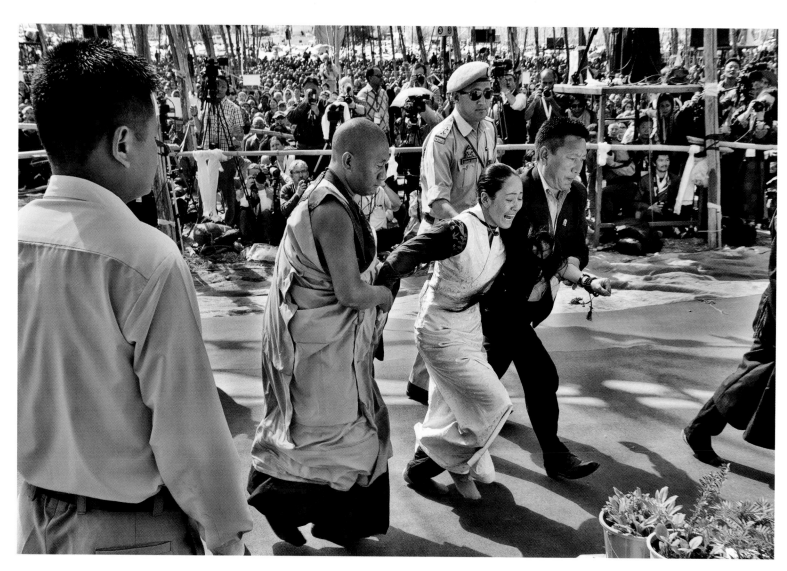

Possessed by superhuman energy, a Tibetan layperson
and a Muslim girl from Kargil rushed to be blessed by
the Dalai Lama and communicate with him, before
falling into a faint.

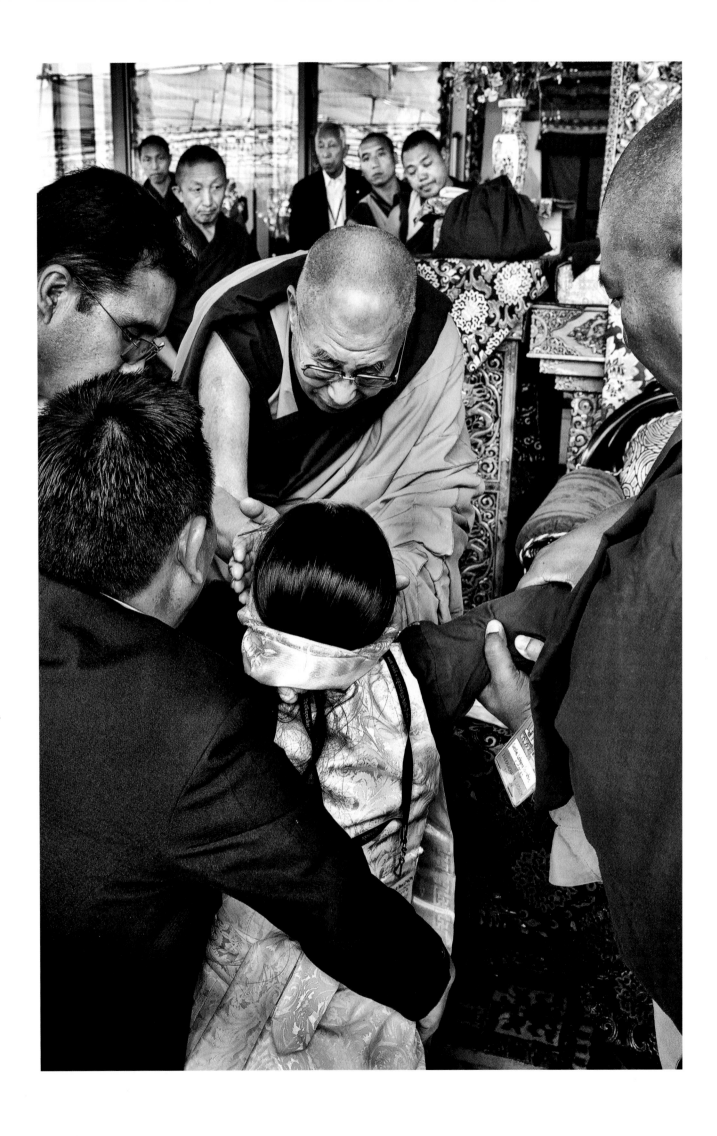

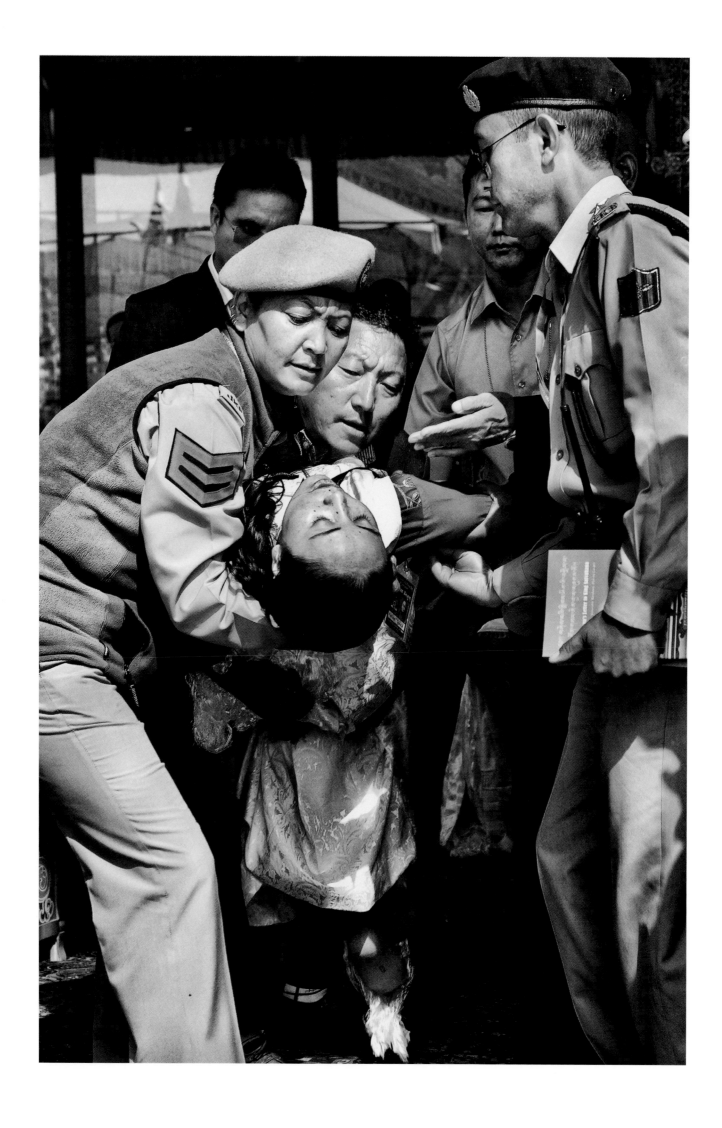

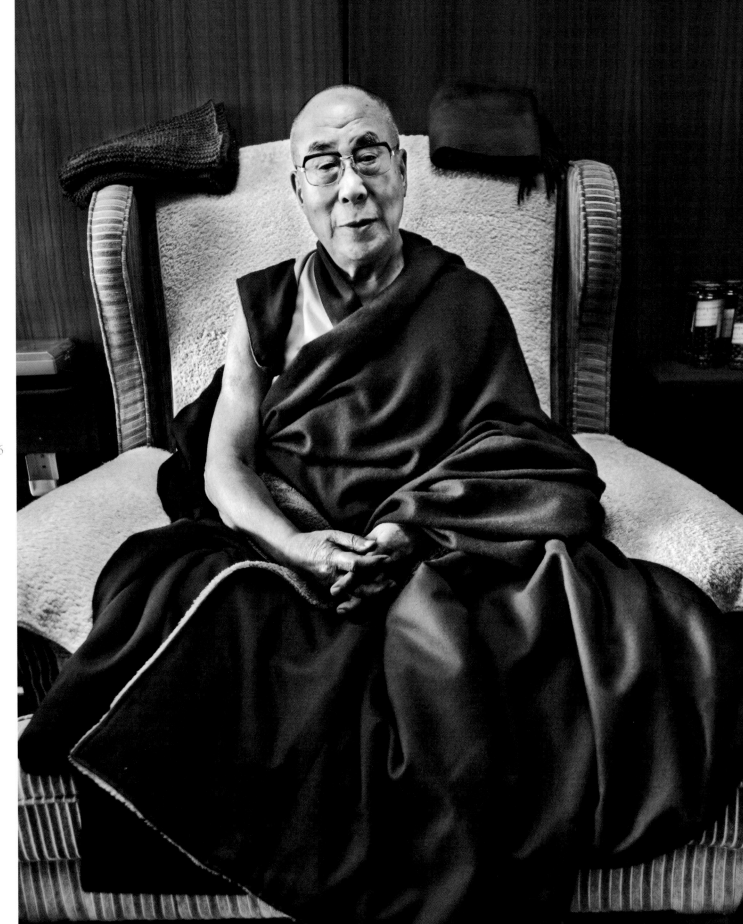

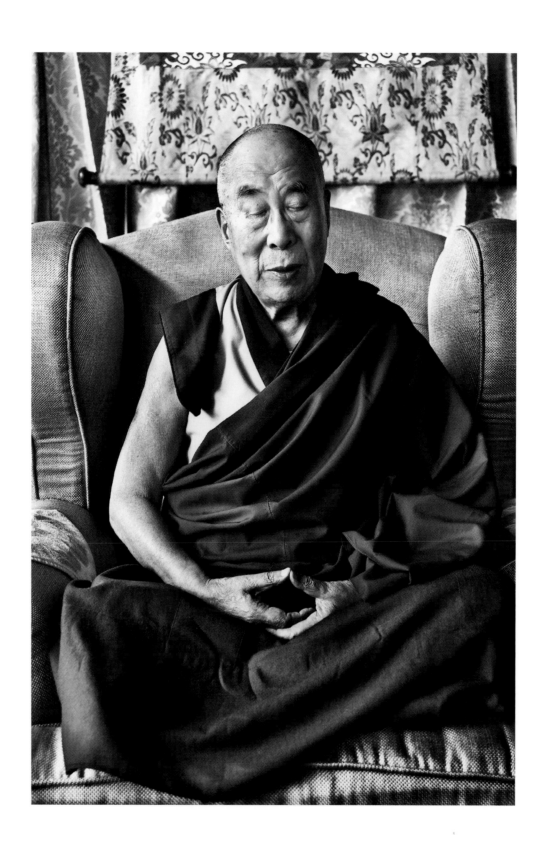

157

In repose, and slipping naturally into moments of meditation.

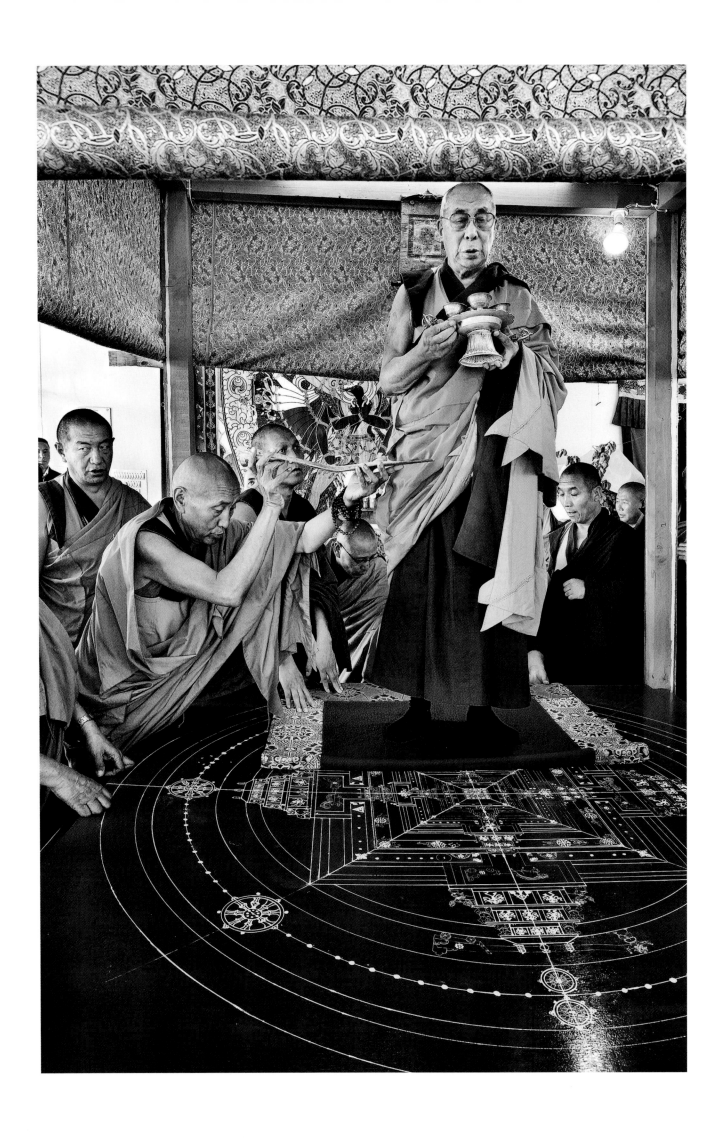

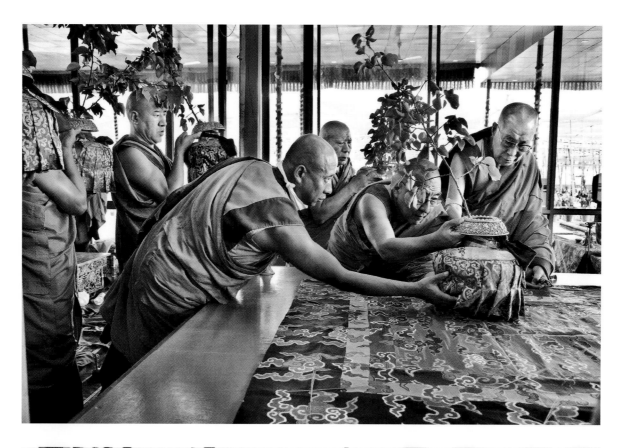

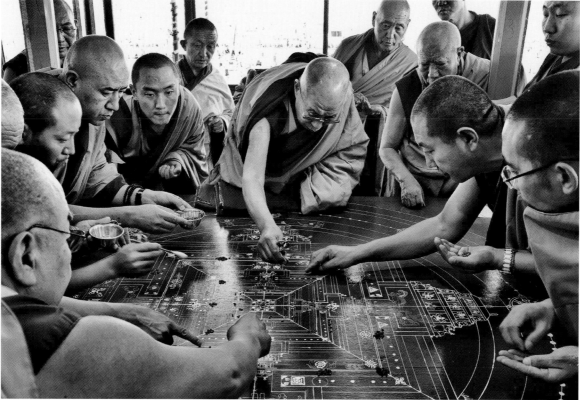

Facing page: Preliminary rituals preparing the Kalachakra mandala.

This page, bottom: Adding the first grains of colored sand to the Kalachakra mandala. Multiple deities are depicted, symbolizing an astrological complexity of stars, planets, and constellations to be visualized by the congregation as the initiation progresses over several days.

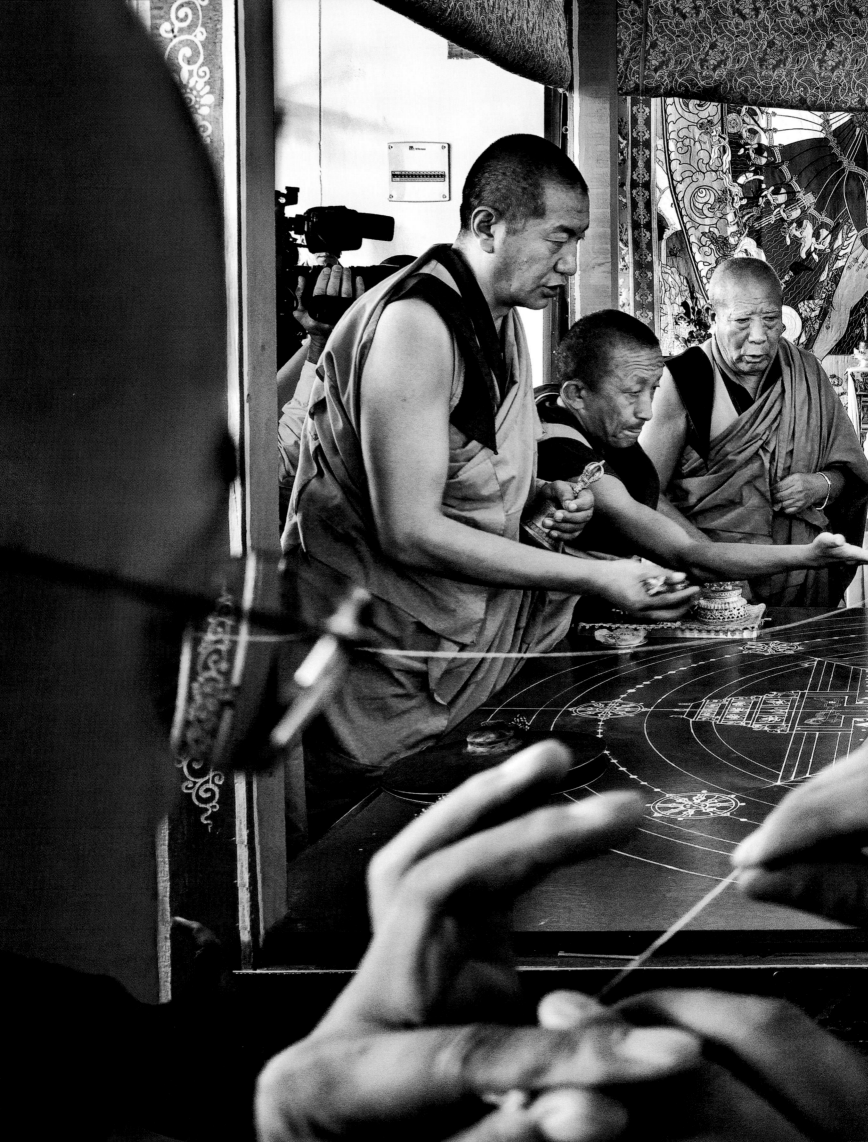

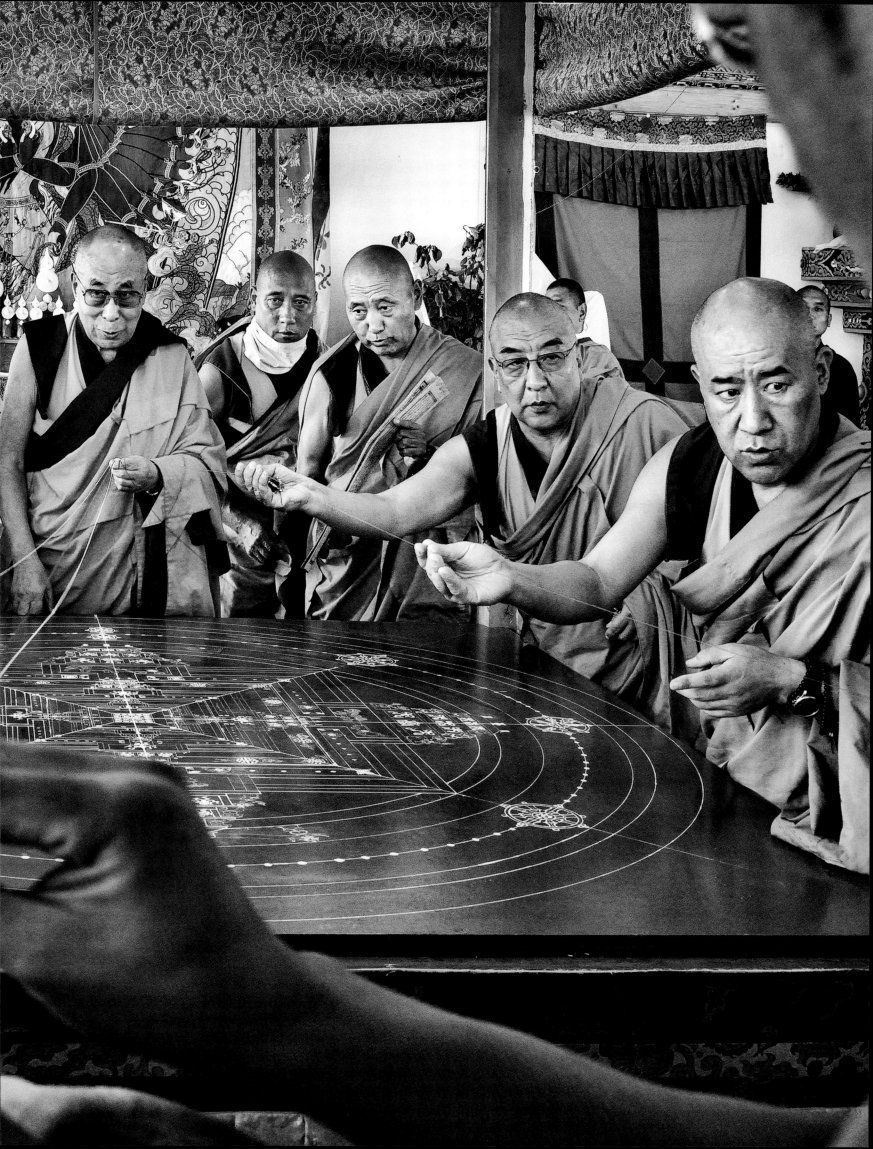

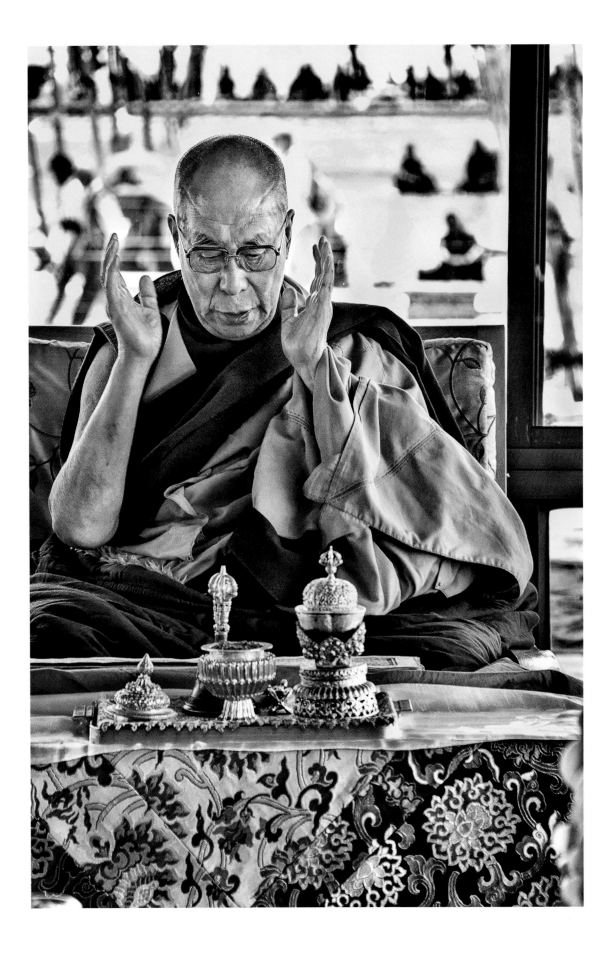

Guiding the participants to enter and connect with the mandala.

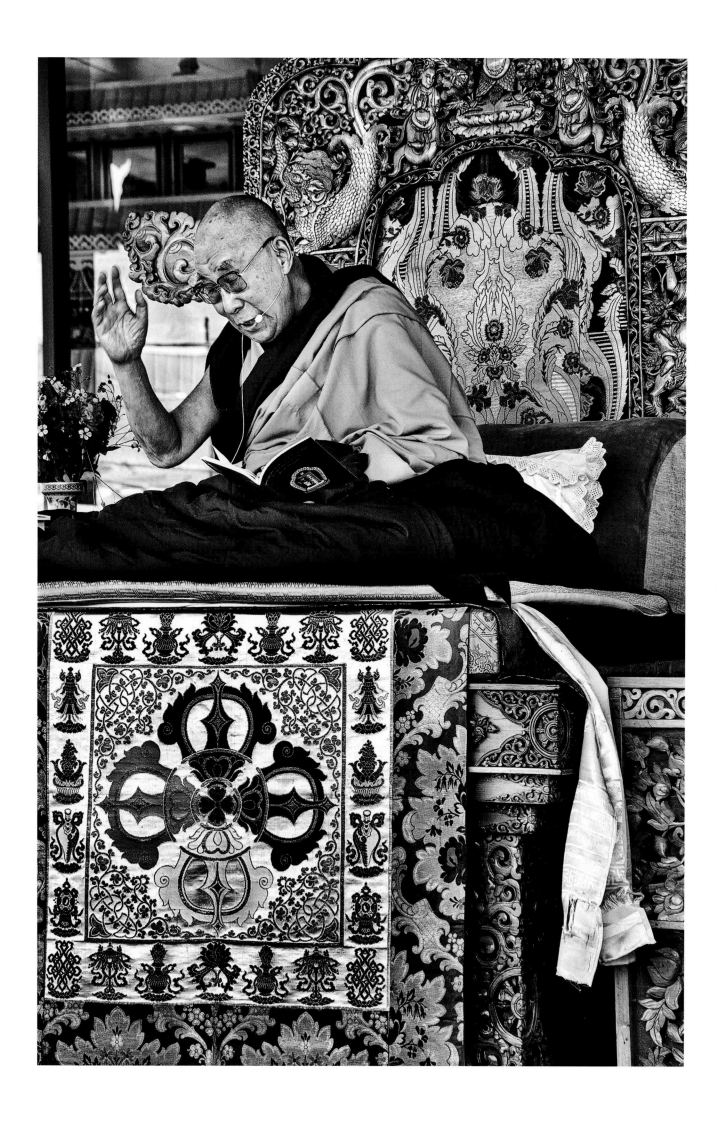

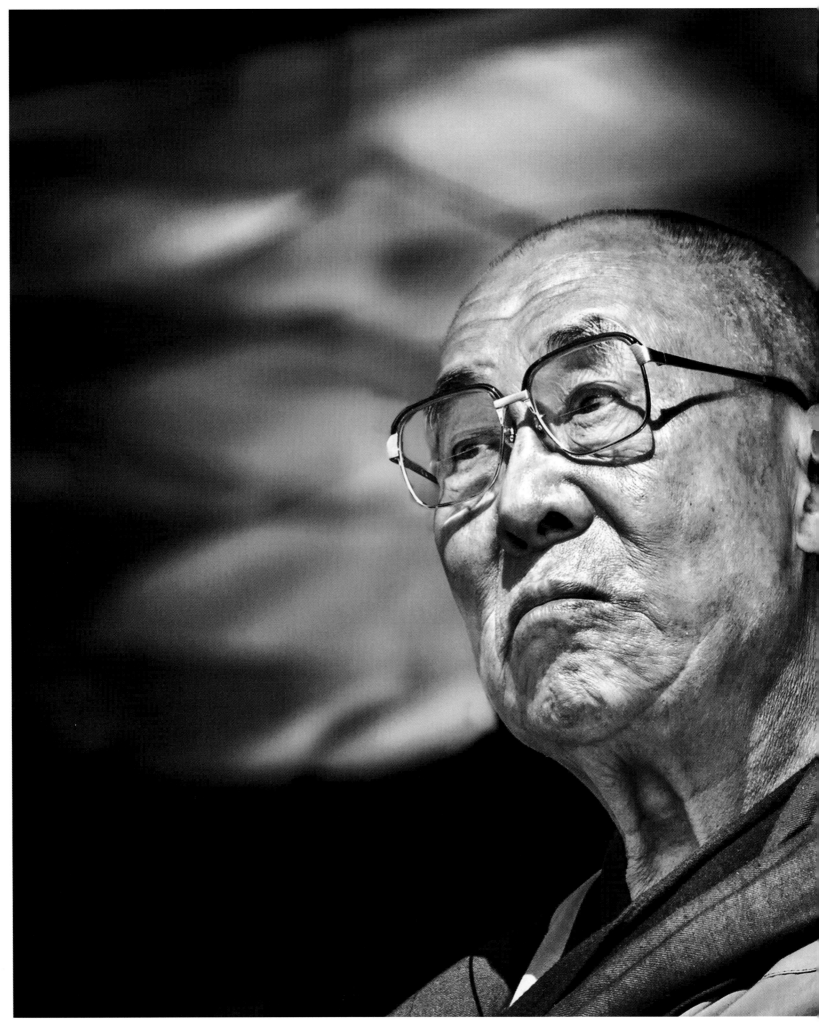

A MAGNIFICENT SOUL

When I first met His Holiness, he was in his prime, clearly very noble and a good soul. Then he knew little English, but over the four decades of interactions, I've seen his command of the language become expressive, communicating his humor and messages swiftly and in simple words. At the same time, his spiritual powers and presence have grown to be overwhelming. And yet he is so humble that he bows to receive the blessings of a Jewish youth of twenty-five.

When supreme energy arises in human form, it is there for everyone to connect with. The purest ones radiate it, and they have the power to heal and transform the lives of people who meet them—whether through physical contact or distant cyberspace. These greats, whether Allah, Jesus Christ, Ram, or Guru Nanak, came to our planet in human form—but as saintly, spiritual souls connected to the supreme energy. They didn't come as gods, or their human forms wouldn't have perished.

I've always been attracted to such beings, filled with spiritual richness. While photographing and interacting with Mother Teresa, Guruji, Sadhguru, and His Holiness, I've seen the power of the divine clearly in their eyes. When souls such as these touch you, whatever feeling there is at that moment becomes manifest. So, as the Dalai Lama hugged me and put his head on my shoulder, his spiritual energy enriched me instantly.

I've never met God, but I'm sure Christ, the Buddha, Guru Nanak, and other great ones must have been just like His Holiness the Fourteenth Dalai Lama.

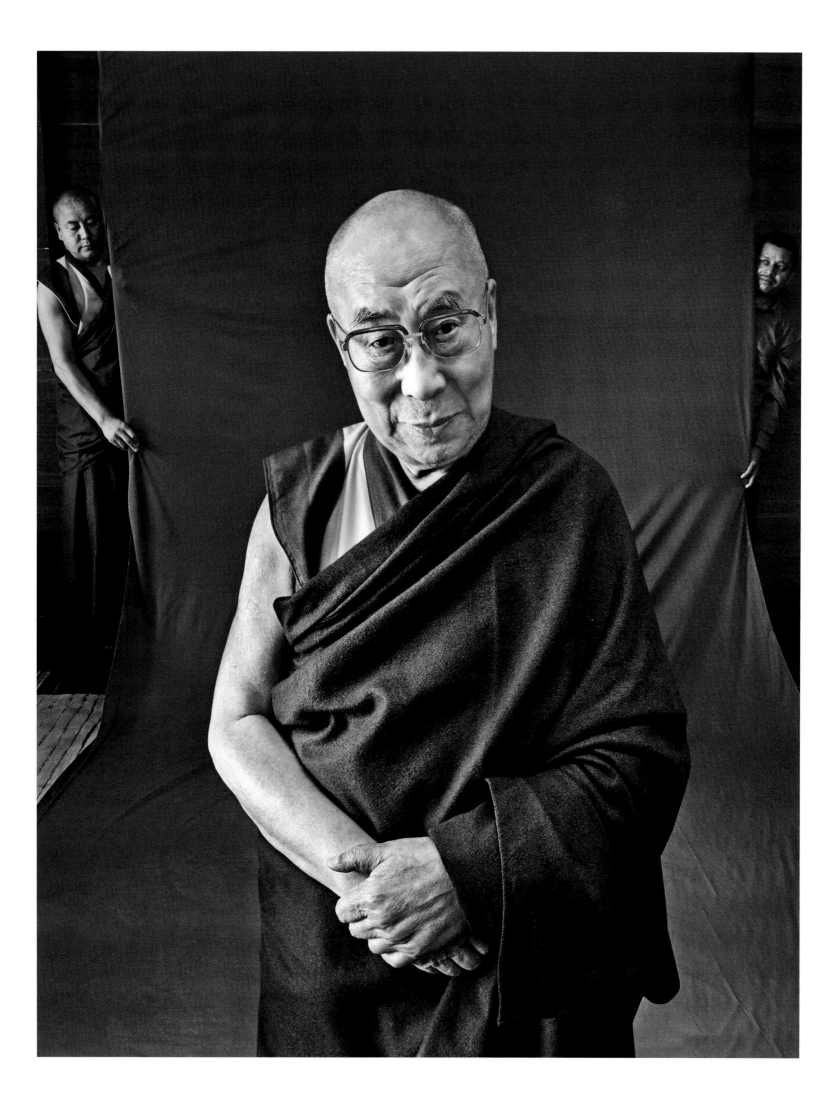

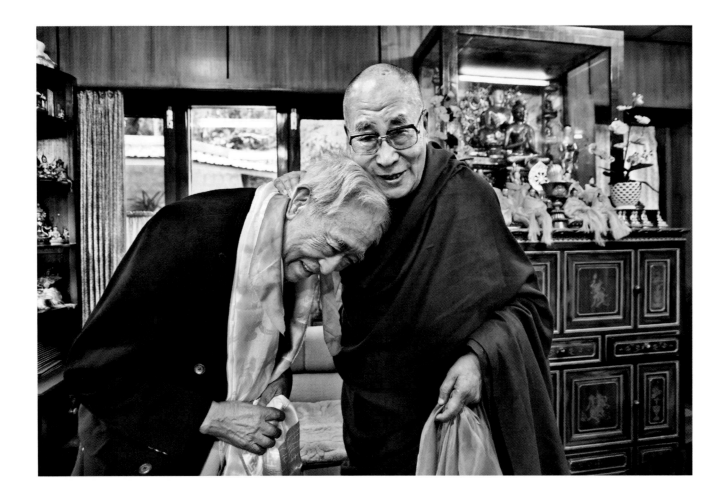

While Tibetans celebrated His Holiness's eightieth birthday worldwide on July 6, 2015, at home in Dharamsala he hosts his siblings and their children and grandchildren for lunch. Jovially introducing his older surviving brother, Gyalo Thondup, to guests as "troublemaker, sometimes," he had a quiet hug for his niece, Khandro Tsering (facing page).

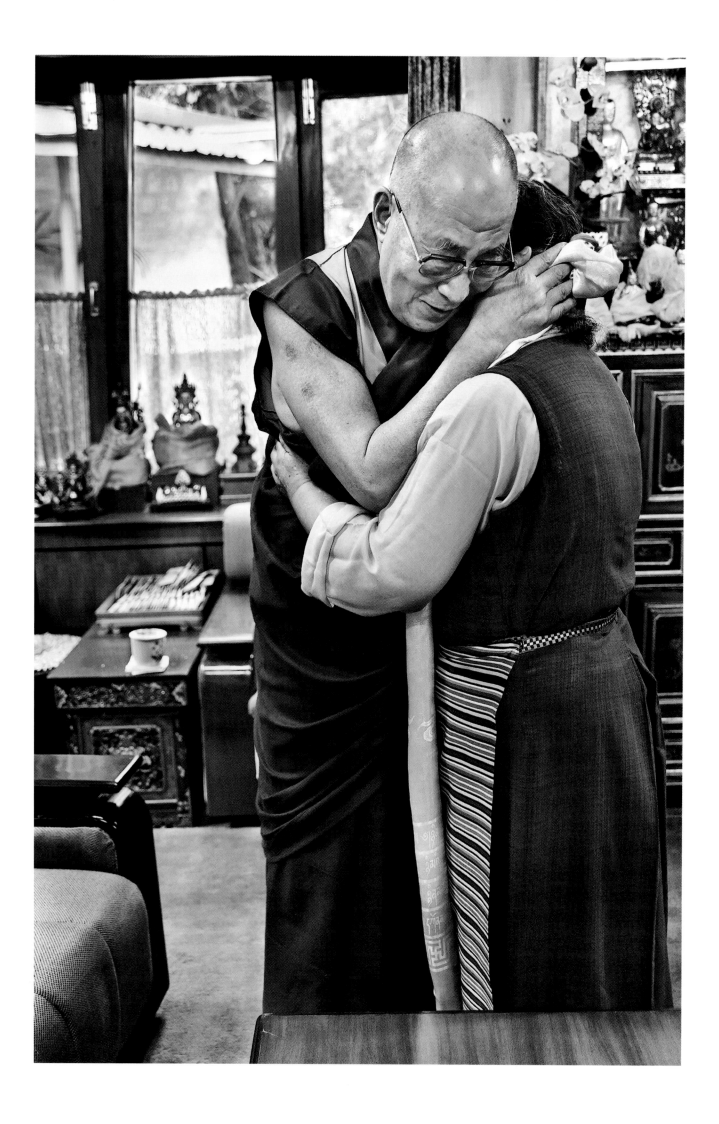

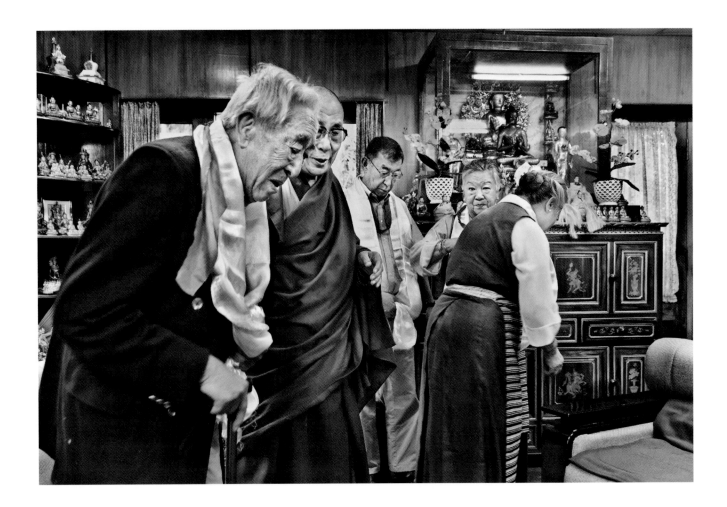

Also present on the occasion is His Holiness's younger
brother, Tendzin Choegyal (third from left).

Facing page: His Holiness's younger sister,
Jetsun Pema, stands at the far left.

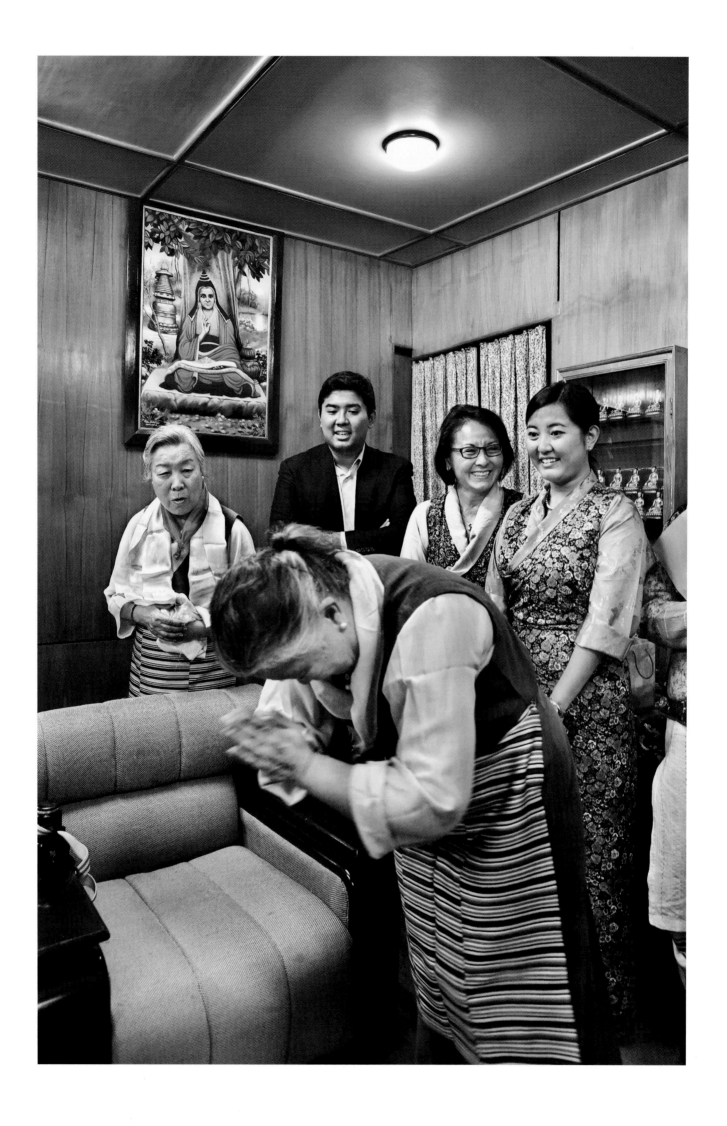

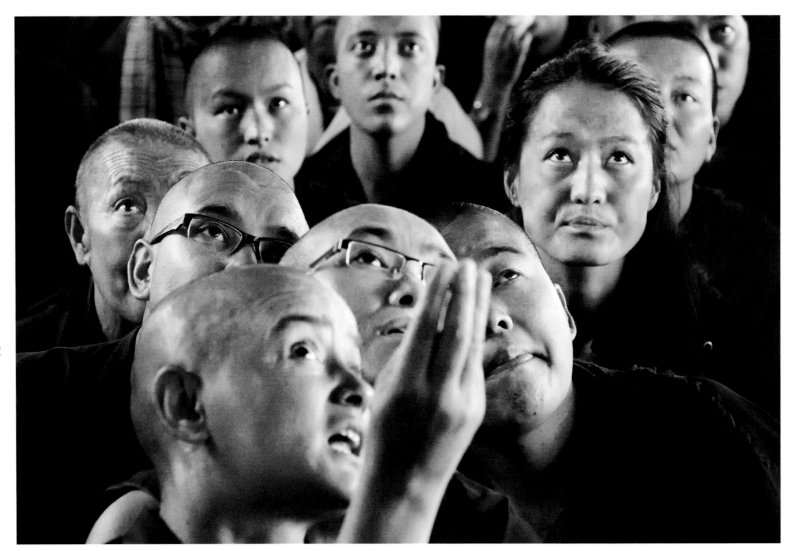

Gazing up at a screen to watch ceremonials during His Holiness's eightieth birthday celebrations at the central temple.

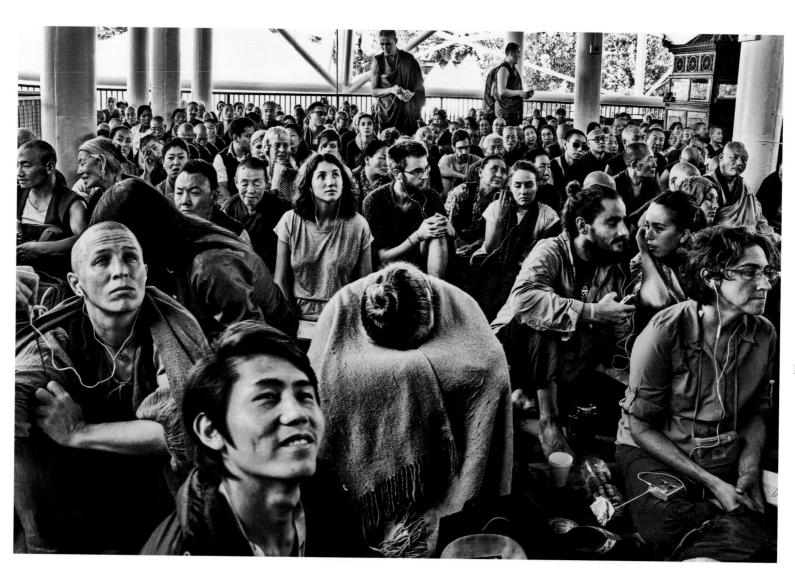

Long-life prayers and offerings of statues and religious
ornaments accompany His Holiness's
eightieth birthday celebrations.

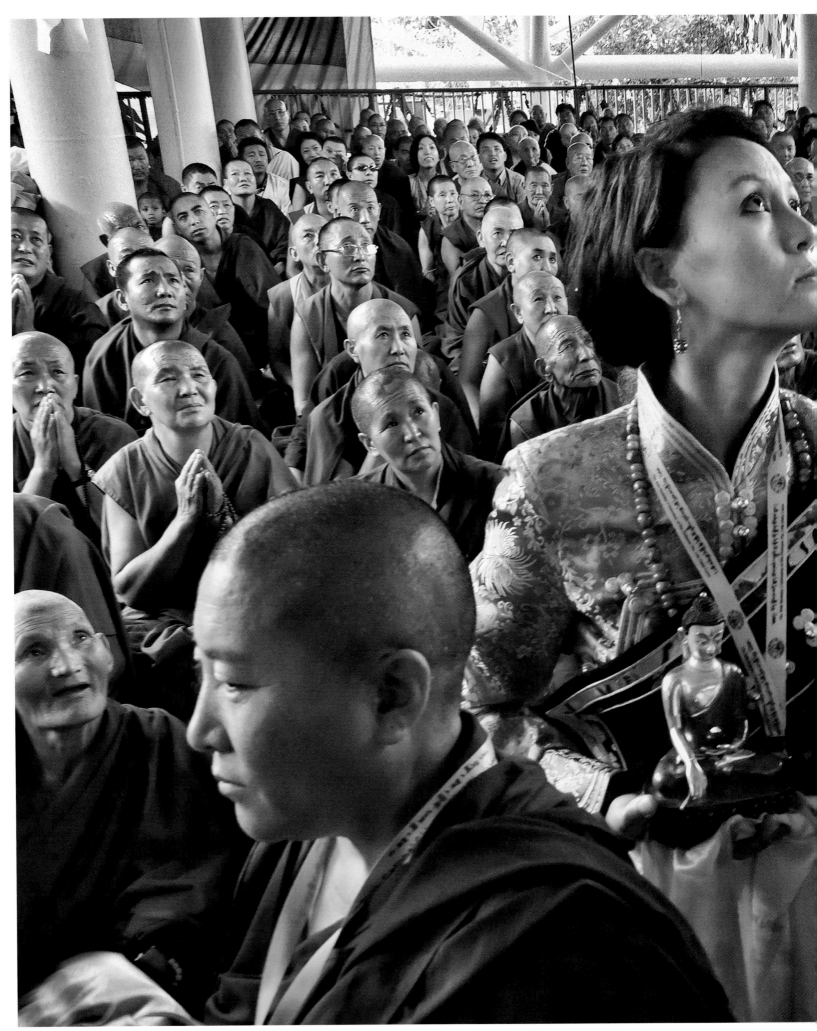

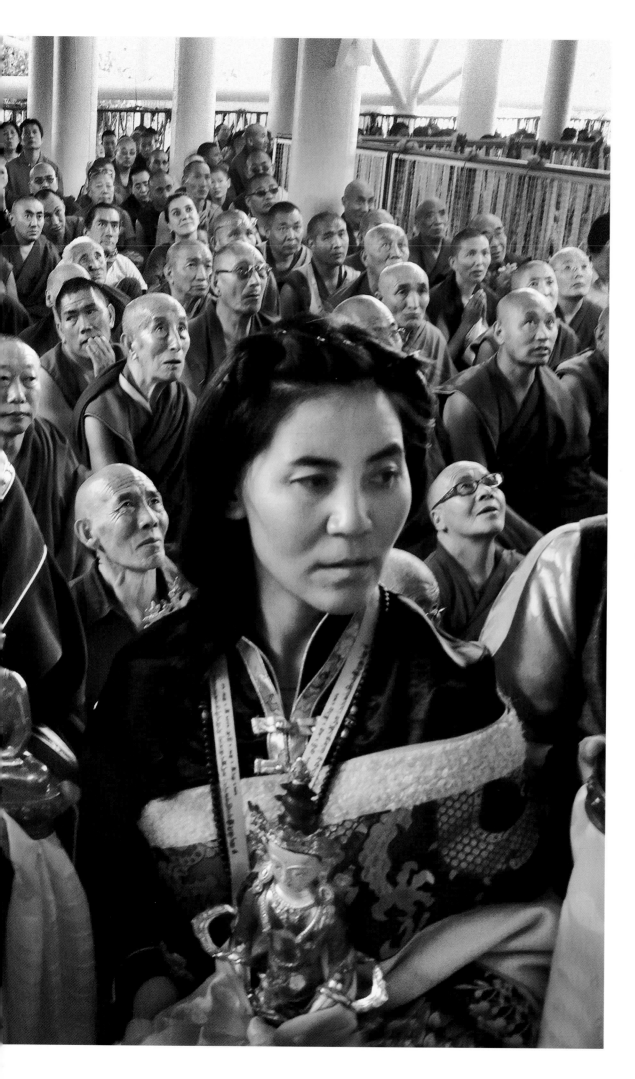

Holding statues to be offered during a long-life ritual at ceremonials for the Dalai Lama's eightieth birthday.

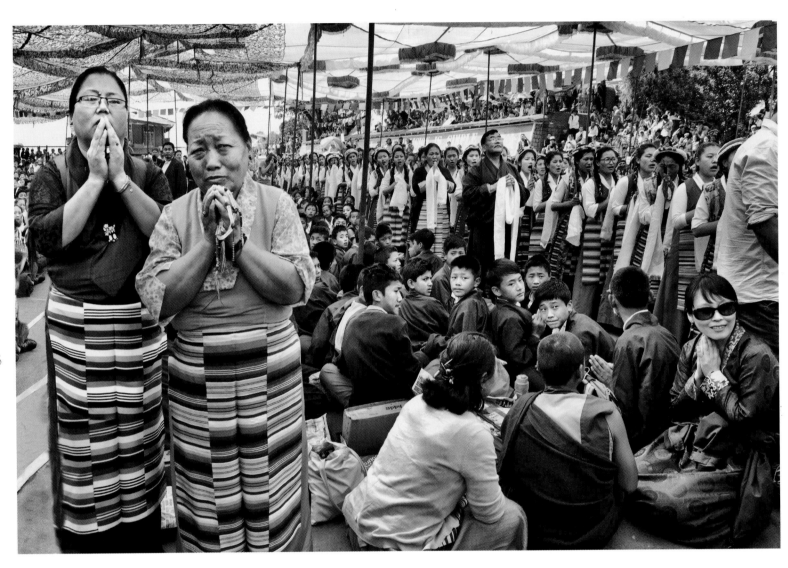

Students from Tibetan Children's Village school during a long-life prayer ceremony.

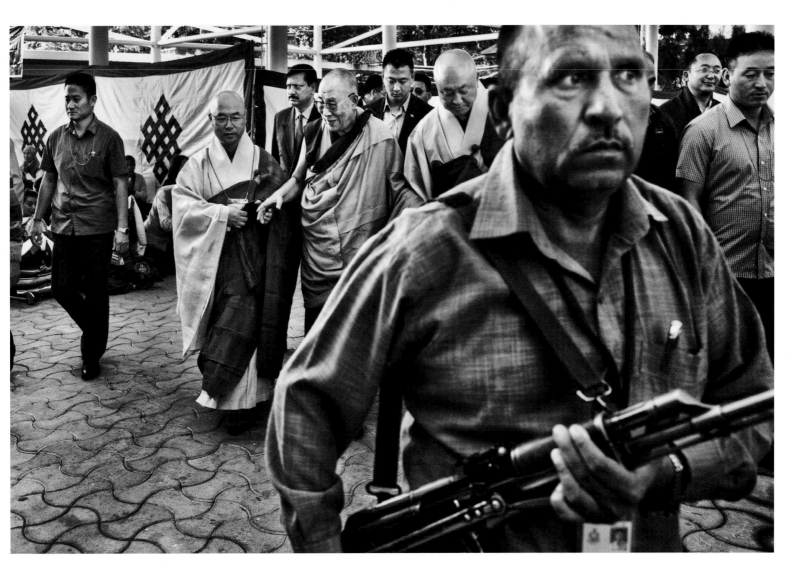

Interacting with monks from Korea during the annual Asian Teachings.

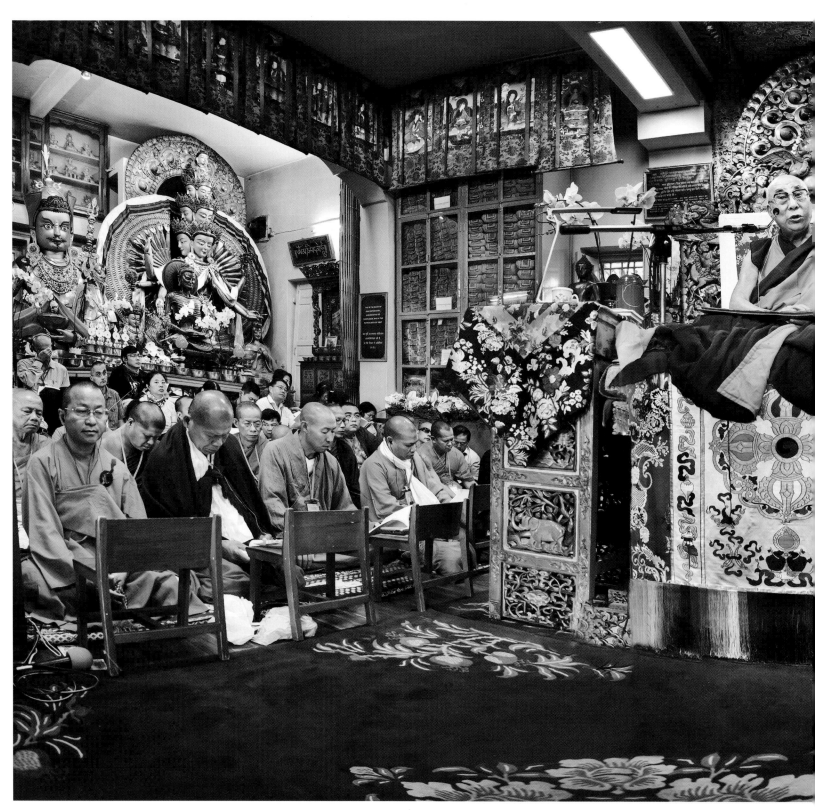

The annual program of teachings for Asian Buddhists,
conveyed through simultaneous translation in the main
place of worship.

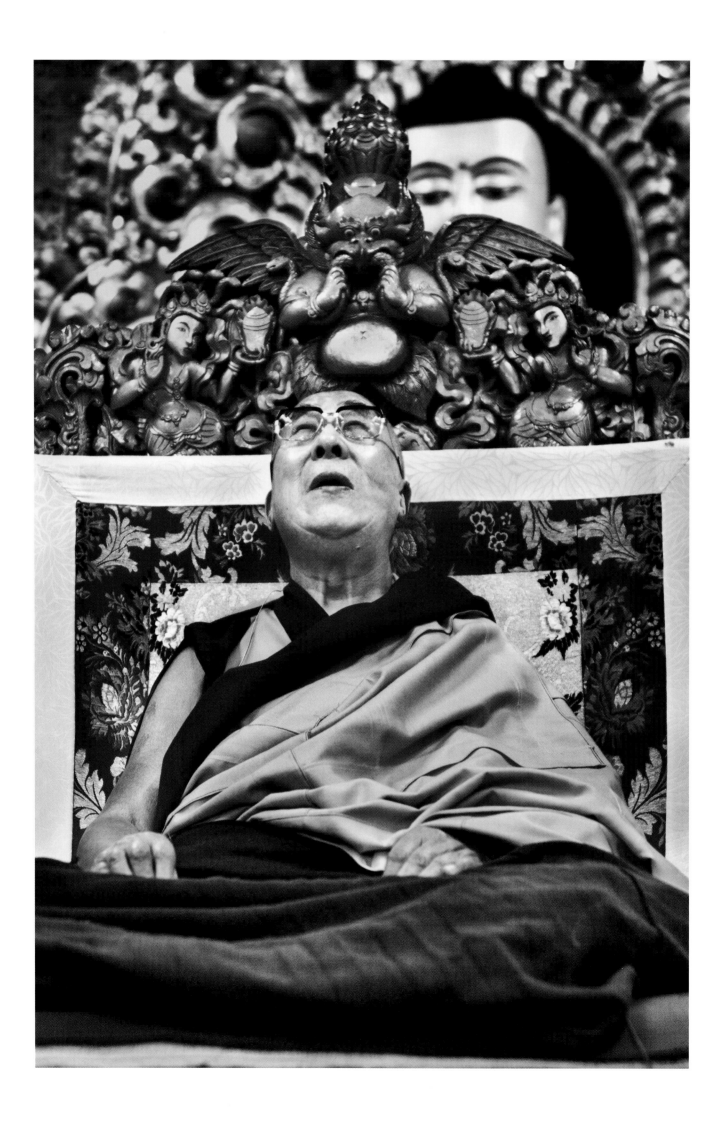

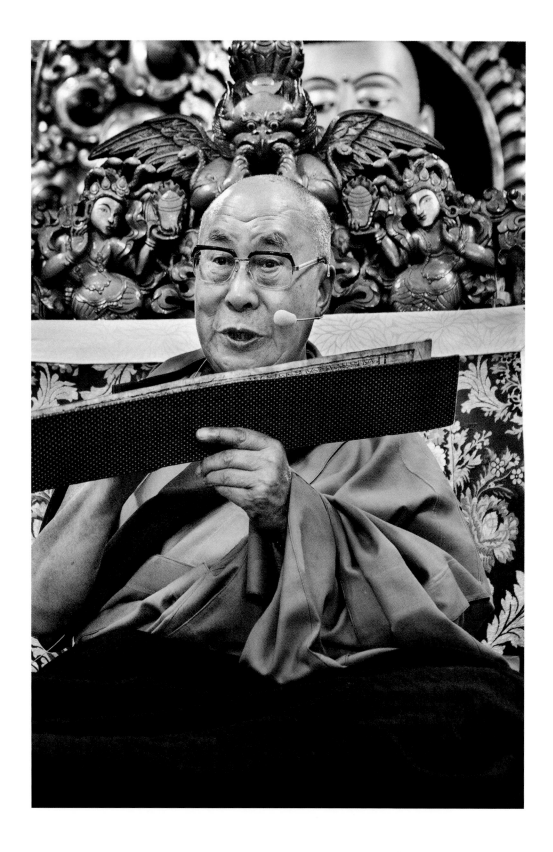

Transmitting a teaching to Asian practitioners from a
traditional woodblock text.

The official female oracle, Tsering Chen-nga, manifests in trance in the main temple.

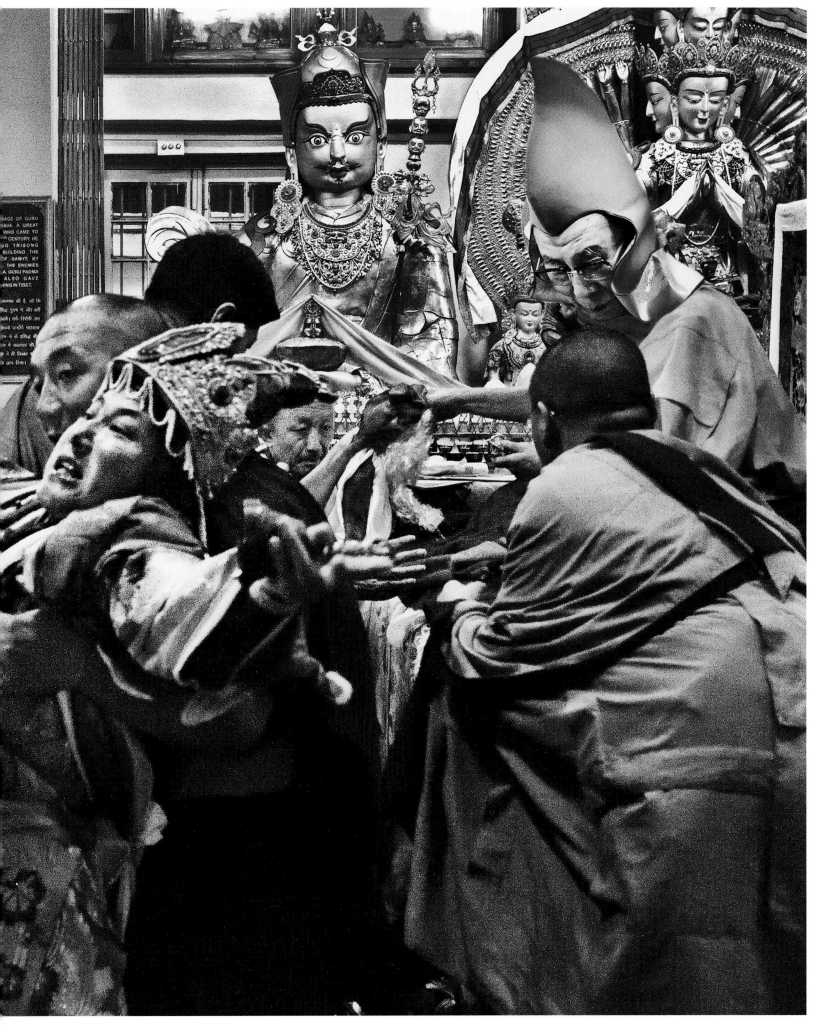

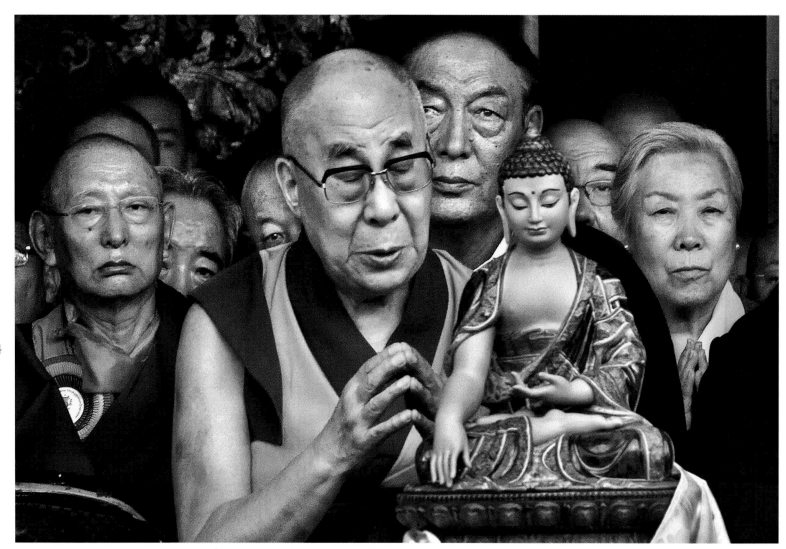

In prayer with cabinet ministers and his sister.

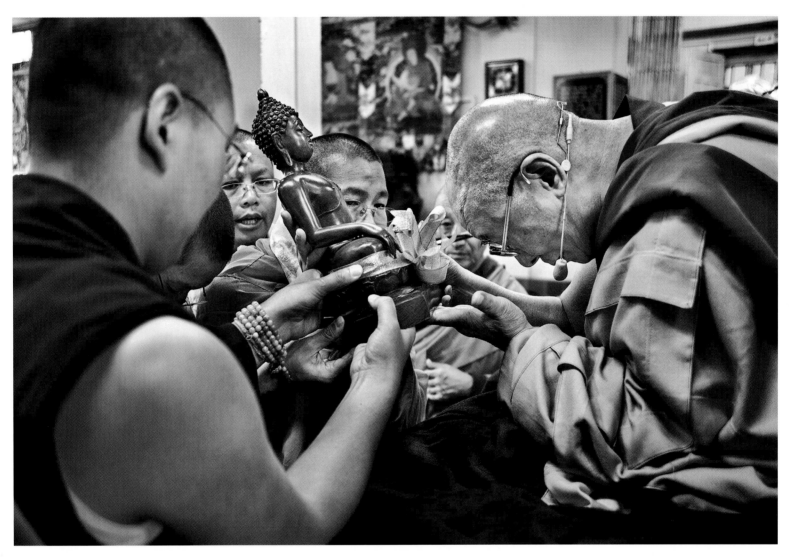

Blessing statues gifted during the eightieth-birthday long-life puja celebrations.

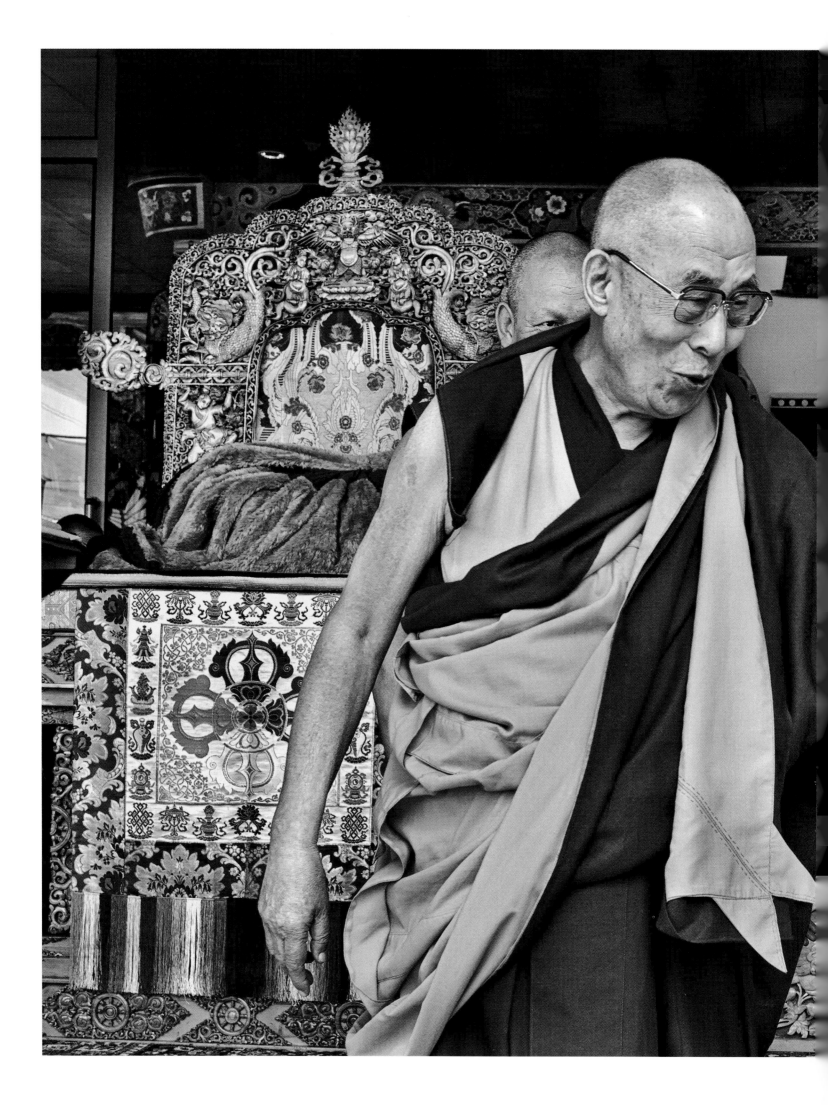

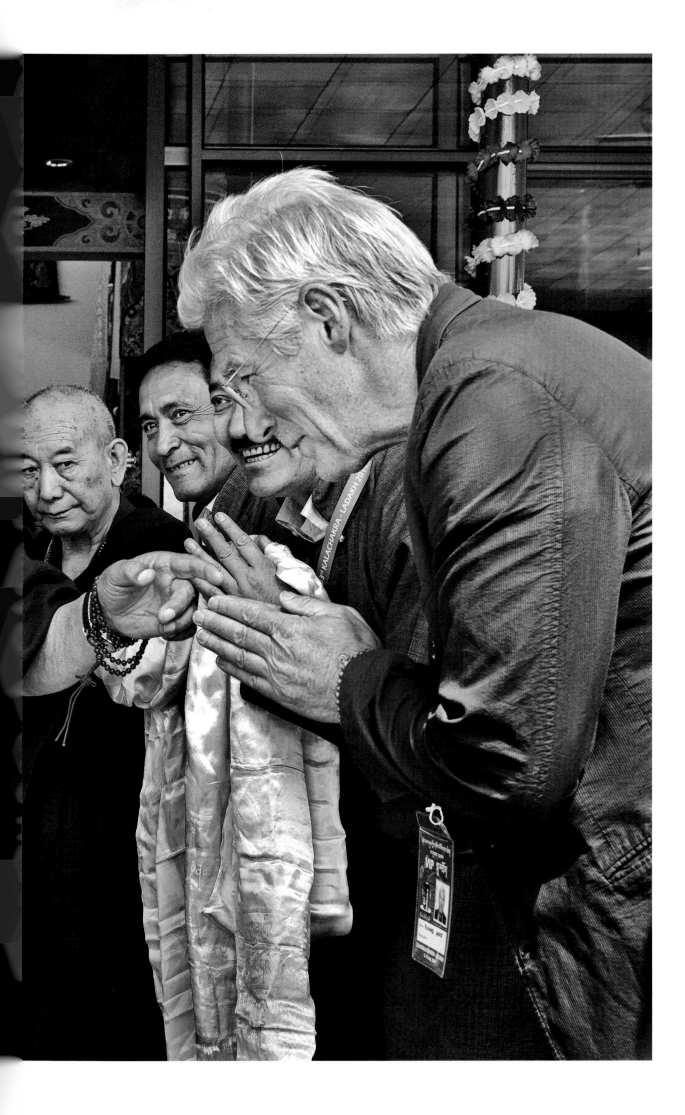

With his student and
longtime Tibet supporter
Richard Gere.

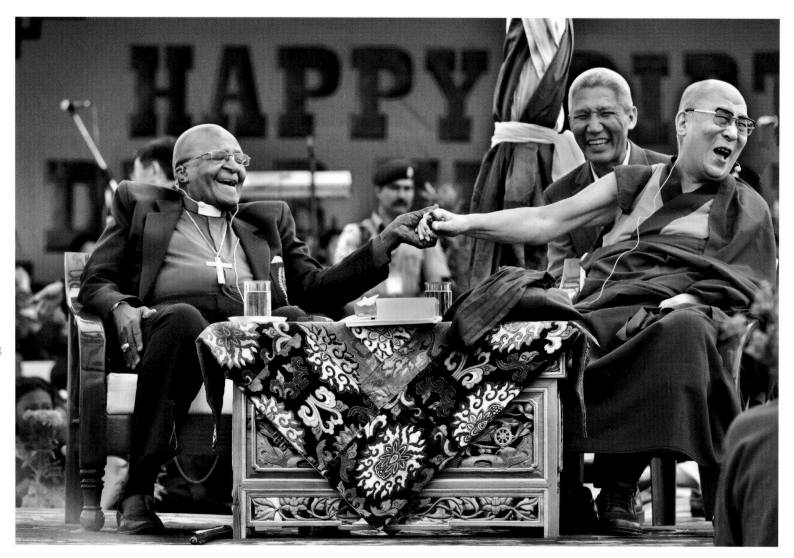

The links of affection and respect between old friends:
Archbishop Desmond Tutu greets His Holiness
as "Mischievous Dalai Lama," and the retort is
"Mischievous bishop." The Nobel Peace Prize laureates
share compatible moral values and similar
openhearted humor.

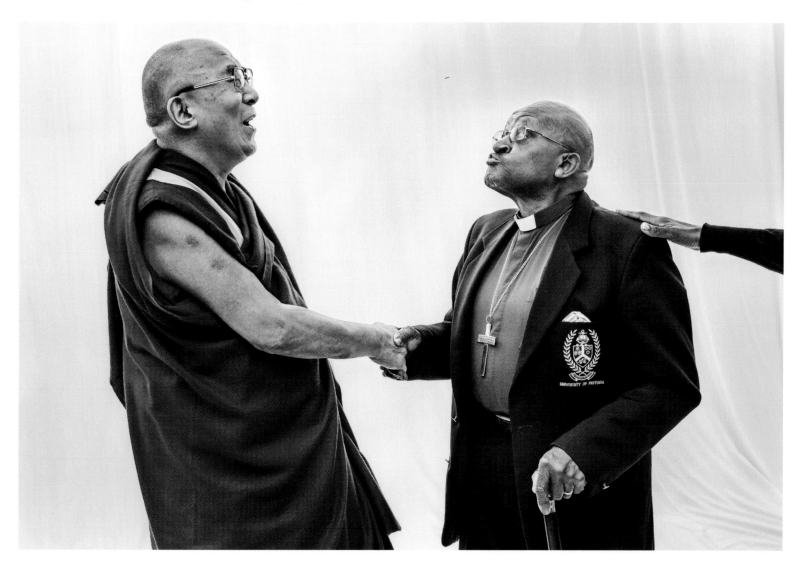

Unable to attend Archbishop Desmond Tutu's eightieth
birthday party in South Africa in 2011 when his visa
was refused, His Holiness is delighted to share his own
eightieth birthday celebrations with his good-humored
companion in 2015.

Following page: Students of Tibetan Children's Village
school join His Holiness to blow out his birthday candles.

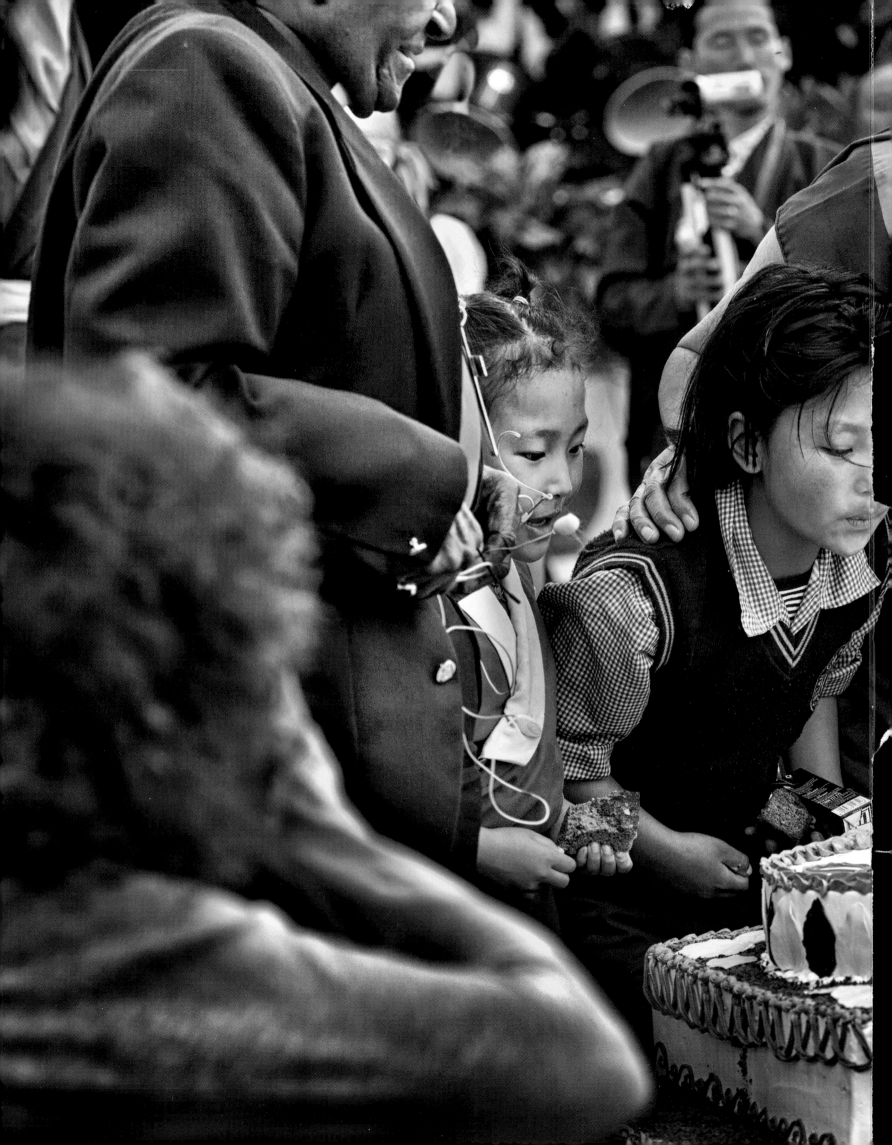

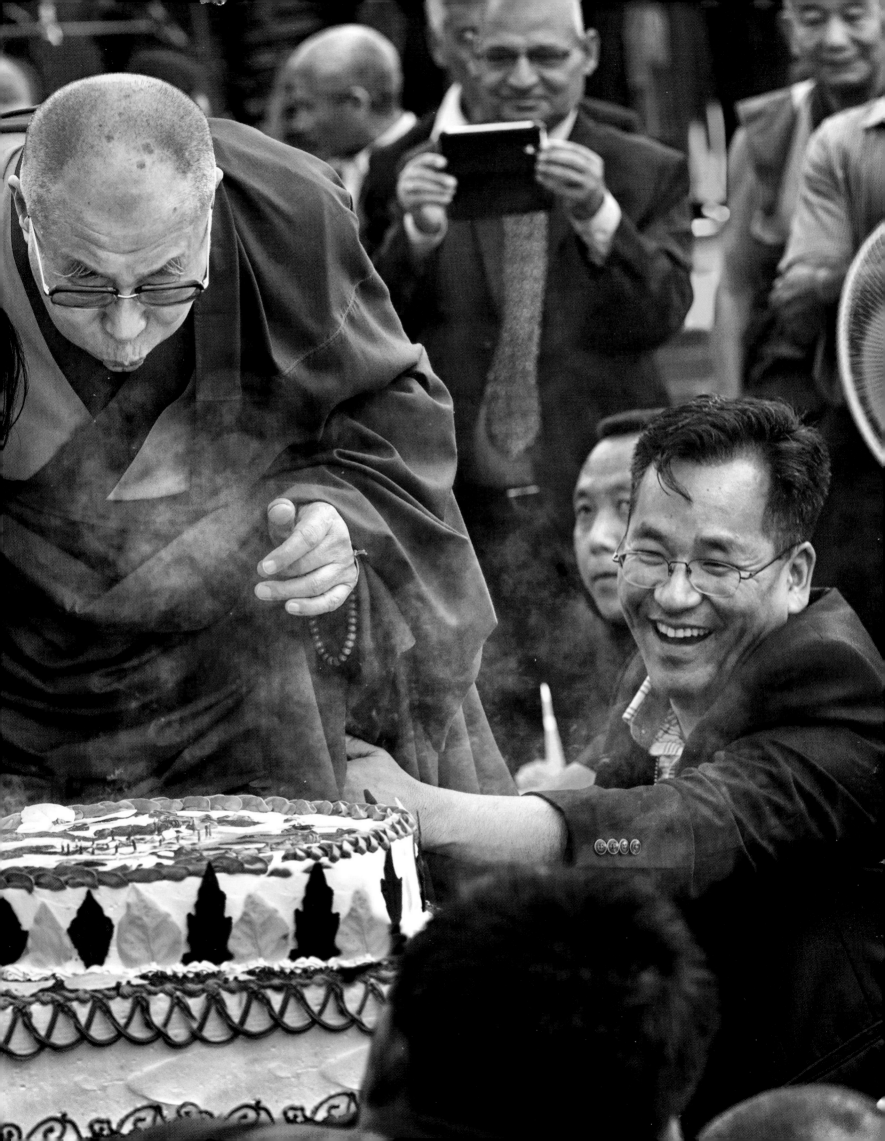

Top: Getting a hug from His Holiness.

Bottom: Posing for a photograph with my daughter, Avani.

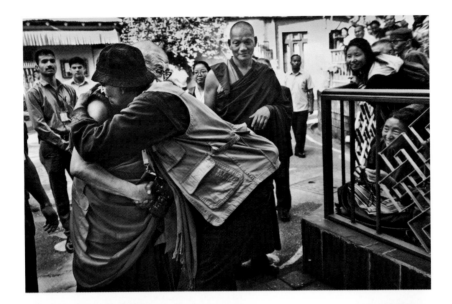

192

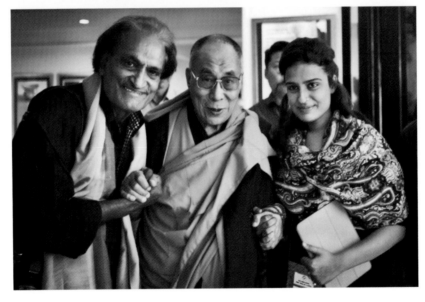

ACKNOWLEDGMENT

To the office of His Holiness the Dalai Lama
for archival images of His Holiness's early life.
To Tenzin Choejor for sharing his images
on pages 71, 100–101, 189 and Marilyn
Silverstone for the image on page 29. And my
thanks to Tenzin Taklha for making special
photo sessions possible with His Holiness.